BY THE PEN

BY THE PEN

by Jalal Al-e Ahmad

translated from the Persian
by M.R. Ghanoonparvar

Introduction and Glossary
by Michael Craig Hillmann

Middle East Monographs, No. 8
Center for Middle Eastern Studies
The University of Texas at Austin
Austin, Texas 78712

The publication of *By the Pen* has been co-sponsored by *Literature East and West*, a world literature journal affiliated with the Department of Oriental and African Languages and Literatures at The University of Texas at Austin. Michael Hillmann of *LE&W* supervised the project; and Cynthia Sánchez handled the formatting and preparation of the camera-ready text. Typing was done by Diane Wilcox.

Library of Congress Catalogue Card Number 88-070404

ISBN 0-292-70770-3

Printed in the United States of America.

CONTENTS

v

TRANSLATOR'S PREFACE AND ACKNOWLEDGEMENTS

By the Pen is a novel about Iranian intellectuals, Iranian men of the pen. But it is also about the Iranian people and society. Set in an imaginary time and an imaginary city, on another level it is a remarkable work of verisimilitude. In this novel, Jalal Al-e Ahmad tells the story of a revolution, of sorts, but more importantly, he addresses the question of whether those who assume power are able to rule in accordance with their own ideals or are compelled, as they face the practical aspects of governing, to resort to measures that in effect compare with those of the government they have replaced. In this respect, even though written in 1961, *By the Pen* may have implications not only to events of the last decade in Iran, but also to the future of Iranian and other societies.

By the Pen is Al-e Ahmad's most mature work of fiction, the one most likely to withstand the test of time. It is an accomplished novel in terms of modern novelistic standards, even if inspired, particularly in language and tone, by traditional Persian storytelling. In this work, Al-e Ahmad successfully disguises the often shrill and opinionated voice evident in his polemical essays and much of his fiction, wherein he points an accusatory finger at various strata and institutions of his society. Instead, in *By the Pen*, he simply delineates the dilemma of the intellectual vis-a-vis society. He invites readers to listen to his "once upon a time" tale, but he also urges them to join him in contemplating theoretical and practical social issues, in particular the role and function of the writer in society.

Al-e Ahmad's writings present the translator with difficulties inherent in his particular modes of expression. *By the Pen* is no exception. In fact, additional challenges arise due to the author's stylistic experimentation in this work. On the whole, the goal of this translation has been to remain faithful to the original. In practice, I have tried to avoid the pitfalls of both a literal translation, on the one hand, and a free translation, on the other, and to thereby preserve as much of the texture of the original as possible. To this end, I have maintained the original paragraphing, perhaps at the expense, at times, of stylistic consistency. In regard to several recurring Persian terms, such as *Qalandar* [a member of an order of wandering dervishes] and

vii

tekyeh [a place of residence for dervishes and the poor; also, a center for religious mourning], established Anglicized spellings of these terms, as found in Webster's third New International Dictionary, e.g., "Calendar" and "tekke," are used. Culture-specific images, Persian terms and proper names are explained in the glossary at the end of the volume. Transliteration is based on Persian pronunciation.

Several years ago, while I was preparing the first draft of this translation, as a classroom exercise in the problems of translating Persian into English, a number of my students at the University of Virginia tried their hand at translating portions of the first three episodes. These early drafts were discussed and analyzed in class by all the participants. I have incorporated many of their suggestions in this translation, and therefore, am indebted to the efforts of Carrington Gregory, Cynthia McGlone, Forozan Navid, James Price, Vernon Schubel and Christopher Stubbs.

Further thanks go to Michael Hillmann and Hamid Dabashi for their painstaking hours of comparing the original Persian with the English translation along with me, and for their suggestions, which have helped improve the translation. I am also grateful to Diane Wilcox, both for her editorial assistance and especially for the laborious task of word-processing in light of the number of times the translated text was revised. And I must express my appreciation both to the Center for Middle Eastern Studies at The University of Texas at Austin for including this volume in the Middle Eastern Monographs series and to *Literature East and West*, cosponsor of the publication.

<div align="right">

M.R. Ghanoonparvar
Austin, Texas
February 1988

</div>

INTRODUCTION

Michael Craig Hillmann

In a twenty-four year writing career which began in the spring of 1945 with the publication of the story "Pilgrimage" in *Sokhan* magazine and which ended in September 1969 with a fatal heart attack at the age of forty-six, Jalal Al-e Ahmad established himself as a major voice in Persian fiction. Characterization of that voice is the purpose of this introduction to M. R. Ghanoonparvar's excellent translation of *Nun v'al-Qalam* [(The Letter) N, By the Pen] (1961), arguably Al-e Ahmad's most effective and relevant fictional work.(1)

Of course, Seyyed Jalaloddin Sadat Al-e Ahmad (1923-1969), Iran's most translated contemporary author in America, was much more than a writer of short stories and novels. As shown by the comprehensive bibliography appended to John C. Green's translation of Al-e Ahmad's 1964 hajj travel diary called *Lost in the Crowd* (1985),(2) Al-e Ahmad was also a translator, ethnographer, and prolific essayist. In fact, he was the leading social critic in Iran during the post-Mosaddeq, pre-Khomayni era from the fall of 1953 through the end of 1978.

Even without his many literary achievements, Al-e Ahmad would remain particularly significant and controversial in Iran today because of his assumption that Twelver Shi'i Islam is a necessary core component of Iranianness and because of an alleged inclination on his part toward a religious government as the necessary successor regime to the Pahlavi monarchy.(3) This presumption led Iranian government authorities in the early 1980s to name a highway and a school in Al-e Ahmad's North Tehran neighborhood after him. On the other hand, it has led some secular intellectuals, many of them now in exile, to denigrate Al-e Ahmad as a "mullah's son" and castigate him for his alleged influence on people who brought about the Islamic Republic of Iran in the spring of 1979.(4)

Although the great variety and continuing thematic relevance of his some twenty volumes of essays, ethnographic studies, and translations make Al-e Ahmad most significant as a writer of non-fiction, his nine volumes of stories and novels certainly put him in the first rank of Iranian writers of fiction. Other leading figures with major works translated into English are: Sadeq Hedayat (1903-1951), Sadeq Chubak

(b. 1916), Gholamhosayn Sa'edi (1935/6-1985), and Hushang Golshiri (b. 1937). Al-e Ahmad's career in fiction began as Hedayat's productivity was waning and ended as Sa'edi and Golshiri were becoming major figures.(5)

Al-e Ahmad's first and best known collection of short stories, called *The Exchange of Visits*, appeared in 1946. It was followed in short order by *Our Suffering* (1947) and *Seh'tar* (1948). *The Unwanted Woman* appeared in 1952, and was reprinted in 1964 with two additional stories. A sampling from what was apparently planned as a fifth collection of stories appeared posthumously in 1971 under the title *Five Stories*. The first of four longer narratives was *The Tale of the Beehives*, published in 1955. Three years later *The School Principal* appeared. Then in 1961 came *By the Pen*, followed in 1968 by *The Cursing of the Land*, at least two chapters of which Al-e Ahmad had previously published separately.

Among nearly fifty published short stories by Al-e Ahmad, a dozen or more have appeared in English translation.(6) Representative of the writer's short fiction in general, they focus on everyday life in Tehran, question traditional religious values and customs, and more often than not depict the plight of lower middle class Iranians in their mostly unsuccessful attempts to find meaning or joy in life.

In "The Untimely Breaking of the Fast," a bazaar porter suffering through the first few days of the Ramazan religious fast finally decides he has to quench his thirst. So he boards a bus to Karaj and there drinks some tea. Because he has taken a trip, he does not violate religious law with respect to religious fasting. In fact, this is what he tells his wife when she voices anger that evening at hearing that he has spent money he could have used to buy food for their small child in travelling to Karaj merely to avoid breaking the letter of the religious law.

In "Seh'tar," a young man whose sole pleasure and one hope for success in life lies in his music finally becomes able to purchase a *seh'tar* [a four-stringed, small-bowled instrument]. But, on the way home the very same day, a religious zealot whose perfume shop stall is next to a mosque accosts the musician who seems about to enter the mosque precincts, no place for a musical instrument. They grapple, and the instrument falls to the ground and breaks into pieces.

The reader senses the authorial presence of Al-e Ahmad as an intellectual social critic in narrative after narrative of people caught in their own traditions. Irony abounds in these mostly simple stories, as in "The Mobilization of a Nation." In that story, patrons of a public bath in Tehran flee it when they hear airplanes overhead, as if they might find some place safer during a World War II air raid.

Another palpable feature of these stories is their realism. They are the products of observation and reflection, rather than of a particularly vivid imagination. As Al-e Ahmad's widow Simin Daneshvar has

observed, "I know or have seen most of the characters in Jalal's stories. They are real people."(7)

Some of his stories are sheer autobiography, "The Joyous Celebration" for example. This story presents Al-e Ahmad as a boy whose father, a neighborhood religious elder and prayer leader, has received an invitation to attend a public reception on the anniversary of the 1936 banning by Reza Shah Pahlavi of the chador veil which traditional Islamic practice in Iran had prescribed for women. Enraged at the invitation, the father ends up arranging for a temporary marriage with the daughter of a military officer acquaintance. By escorting her to the reception he will avoid getting in trouble with the authorities and, at the same time, not have to take his own wife "bareheaded and barebottomed" out in public. In this and other such autobiographical stories, the adult Al-e Ahmad reviews his religious upbringing.

In "My Sister and the Spider," he tells the story of his older sister who dies of breast cancer which she refused to have treated by a modern medical practitioner because it would be inappropriate for a male physician to look at her unclothed. Instead, she submits to a traditional remedy, the imposition of red, hot lead filings on her breast, which her younger brother 'Abbas (= Jalal) brings home from the bazaar, not knowing at the time the purpose to which they are to be put.

In his shorter narratives, Al-e Ahmad exhibits two further characteristics as well: a knowledge and feel for Iranian folklore, and a rich colloquial Persian style, which becomes identifiable as his at least when the speaker or narrator is the author. These two characteristics, together with his autobiographical and social critical interests, are central to his longer fiction as well.

Among Al-e Ahmad's four published novels, *The School Principal* is the most read and highly regarded, and the first of his major works to appear in English. As a portrayal and indictment of negative aspects of the Iranian educational system at the local and elementary level, *The School Principal* holds a special place in contemporary Persian fiction: at the time of its publication it exhibited an unprecedented, uncompromising realism and force in its representation of a specific contemporary problem involving explicit social criticism, with the portrayal couched in prose of appropriate directness, vigor, and informality. *The School Principal* is a book which seems to have struck a chord of familiarity and recognition in many readers who discover in it a palpable verisimilitude and pieces of their own experiences.

The School Principal recounts events at an elementary school in a new neighborhood throughout most of a school year. The story is told by the newly appointed principal, a thinly disguised autobiographical character: Al-e Ahmad had served as the principal of Safa Elementary School in the north Tehran neighborhood called Tajrish during the

1955-1956 school year. The principal is a frustrated and somewhat cynical former teacher, who has pulled whatever strings he could to get out of the classroom and into the principal's office. Through his eyes, the urban Iranian environment of the mid-1950s is detailed as seen from within the arena of elementary education. The previous principal was fired because of Tudeh Party Communist leanings; and during the school year in question, one of the teachers is arrested on suspicion of Communism. Another teacher is injured in an automobile accident involving an American driver, "one of those who trample the world." This irritates the narrator who perceives undesirable American influence in Iranian life. But the teacher in question is not perturbed for long by the accident because the Americans offer him a job. The principal also feels sympathy for children being administered corporal punishment and for the poverty that is the lot for the majority of them. His years in education have persuaded him that poorer children are brighter than "spoiled rich kids."

During his tenure, improvements are made in the school. But the narrator is not cut out for the job. He does not know how to deal effectively with the local gentry, the other teachers, or tradesmen and others who provide services and expect special consideration and favors. He is frustrated by a system of giving and receiving favors and is fearful of becoming corrupted by it. Several times during the year he prepares a letter of resignation, which he does not send. The climactic event in the novel is the principal's loss of control when confronting a larger boy accused of raping a smaller boy. He thrashes the rapist, would really like to have killed him, and goes home to his wife, utterly done in. He then submits his resignation, together with a lengthy critique of the school system.

The School Principal has survived as an exemplary piece of social criticism and will maintain its relevance for as long as its message reflects existing social circumstances in Iran. The force of this message and the appeal of its prose are highlights of Al-e Ahmad's achievement in the novel. At its publication *The School Principal* stood almost alone in modern Persian fiction as a direct commentary on a social issue involving and perhaps indicting its own readers. In the severely censored post-Mosaddeq age, it was in fact a somewhat daring book.

One later piece of Persian fiction more than superficially comparable to *The School Principal* is Al-e Ahmad's fourth and last published novel called *The Cursing of the Land* (1968), the first person narrative of an elementary school teacher who, after having taught in various villages for five years, arrives at his new post.

Change has begun to affect the village, and at a gathering at the school principal's house on the new teacher's first evening in the village, talk is of the old ways and the new. The principal's uncle, who had taught under the previous educational system and now teaches the

lower grades at the new village school, complains that whereas in the old days children were taught to become good villagers, nowadays they learn about the city and end up leaving the village. There is talk also of a neighboring village called Amirabad, where trouble has arisen between the farmers and the city-bred landlord. The latter's tractor driver has plowed into local farmers' plots, resulting in a quarrel, the interference of gendarmes, and the consequent arrests of several farmers. The principal and his younger brothers favor modernization and have already become petty capitalists: one brother has a truck, and the family owns the village flour mill. However, their competitor, the overseer, has ordered an electricity-powered mill for the village, which is not large enough to support two mills. News of the progressive outside world via transistor radios has made the villagers restless for modernization.

During his first week in the village, the teacher has a conversation at the local mosque with Darvish 'Ali who is contentedly smoking hashish in a corner. He reflects that the latter, although a vagabond, is really a part of the village while he, the teacher, is an outsider. He observes that the dervish has "roots" while he himself has not only lost his, but also now teaches children things not really relevant to their own way of life.

The electricity-powered mill is brought to the village, accompanied by journalists and photographers who plan to take the news of the village "progress" to the outside world. A cow is sacrificed for good luck. One of the landlady's sons, a representative in Parliament who has come for the occasion, converses with the teacher who intimates that he must be comfortable living in town, since his mother owns most of the village. The son denies this and explains that villages no longer support the cities, and that he himself makes five times more money from his law office than the village as a whole does. Later, however, Bibi refutes her son's statement by revealing that she has been paying his gambling losses from village income.

Bibi is one of the last members of the old rural aristocracy, and took over the affairs of the village after her husband's death many years before. She rules authoritatively through her overseer, with whom she has contracted a mock marriage to avoid the obligation of wearing her chador veil when he visits her on business. She also warns the teacher not to get involved in the quarrel between the principal and the overseer. During this celebration of the new mill held in Bibi's house, the landlady must settle various disputes among the peasants concerning their dry farming as well as answer their objections to her having sold a piece of land to a non-Moslem outsider who intends to start a chicken farm.

With the coming of winter, the village death rate increases, and the teacher learns that some of the older villagers, including the principal's uncle, on the advice of a religious reader, do not drink the village water,

which had been diverted from another, subsequently abandoned, village. Ever since the event, many of the older villagers have been collecting rainwater for their needs as they consider the village water "tainted." This winter, through negligence, their supply has frozen, breaking the containers and spilling out the remaining water. Shortly thereafter, the uncle dies.

At this time, the feud between the overseer and the principal erupts again. When the electric generator at the new mill is cut off one night, one of the principal's brothers is accused of having put sand in it. In revenge, the overseer's supporters attack and destroy the "enemy's" crops. The next day, a group of the villagers gather to counterattack, deciding to destroy the new chicken farm. The riot, however, is squelched when the villagers are confronted by the overseer and the gendarme, both armed.

After a brief holiday trip in early spring, the teacher-narrator returns to the village to find that the gypsies have again set up camp near the village. The teacher goes there for a visit, to see the gypsy painter who had earlier been run out of the village because of his affair with a village woman. The latter tells the teacher of the misery he has seen all over the country. The government's land reform program, he says, has not helped the peasants at all. He also says that he does not want to wander constantly; but, like other gypsies, he is not allowed to settle down anywhere.

The village is rapidly becoming modernized, and the villagers are becoming increasingly aware of new changes including those the land reform has brought about. They question the teacher about rural cooperatives and other elements of the reform. Among official visitors who come to the village in conjunction with the land reform program is a young agricultural advisor, who, along with his other duties, is to take the census. But the villagers are suspicious and uncooperative. With the help of the teacher, the agricultural advisor learns that he must gain the trust of the people to obtain the information he wants. Later, at a holiday gathering in Bibi's house, the agricultural advisor appoints the members of the "rural coop committee": the overseer as president and the principal as vice-president, in essence, the same people who had control in the old system get controlling positions in the new.

While the teacher is away in Amirabad, for the purpose of establishing a school there, Bibi dies, and riots break out again. He returns to the village to learn, in addition, that the overseer has been fatally shot, many people injured and hospitalized, and the gypsy tents burned. The gendarmes have made many arrests. With the bodies of Bibi and the overseer in the truck, the teacher joins the burial party on their journey to the holy city of Qom, and the novel ends.(9)

In terms of narrative point of view, the as yet untranslated *Cursing of the Land* is obviously a continuation of *The School Principal*. In

both novels, the reader meets a narrator already imbued with either cynicism or what might be termed an unsympathetic realism resulting from experiences prior to and outside of the narrative context. But whereas the narrator of *The School Principal* has moments when the reader can sympathize and almost identify with him, the narrator of *The Cursing of the Land* exhibits almost no chinks in his armor of cynicism. It is as if in the course of development of sharper focus in his war against social ills, Al-e Ahmad becomes in the decade between the two novels more impatient in his desire for reader awareness of and attention to the seriousness of these problems and thus feels less constrained to take pains to give plausible and entertaining fictional form to his exposé in the latter novel.

The Cursing of the Land is richer in detail, characterization, and narrative conflict than *The School Principal* and exhibits a much wider scope of social criticism. In *The School Principal*, the subject is the educational system, and very little is represented that somehow does not reach back to the school. But in *The Cursing of the Land*, social problems treated include aspects of land reform, mechanization, education, and military conscription. Since the picture of life shown is comprehensively negative, the reader feels eventually that some of the action has been contrived to create such a wholly negative situation.

Probably because the social criticism in *The Cursing of the Land* involved direct questioning of the various reform programs in the Pahlavi "White Revolution" or "Revolution of the Shah and the People," the book was banned, unlike *The School Principal*, the social criticism in which antedated the White Revolution promulgated in 1963. Therefore, *The Cursing of the Land* was not widely read during the Pahlavi era. It became available in 1978 and later, along with the *By the Pen*, *Weststruckness*, and others among Al-e Ahmad's previously banned books, mainly through the efforts of his younger brother Shamsoddin who was associated with both Ravaq Press and Islamic Republic officialdom.

But, regardless of its failure to influence readers by virtue of its unavailability for a decade, *The Cursing of the Land* is a landmark statement in two regards. First, it embodies a continuation of Al-e Ahmad's arguments in *Weststruckness*. The basic or ultimate problem in Iranian villages, Al-e Ahmad's story implies, is the West, that dehumanizing civilization which is no more than a process of production and consumption. Western technology is both alien to Iranian villagers and beyond their means to acquire. It is technology, further, that is not being introduced in response to real needs, but by royal fiat. Second is its more encompassing and insightful concern about growing rootlessness in Iran, a theme which became common in Persian literature of the 1970s.(10)

The Cursing of the Land was the last of Al-e Ahmad's major writings to be published in his lifetime. Among them, *The Exchange of Visits* (1946) had announced to the Iranian literary world that Al-e Ahmad was a writer of promise. *The School Principal* (1958) represented the fulfillment of this promise and demonstrated that its author had determined to be a chronicler of the Iranian present and not primarily of grand and timeless issues. *The Cursing of the Land* reaffirmed this and broadened the scope of Al-e Ahmad's social criticism in fiction.

Two of Al-e Ahmad's works of fiction, *The Tale of the Beehives* (1955) and *By the Pen* (1961) would seem, as folktales, not to fit into this characterization of Al-e Ahmad's fiction as being directly concerned with contemporary issues and deriving from observation and autobiography. But they are just as much a part of Al-e Ahmad's personal approach to social criticism as are his other works. It is just that they derive also from academic training and interests and intellectual activities, rather than exclusively from everyday observation of life.

Al-e Ahmad's first piece of longer fiction, *Tale of the Beehives*, is the shortest of the four and, in its author's view, the least noteworthy.(11) However, this fable told in a 'once-upon-a-time' narrative mode ought not to be overlooked or underestimated despite its brevity, superficiality, and allegorical oversimplification. First, as a folktale, it is representative of a form which regained popularity in Iran during the later Pahlavi era. In comparison with the more famous tale by Samad Behrangi called *The Little Black Fish* (1968),(12) Al-e Ahmad's *Tale of the Beehives* seems considerably more stylish with much more believable characters. Second, as allegory, *Tale of the Beehives* offers a still relevant tableau of issues of cultural authenticity, a people's rights to their natural resources, and social responsibility.

Tale of the Beehives relates the story of a prosperous villager named Kamand 'Ali Bek who, besides land and other crops, owns twelve beehives from which he takes honey each fall. Kamand 'Ali Bek is a man of local distinction precisely because of these hives. Actually, there used to be sixteen of them, but ants infest several owing to Kamand 'Ali's son's carelessness. Consequently, to compensate for his losses, Kamand 'Ali removes honey from the hives a second time one year, in the spring, leaving syrup in its place as food for the bees. The syrup attracts an invasion of red ants in two hives.

The bees, used to the annual depredation by an unknown force each fall and unclear in any case as to the significance their honey could have for anyone, including Kamand 'Ali, are stunned by this new plunder. They dislike syrup, which dulls their senses and makes them incapable of productive activity. And their very homes are now threatened by red ants.

Two queen bees discuss options. One is to return to their original homeland in the mountains which they had been obliged to flee years ago after their hive collapsed. Different bees have different views as to what course of action to take. Some younger bees think they should put up with any hardship the owner or fate might have in store for them as long as they have a home, which they now do. Another view is that for a bee, life is not life unless they make their own food and homes for themselves. The leading queen bee persuades the others that migrating is the only answer. One of three bees sent to check out the old land survives to return with the news that all is well there. Of course, they will have to put up with the rigors of the wild there. But they will have their freedom again.

So, the day after the greedy Kamand 'Ali replaced the remaining honey with syrup, the bees depart in twelve groups to the consternation and chagrin of their former owner. Thus ends Al-e Ahmad's optimistic allegory on Iranian oil and what Iranians would have to do to avoid continued subjugation to the West with respect to the exploitation of their natural resources.

The relevance of *Tale of the Beehives* to issues facing Iranian intellectuals during the 1950s is just one significant dimension to the story. A second, already cited, is its form, the indigenous folktale rather than a Western short story or novel. Third is the texture of research into bees which Al-e Ahmad undertook in preparing to write the book. In all three regards, *Tale of the Beehives* proved a useful experiment for the later and lengthier tale called *By the Pen*.

By the Pen utilizes the same folktale format as in *Tale of the Beehives*. But whereas in the earlier book the format is used for a fable, in *By the Pen*, it functions in a narrative with human characters in a pseudo-historical setting, But in both cases, it is the style which first gets reader attention. In other words, it is not Al-e Ahmad's own prose voice. As he himself later observed on the subject of the book's style and narrative point of view: "If its prose seems special, it is because I took the language of the masses. Once-upon-a-time. Straight and simple. The language of *By the Pen* is not mine. I made use of an existing substance."(13)

As for the allegorical import of the story, Al-e Ahmad reveals at least two thematic intents which alone should have made the book a subject of serious scrutiny by Iranologist political scientists and historians. First, he asserts that the story depicts the effects historically consequent to the official linking of church and state with the advent of the Safavid Dynasty (1501-1722); that is to say, the creation of a society no longer willing to suffer for principles and ideals, but preferring to pay lip service to past Shi'i Moslem heroes and martyrs instead.(14) Secondly, he asserts that *By the Pen* portrays the course of the defeat of leftist movements in Iran after World War II.(15) On both

counts, Al-e Ahmad's comments are deliberately vague, owing to his justifiable concern over censorship of the essays in which he discusses these issues. The fact is that the plot of *By the Pen* closely parallels, first, a specific period in the reign of Safavid Shah 'Abbas the Great (ruled 1587-1629) and, second, the rise and fall of Mohammad Mosaddeq (1882-1967), who served as prime minister of Iran from the spring of 1951 to mid-summer 1953.

The physical and temporal setting of *By the Pen* is obviously Islamic Iran before modern times, specifically a fictionalized Esfahan in the late sixteenth century. The country is described as a Shi'i empire (The Safavids) at war with a powerful Sunni neighbor state (Ottoman Turkey). There are allusions as well to contemporary events in Europe.

The title of the novel is an allusion to Surah [chapter] 68 of the Koran, which is called "The Pen." In that surah, after the invocation "in the name of Allah, the merciful, the compassionate," the text reads *n va'l-qalam*, which translates literally as "n/by the pen." Scholars are not certain as to the significance of this letter 'n' here and other so-called "mystery" or "mystical" letters that begin a number of surahs. The remainder of the first two verses of this surah reads in translation: "[By the pen] and what they write with it, you, by virtue of the Lord's blessing, are not mad."(16) Al-e Ahmad quotes these two verses on the page facing the Table of Contents in *By the Pen*. But he entitles the book in Persian *nun va'l-qalam*, giving the name of the alphabet letter *nun* in three letters (n+u+n) rather than just its shape as occurs in the beginning of the Koranic surah. Furthermore, because he juxtaposes *nun v-al-qalam*, the title comes out in English as "*Nun* and/by the Pen." *Nun* is both the name of the letter and the colloquial pronunciation of the Persian word for "bread" (the literary pronunciation is *nân*).

In short, the title invokes an oath, implying that what Al-e Ahmad will write will be nothing short of the whole truth. In addition, the title focuses attention on writing as a craft or profession and the connection between what one is writing and the source of one's daily bread.

The title postulates the dilemma which the protagonist Mirza Asadollah faces in trying to be righteous while feeding his family.(17) It also highlights the distinction between him and the other protagonist, Mirza Abdozzaki: the former wields the pen for the pen's sake, while the latter uses it for bread's sake. The rest of the Koranic verse "and what they will with it," omitted in the title but quoted before the beginning of the story, further distinguishes between responsible writing and irresponsible "selling of one's pen."

Such aspects of the title's allusiveness imply that the novel treats Al-e Ahmad's own feelings about his own craft, even if the narrator proper is not directly autobiographical. Asadollah, however, seems ideologically very close to Al-Ahmad. As for the author's choice of a

distant, pseudo-historical setting for his novel, the fact of censorship and the desire to use native materials seem two obvious explanations. Unfortunately, despite his caution, government censors saw to it that the bulk of the copies of *By the Pen* stayed in its publisher's warehouse until the late 1970s. And the book remains little discussed, and perhaps little read, nearly thirty years after its publication.

By the Pen begins with a version of a famous folktale about a shepherd who is chosen vizier. The narrator tells readers that this preliminary tale is a mere prologue to the main story. As a prologue, it establishes the narrative mode and point of view of the main action to follow. For although the main story takes place in a once-upon-a-time age and place different from that of the shepherd-vizier tale, the prologue prepares readers for a traditional folktale on the subject of the ways of politics and how people involuntarily become actors in the political arena. Further, with the already discussed allusion in the title to the power of the pen described in the Koranic chapter of that name, readers are better prepared to meet the two protagonists of the main tale, who are scribes and, like the shepherd, become suddenly entangled in the web of politics. As it turns out, after the main tale, the threads of the prologue are used in an epilogue, thus creating a frame for the main tale. In the epilogue, the narrator reports the fates of the shepherd-vizier's sons, one of whom is assumed by some people to have been the 'real' author of the main tale. Others assume that one of the two protagonists in the main tale wrote the story. In either case, the narrative frame establishes the main tale as a legacy from the pseudo-historical age for modern Iranian readers. This device is a salient feature of Al-e Ahmad's characteristic focus on issues and themes of social relevance.

As the story of the two scribes, the main tale of *By the Pen* unfolds slowly at first. In fact, its deliberately unhurried pace and gradual momentum, together with the balanced contrast in the early chapters of the lives and personalities of the two protagonists, create and develop the folktale quality of the story. The very human, everyday details and concerns with which the characters are fleshed out lend to the narrative a texture of credibility and to the following action a retrospective plausibility that may be lacking in *The School Principal* and *The Cursing of the Land*. Finally, through the very form and narrative point of view of the Iranian folktale, which involves a personable, narrator-reporter who maintains direct verbal contact with the audience, Al-e Ahmad achieves a natural detachment from the characters, especially since the folktale narrator is generally a stock character who merely relates and embellishes stories heard from others. This detachment or aesthetic distance makes it possible for Al-e Ahmad to avoid speaking with his own voice and merging his personality as a social critic with that of his character. It is this lack of distance in *The School Principal*

and *The Cursing of the Land* that may leave some readers feeling that Al-e Ahmad sometimes sacrifices narrative plausibility on the altar of social aim.

All of these factors afford *By the Pen* the potentiality of proving more effective than Al-e Ahmad's other longer works of fiction. At the same time, despite its allegorical mode, it is as pertinent and timely as *The School Principal* and *The Cursing of the Land* in terms of social criticism, something the Pahlavi monarchy apparently recognized in not allowing its distribution.

The basic action of *By the Pen* is revolution and how Asadollah and 'Abdozzaki, among others, including the people at large, are caught up in it. Readers familiar with the civil upheaval in Iran during 1978 which led to the establishment of the Islamic Republic of Iran in the spring of 1979 will find much food for thought in Al-e Ahmad's narrative. But as prescient as some readers of *By the Pen* have found Al-e Ahmad, his story owes more to the Iranian past than to prophecy.

The details of the setting of the novel, as well as its action, call to mind Safavid Esfahan during that period when the Noqtavi sect pursued its secret activities against the Safavid regime. In response, the government secretly poisoned people in the bazaar and otherwise caused people to disappear. In turn, the Noqtavis established safe houses and sanctuaries for the oppressed and dispossessed and gradually achieved widespread popularity.(18) Such a historical environment is mirrored in the novel in the rise of the *Qalandars* (= Noqtavis, or "Calenders" in the translation) as a voice of dissidence in the realm of *Qebleh-ye 'Alam* (= Safavid Shah, or "His Imperial Majesty" in the translation).

Histories of Safavid Iran also record a specific sequence of events likewise worked into Al-e Ahmad's tale. In the early years of the reign of Shah 'Abbas, astrologers and aides predicted an untoward event, to avoid which the monarch was advised to relinquish the throne for three days so that the ominous events might befall a temporary successor.(19) In history, that person was called Yusef Tarkeshduz[=Joseph the Quivermaker], whose name is echoed by that of the leader of the Calenders in Al-e Ahmad's tale, Torab Tarkeshduz. The revolutionary threat to the Safavid state on the part of the Noqtavis did not succeed in history, nor do Al-e Ahmad's Calenders achieve their goals. But it is not giving away too much of the story to say this in an introduction because the appeal and the point to the narrative are much less in what happens next than in why things happen as they do in Iranian culture, including what readers will early on guess is an almost inevitable outcome.

As a reinterpretation and creative reconstruction of a seminal age of Iranian history, in which traditional ruler-subject relations, governmental forms, and Twelver Shi'i Moslem values and clergy play major roles, *By the Pen* would seem to have become potentially more

interesting in the post-Pahlavi era, insofar as Twelver Shi'ism has now become the essential shaping principle of Iranian social and political life. Not that there are necessarily close parallels. Nevertheless, because Al-e Ahmad had a more sensitive appreciation of the importance of Shi'i religious values, customs, and institutions to Iranian life than did most other secular-minded intellectuals of his generation, his fictions often seem less separated from the facts of Iranian life as they have revealed themselves in the years after the revolution in 1978. However, that may not be the chief aspect of the sociological interest today in *By the Pen*. For one event in recent times outshadows even the advent of the Shi'i Safavid state and the Khomayni phenomenon for some Iranians. That is the rise and rule of Mohammad Mosaddeq and the coup d'état in August 1953 that brought down his government and forever dashed the reasonable hopes of secular-minded intellectuals for the possibility of liberal democratic values and institutions in their society. As cited above, Al-e Ahmad is on record as having intended his tale to reflect the causes of the failure of leftist movements in Iranian politics after World War II. The parallels are obvious and thought-provoking, and deserve bearing in mind in the reading of *By the Pen*.

Mohammad Mosaddeq was a truly popular man, a charismatic figure in whom even cynical intellectuals apparently believed. Even apolitical types were willing to participate in his movement, as the scribes participated in the Calendar movement in the story. In mid-1953, Mosaddeq's power reached the point that Mohammad Reza Shah, the second and last Pahlavi monarch (ruled 1941-1979), was obliged to flee the country temporarily.

As for the Shah, like "His Majesty" in the story, he was a ruler surrounded by secular and religious sycophants. One prominent Pahlavi official mirrored in the tale is Parviz Natel Khanlari (b. 1913) (= Khanlar Khan in the novel), a traditionalist poet, university scholar, and magazine editor who served also as Minister of Education and Governor-general of Azarbayjan Province. Al-e Ahmad had sought Khanlari's support early in his career, but counted Khanlari an enemy of the people once the latter decided to accept important government positions. Al-e Ahmad's neighbor the poet Nima Yushij, a cousin of Khanlari, used to call the latter "Khanlar." As for the loyalty of prominent members of the Shi'i religious hierarchy in Iran during the Mosaddeq Era, that is paralleled in the novel by the behavior of Mizanoshari'eh.

Royalists, including religious elements, were aided by American plotting and money to overthrow Mosaddeq and bring the Shah back to Iran after a week in Baghdad and Rome. In the novel, the monarch is aided by a treaty with a foreign power and by the fickleness of the population, as in the historical context, where people in the bazaar and

on the streets turned against Mosaddeq as a result of the clamor of several rabble-rousers. But the Safavid and Pahlavi eras are history. The spring of 1989 marks the end of a decade of Islamic Republican rule over Iran. Al-e Ahmad's novel may thus be more relevant as an insightful depiction of the role of religious belief as a political force in Iranian life. However, because the conclusion of Al-e Ahmad's novel has been contradicted by history and the success of the Islamic Republic, the overriding value of *By the Pen* has to lie in its appeal as fiction, in its depiction of both culture-specific and universal aspects of the behavior of people involved in politics and in Al-e Ahmad's masterful weaving of a tale.

NOTES

1. The bases for the appeal of *By the Pen* are argued in a preliminary way in Michael C. Hillmann, "Al-e Ahmad's Fictional Legacy," *Iranian Studies* 9 (1976): 248-265, an essay updated in *Critical Perspectives in Modern Persian Literature*, compiled by Thomas Ricks (Washington, D.C.: Three Continents Press, 1984), pp. 331-342. The present essay draws heavily from these earlier articles.

2. John C. Green, "Bibliography," *Lost in the Crowd* by Jalal Al-e Ahmad, translated by John C. Green (Washington, D.C.: Three Continents Press, 1985), pp. 135-157. Salient items in English not cited in Green's bibliography include: Simin Daneshvar, "Jalal's Sunset," translated by Farzaneh Milani and Jo-Anne Hart, *Iranian Studies* 19 (1986): 47-63; William L. Hanaway, Jr., "[Review] *Lost in the Crowd*," *World Literature Today* 60 (1985): 515-516; Michael C. Hillmann, *Iranian Culture: A Persianist View* (Lanham, Maryland: University Press of America, 1989); and Roy Mottahedeh, *The Mantle of the Prophet: Religion and Politics in Iran* (New York: Simon & Schuster, 1985), pp. 287-336.

3. According to Robert Wells, "Jalal Al-e Ahmad, Writer and Political Activities," Ph.D. Thesis, University of Edinburgh, 1982, p. 124, Parviz Daryush claims that Al-e Ahmad declared his acceptance of Ruhollah Khomayni's leadership at a meeting in Qom during February/March 1963.

4. Firmly opposed to Al-e Ahmad are such intellectuals as Ahmad Shamlu, Ebrahim Golestan, and Nader Naderpur. Even nonexpert readers can judge for themselves on this issue because a representative sampling of Al-e Ahmad's nonfictional works is available in translation. For example, in *Iranian Society: An Anthology of Writings* by Jalal Al-e Ahmad, edited by Michael C. Hillmann (Costa Mesa, California: Mazda Publishers, 1982), appears an important, albeit brief, 1968 autobiographical sketch, and several literary critical essays, including tributes to Al-e Ahmad's longtime neighbor Nima Yushij (1895-1960), the 'father' of modernist Persian poetry, and Samad Behrangi (1939-1968), Al-e Ahmad's Azarbayjani protégé and a likeminded social critic. Also available are three published translations of Al-e Ahmad's most famous piece of nonfiction, the polemic essay call *Gharbzadegi* [Weststruckness], one of them, *Occidentosis* (Berkeley, California: Mizan Press 1984), featuring a sympathic essay by the Moslem historian Hamid Algar. The published translation of *Lost in the*

Crowd has already been cited. Another book that needs translating in this context is *A Stone on a Grave*. Written in 1964 but not published until late 1981, it is an autobiographical narrative prompted by Al-e Ahmad's reaction to the discovery early in his marriage to the writer and academic Simin Daneshvar (b. 1921) that he could not father a child.

5. For an overview of post-World War II Persian fiction see Michael C. Hillmann, "Persian Prose Fiction (1921-77): An Iranian Mirror and Conscience," *Persian Literature*, edited by Ehsan Yarshater (Albany, New York: State University of New York Press for the Persian Heritage Foundation, 1988), pp. 291-317.

6. "The China Flowerpot," translated by Michael C. Hillmann, *Iranian Society*, pp. 43-47; "The Joyous Celebration," translated by Minoo S. Southgate, *Modern Persian Short Stories* (Washington, D.C.: Three Continents Press, 1980), pp. 19-33; "My Sister and the Spider," translated by A.R. Navabpour and Robert Wells, *Iranian Society*, pp. 20-33; "The Mobilization of Iran," translated by David C. Champagne, *Major Voices in Contemporary Persian Literature*, edited by Michael C. Hillmann, *Literature East & West* 20 (1980): 61-70; "Pink Nailpolish," translated by A.R. Navabpour and Robert Wells, *Iranian Studies* 15 (1982): 81-96; "Seh'tar," translated by Terence Odlin, *Iranian Society*, pp. 58-62; "The Sin," translated by Raymond Cowart, *Iranian Society*, pp. 63-69; "Someone Else's Child," translated by Theodore Gochenour, *Iranian Studies* 1 (1968): 155-162; "The Untimely Breaking of the Fast," translated by Carter Bryant, *Iranian Society*, pp. 48-57; "The Unwanted Woman," translated by Leonard Bogle, *Iranian Society*, pp. 70-79.

7. Simin Daneshvar, "Showharam Jalal" [My Husband Jalal]. *Ghorub-e Jalal* [Jalal's Sunset] (Tehran: Ravaq, 1981/82), pp. 11-12. Wells, "Al-e Ahmad, Writer and Political Activist," pp. 158-206, details autobiographical dimensions to many Al-e Ahmad fictions.

8. Jalal Al-e Ahmad, *The School Principal*, translated by John K. Newton (Minneapolis: Bibliotheca Islamica, 1974). Girdhari Tikku's translation, also called *The School Principal*, was published in New Delhi in 1986.

9. This plot summary is based on that by M.R. Ghanoonparvar in *Literature East & West* 20 (1980): 240-244.

10. Mohammad Dowlatabadi, *Ja-ye Khali-ye Soluch* [Soluch's Empty Place] (Tehran: Agah, 1979), treats this same cultural disintegration and creation of rootlessness. In a review of the novel, A. R. Navabpour, *Iranian Studies* 15 (1982): 244-250, observes: "Dowlatabadi shows that the Pahlavi land reform failed" and that "an old system which at least worked has been sacrificed for a new system" of modernization and westernization which leads to "the disintegration of society." Ironically, the anti-western Islamic Republic of Iran has created even greater rootlessness during its first decade. An unprecedented number of young men have been taken from their villages and towns to the warfront, and inmigration has been even greater than during the Pahlavi Era, owing to economic problems. In addition, tens of thousands of Iranians have fled their homeland for uncertain and rootless futures in Pakistan, Istanbul, Western Europe, and North America.

11. Jalal Al-e Ahmad, "Goftogu ba Jalal Al-e Ahmad" [A Conversation with Jalal Al-e Ahmad], *Andisheh va Honar* 5, no. 4 (1964/65): 393.

12. Samad Behrangi, *The Little Black Fish and Other Modern Persian Stories*, translated by Mary Hegland and Eric Hooglund (Washington, D.C.: Three Continents Press, 1976), pp 1-19.

13. Jalal Al-e Ahmad, *Arzyabi-ye Shetabzadeh* [Hasty Assessment] (Tabriz: Ebn-e Sina, 1965), p. 93.

14. Idem, *Gharbzadegi*, p. 23.

15. "Masalan Sharh-e Ahvalat" [An Autobiography of Sorts], *Jahan-e Now* 24, no. 3 (1969): 7; available in translation in *Iranian Society*, p. 18.

16. The Arabic text of the two Koranic verses Al-e Ahmad quotes is; "nûn. w'al-qalami wa mâ yasturûna. mâ anta bini'mati rabbika bimajnûnin," which literally rendered in English reads: "N. By the pen and what they write in lines. / You by the blessing of your lord are not crazed." M.H. Shakir, translator, *Holy Qur'an* (Elmhurst, New York: Tahrike Tarsile Qur'an), p. 573, translates the two verses as: "Noon, I swear by the pen and what the angels write. By the grace of your lord you are not mad." According to Richard Bell, translator, "Surah LXVIII," *The Qur'an*, 2 volumes (Edinburgh: T. & T. Clark, 1937, reprinted 1960) 1: 596, footnote 1, the phrase "By the pen and what they write" is "usually taken as a reference to the heavenly Qur'an, but more probably it is to previous written revelation." As for the meaning of the letter 'n' here, it is discussed by Arthur Jeffrey, "The Mystic Letters of the Koran," *The Muslim World* 14 (1924): 247-260, and by Alan Jones, "The Mystical Letters of the Qur'an," *Studia Islamica* 16 (1962): 5-11, who asserts that the letters are in the main "intentionally mysterious and have no specific meaning"; yet, "the Nun prefixed to Sura 68 . . . could well be a reference to the story of Jonah and the fish mentioned briefly in verse 48 of that sura." The letter 'n' appears in this fashion only at the beginning of Sura 68; but the "mystery" letters uniformly preface surahs in which the Koran itelf is discussed. As for the appropriateness of the Koranic allusion to Al-e Ahmad's *By the Pen*.,"The Pen Surah" preaches repentence from apostacy, nonbelief, and hypocrisy, includes a passage often quoted to encourage Shi'i Moslems to accept only imamate government and to disobey other sorts of government, and in general deals with the failure of people both to attend to fundamental duties and to see what their true self interest is.

17. According to Hamid Dabashi, in conversation with this author in Austin in March 1988.

18. Maryam Mirahmadi, "Tahlili Tarikhi az *Nun v'al-Qalam-e Al-e Ahmad*" [An Historical Analysis of Al-e Ahmad's *By the Pen*], *Yadnameh-ye Jalal-e Al-e Ahmad*, edited by 'Ali Dahbashi (Tehran: Pasargad, 1985), pp. 551-558.

19. Eskandar Beg Monshi, *History of Shah 'Abbâs the Great*, 2 volumes, translated by Roger M. Savory (Boulder, Colorado: Westview Press, 1978) 2: 646-650.

BY THE PEN

... and by that which men write. Thou art not, by the grace
of thy Lord, mad.

PROLOGUE

Once upon a time, there was a shepherd who had a flock of goats and
a bald head, which he always covered with an animal-hide cap to keep
the flies from bothering him. As fate would have it, one day our
shepherd was tending his flock on the outskirts of a big city when he
noticed a huge commotion. People had poured out of the city to the
other side of the moat, carrying flags and banners, each group shouting
different slogans or invocations. All heads were turned up, their eyes
lifted towards the sky. Our shepherd left his flock in a secure place near
a stream in the shade of a mulberry tree. He charged his dog with
looking after the goats, and went to find out what the commotion was
all about. But no matter how intently he looked at the sky, he could not
see a thing--except for the tops of the battlements and the city gates,
decorated with mirrors and carpets. On the balcony above the main city
gate, the king's drummers and trumpeters were pounding and blowing
loud enough to deafen the sky itself. As our shepherd was slowly
wandering through the crowd, before he had a chance to ask what was
happening, a trained hunting falcon suddenly shot through the sky like
a meteor and landed on his head. It was one of those falcons that could
lift a whole goat into the air. And before our shepherd could figure out
what was what, the people rushed to him, tossed him up over their
heads and whisked him away cheering and chanting invocations. Where
to? God only knew. No matter how he struggled or screamed, the
people paid no attention. It had no effect at all. He said to himself:
"Dear God, what have I done wrong? What in the world are they going
to do with me? Thank God I was saved from that damned animal; it
could have gouged my eyes out..." And as he was talking to himself
thus, the people passed him over their heads, brought him past the
king's stables, right to the royal tent, and took him inside. Out of fear
for his life, our shepherd took several deep bows, but before he could
say, "Your Majesty," the king coughed and held his nose in disgust,

1

motioning for him to be taken away, bathed and dressed in fresh clothes before being brought back to him.

Our shepherd was utterly confused, and also worried about his goats. Again, before he realized what was what, they poured three buckets of hot water over his head, and a hefty bath attendant went to work on him. This was all well and good, since our shepherd had not seen the inside of a bathhouse in years. Of course, once in a blue moon, if he happened upon a stream, he would take a dip. But, except for his wedding night, he could not remember having been to a bathhouse for a good scrubbing. So, he resigned himself to his fate, pulled the animal-hide cap off his head and set it aside. He then began to get to the bottom of what was going on from the bath attendant,who had never before seen a head like his and was quite dumbfounded. The story was that the week before, some hot lead had apparently found its way into the throat of the king's right-hand vizier, thus blocking his windpipe. And the current goings-on represented how they were going about appointing his replacement.

Once our shepherd's mind was set at ease, he began to pour his heart out to the bath attendant. Before the business of washing and scrubbing was finished, while they were bringing the ministerial garb to put on him, he learned all the intricacies of the art of viziership from the bath attendant. He committed to memory all the protocols of the grand, such as: "At your service with my life, Your Majesty" and "To the greater glory of Your Royal Highness." And the bath attendant did not fail to perform his duty well; he rubbed down his back thoroughly with warm water to limber up his bones so that he could really bend and bow. When the bathing was finished, he put himself in the hands of God and slipped into the mantle of viziership.

However, since our shepherd was essentially a man of the hills and mountains and not of the cities with their noblemen, kings, and viziers, and since he was basically of a simple nature, a simple, novel idea dawned on him. When he came out of the bathhouse, he wrapped up his shepherd's vest, his sandals, and the animal-hide cap into a bundle around his shepherd's staff and entrusted the bundle to one of the guards. Upon reaching the ministerial palace, he went first to the cellar and searched and searched until he found an inconspicuous nook, a closet, where he put the bundle into a chest, locked it up, and placed the key in his sash. Then he set about his task as vizier, attending to the business of the court.

Now, let me tell you about the cohorts of the former right-hand vizier. With the arrival of our shepherd, their hands were tied. They could no longer live so high on the hog, because our shepherd-turned-vizier had cut off their freeloading. He had said: "As is customary in the village, you reap what you sow." Well, dearest reader, these cohorts got together, conspired and schemed and plotted with the left-hand vizier to

2

do in this bumpkin of a vizier who somehow thought that the business of viziership was like being a village headman. So, first they greased the palm of the new vizier's special gatekeeper and, with his help, they eavesdropped on him, spied on him, and shadowed him until they finally discovered that the new vizier went to some closet once a week and spent an hour doing something or other in secret. With this tidbit at their disposal, they began to spread the rumor, making sure the king would get wind of it: "The king has not been informed, but, the right-hand vizier, having just barely arrived, has stored up a treasure vaster than that of Croesus or Solomon, which he has undoubtedly stolen from the royal treasury." And, since the king was very just and devoted to his subjects--after all, for this reason, he built twelve new jailhouses every year so that no one would dare pilfer or philander--he agreed with the left-hand vizier that they should go and catch the right-hand vizier red-handed and expose him.

Dearest reader, the silver-tongued storytellers have related the tale thus: When the appointed day and hour arrived, the king, along with his left-hand vizier and a group of guards and sentries, as well as all the old cohorts, rushed to the secret closet of the right-hand vizier. When they sprung open the door and entered, they could not believe their eyes. They saw the right-hand vizier out of his ministerial garb, sitting with an animal-hide cap pulled over his head, wearing his shepherd's clothing, leaning against his old, rough staff, and weeping loudly. The king was in absolute dismay, not to mention the left-hand vizier and the old cohorts.

Well, you can imagine the rest for yourself. After the right-hand vizier was past these initial hassles, he dispatched a trustworthy emissary to his ancestral village to pay compensation to the people whose flock had been slaughtered. You see, our shepherd had found out that on that first day, each one of his scrawny goats had been sacrificed by roughnecks of the various quarters of the city as offerings to the king while the imperial retinue was going by. Having paid his debt, he sent for his wife and children to come to the city. He put his children into school. And they lived happily ever after, that is, until Divine Fate determined that it was time for a new vizier. The right-hand vizier fell out of favor and his food was poisoned at a court banquet. The court physician, who was present and saw what was going on, ordered (under the pretext of a diagnosis of colic) that the vizier be taken home immediately. Our shepherd, to whom viziership had brought bad luck, immediately realized what had happened. When he arrived home, he had himself laid down facing Mecca, called his children to him, and cautioned them never to be lured by the mantle of viziership. He also told them that they should always remember where they had come from. Then, he entrusted them with his shepherd's vest and sandals, lay down his head, and quietly passed away. Since he had neither accumulated any

3

wealth nor saved any money, no one bothered his wife and children. So, after his burial, his wife and children returned to their ancestral plot of land. His daughters married quickly and went away. Their mother did not survive the separation from her husband for more than six months. And the two sons, who had been taking it easy and whose hands were no longer calloused after so long in the city, were not able to pick and shovel and irrigate. So, they sold the plot of land they had inherited from their father and returned to the city. Since they knew no other trade, they started up a school.

Well, while it is true that our story appears to have ended, you realize that there was no "happily ever after" to it. Besides, in this day and age, nobody would accept a story as short as this. As fate would have it, the storytellers have narrated this story only as a preface to what they really want to tell you. While we are waiting for the "happily ever after," let us turn to the main story.

EPISODE ONE

Once upon another time, there were two scribes, both of whom spent from sunup to sundown by the door of the Grand Mosque of a big city writing letters and seeing to the affairs of the people. This city had not only a king and viziers, but also mullas and fortune-tellers, a chief constable and a civil magistrate, poets and an executioner. One scribe was named Mirza Asadollah and the other was Mirza Abdozzaki. They had grown up together since school days, and their reading and writing skills were comparable. They not only shared a profession, but also operated their businesses side by side. Both were between thirty and forty years old and were married. Mirza Abdozzaki, however, had no children, which caused him much anguish. Although his business was more successful than that of Mirza Asadollah, his wife nagged him incessantly, throwing up to him seven days a week the plump, darling children of the other scribe. Despite the old saying that men of the same trade cannot stand the sight of each other, their situation was such that neither scribe saw a need to view the other as a competitor. The childless scribe had money and stature and socialized with important people. The other had little money or property, but he had two precious children, and he would not have traded a single hair on their heads for all the riches of the world. Moreover, although the city was a big capital, few of the people were literate. Even if each resident were to lodge only a single complaint a year, either with the local Chief Constable or the Civil Magistrate, there would be enough work to keep these two scribes out of each other's hair, considering that in the city once a month someone was thrown from the city wall to the hungry wolves in the moat, and once every two months someone was scalded with burning candle wax and dragged around the city from sunup to sundown, so that no one dared pilfer or philander. In any event, our scribes had plenty of customers. This accounted not only for their maintaining their friendship, but even for their helping each other out at times. Furthermore, they never stood on ceremony with each other. They knew each other's secrets, and often confided in one another. Each one, however, had chosen a different path through life and did not pry into the other's business. Now, let us follow these two scribes and take a look at the circumstances under which each of them lived.

5

Well, dear reader, although Mirza Asadollah's wife had gone through childbirth six times, only two of the youngsters had survived. One was a twelve-year-old boy named Hamid. In the morning, he went to school and in the afternoons, he went to his father to run errands and learn the trade of a scribe. The other was a sweet little girl of seven years named Hamideh, who followed her mother around all day long and said such cute things. And she would undertake any task her mother assigned her, from cleaning vegetables to pounding meat. Their house had two rooms and one small courtyard pool. It also had a tiny garden that would fit in the palm of your hand, in which the children had planted four-o'clocks, which they watered themselves. In the pool, five goldfish chased each other around from dawn to dusk. One room was carpeted with two Turkoman rugs and had a pair of tulip-shaped lamps on a shelf. The other room had a simple cotton rug and two bedrolls against the wall. The shelves were filled with copper and china bowls and plates, and the other odds and ends of living for which they had no daily use. There was also a trunk in one corner of the room in which they stored their clothes. Among their clothing was a tattered shepherd's vest, a pair of sandals and a shepherd's staff, which drove Mirza Asadollah's wife crazy. She could not understand why Mirza was so attached to them and would not let her give them to the old clothing peddler.

Mirza Asadollah's wife was named Zarrintaj. She was a homemaker with every kind of skill at her fingertips. She could feed an army single-handedly. But, alas, in Mirza's life there were no parties or guests, let alone an army of them, no comings and goings, no fancy dishes, no mules or horses, no maidservants and no male servants. When on occasion Zarrintaj was not feeling well and she had to give the mortar and pestle to her dear little daughter to pound the meat, her heart cried out. But what could she do? Sometimes, when she was very depressed, she would take out her frustrations on Mirza. One day she would grieve about the new pantaloons of Darakhshandeh (the wife of Mirza Abdozzaki); another day about why Mirza had come home late or why he always had ink on his hands; another time about why the local water master would fill their water tank with muddy, grimy water; and things like that. None of this ever led to a serious quarrel, though, and wife and husband would make up before nightfall.

As for Mirza Asadollah's work, every morning right after breakfast, he took up his pen case, slipped it under his sash, and, trusting in God, went to the gate of the Grand Mosque of the city. The tools of his trade consisted of a small desk and a sheepskin. He would retrieve them from the shoe storage area and set them up near the gate of the Grand Mosque. He would spread the hide underfoot in the entrance hall and kneel down at his desk awaiting customers. His business was writing letters and he did so in a fine, polished handwriting, with wide margins and bold strokes. For each page he wrote, he received a small coin. The

6

price was fixed. Among his customers were the bazaar merchants, who traded rice, oil, chick-peas and beans and gave each other bills of lading and receipts. He also had fuddy-duddies writing to their relatives behind their husbands' backs with complaints about their new co-wives or mothers-in-law. Then came the servants and maids who were far from home and stuck in the city, missed their friends and relatives, asked about each and every sheep and cow back home, sent regards to each person in the village by name, and prescribed medication for the family's emaciated donkey. Furthermore, his customers included masons' apprentices who sent their summer wages to the provinces, or people with a complaint who wanted to write a petition to the ruler, the Chief Constable, or the court. There were more customers of this kind than any other. In due course, I will tell you how life was back in those days, how it was so tenuous that no matter whose heart you listened to, it would cry out to the heavens in agony and complaint.

Also, dear readers, each week there were two or three school children whose parents were wealthy aristocrats who cringed at the thought of their little darlings' fingers getting calloused from a pen, and who would have their children's homework brought by a governess to Mirza Asadollah to write out. He made perhaps four 'abbasi coins a week at this, perhaps one qeran, sometimes even more. Of course, with this sort of work, some nights Mirza Asadollah would burn the midnight oil, thus awakening the children, and Zarrintaj's temper would flare. The feeding of four mouths was no easier a task in those days. However, the next day, when Mirza put his hand into his sash, drew out the assorted coins and dumped them into his wife's lap, all was forgiven and forgotten, and if the children were not looking, they would kiss each other and make up.

Another of Mirza Asadollah's ways of making money was to write out sometimes--when the clerics, the "cabbageheads," were not looking--documents of conciliation and wills for local hajis or deeds of sale for various houses, stores, or plots of land. Of course, if the clerics, who were representatives of the Religious Magistrate, did not get wind of what was going on, this sort of thing made him a pretty penny, often equal to an entire year's work, sometimes even including a dish of rock candy and silken robes in return for this work. Unfortunately, such lucrative deals were more troublesome than they appeared! In the fifteen years since Mirza Asadollah had taken his father's place, this kind of opportunity had only arisen three times, the last being three years ago. And that incident had almost numbered his days. The whole thing caused Mizanoshshari'eh, the Congregational Prayer Leader and Religious Magistrate of the city, to grease the palm of the washroom attendant of the mosque to keep an eye on Mirza Asadollah and keep the local Chief Constable informed of every minute detail of Mirza's daily activities.

7

The last incident was as follows: They had taken Mirza to write up a will for Haji Abdolghani, who had become old and senile. His temporary and permanent wives were afraid that he would lay his head down and die without a will and that the Religious Magistrate and the Civil Magistrate would take over his property without leaving anything for their offspring. As fate would have it, the haji kicked the bucket exactly one week later. The Chief Constable and the Civil Magistrate, who had planned to fill their money bags, were steamed when their eyes fell upon Mirza Asadollah's handwriting and seal. But, there was not much they could do. Everyone in the neighborhood recognized, respected, and trusted Mirza's handwriting. They knew that he would not change a dot of any word in any transaction. So, the local Chief Constable sent a messenger to Mizanoshshari'eh telling him that Mirza Asadollah must be whipped at his place of business, right there in the middle of the bazaar, for having interfered in the business of the religious court. To tell you the truth, if it had not been for the quick mediation of the local elders, it would have been all over for Mirza. Ten or twelve of them, led by the local physician, who was Mirza Asadollah's maternal uncle, went to Mizanoshshari'eh, the Congregational Prayer Leader, and pledged that Mirza would never again meddle in the affairs of the religious authorities. Despite the fact that Mizanoshshari'eh had already lost the customary one-third, the one-fifth, and the tithes on Haji Abdolghani's wealth, which he had expected to collect, he did not want to be shortchanged the same way when each one of these local elders died, so he consented to withdraw his complaint. They also appeased the Chief Constable somehow and things quieted down. The truth of the matter was that the local elders had not interfered in this affair merely to do good or for the sake of the physician. Thinking that they would all be in need of his services one day, they had mediated on behalf of Mirza Asadollah, mostly because they themselves would prefer to go to an easily contented and trustworthy person such as Mirza for such transactions as writing up deeds and wills rather than to the Religious Magistrate, the Chief Constable or the Civil Magistrate. If, for any small financial transaction or minor business, the Religious Magistrate, Civil Magistrate or courts were to be involved, they would ask for so much in taxes, tithes, fifths, God's shares, penances, and other back payments, that at times these would add up to more than the amount of the transaction itself. It was for this reason that the local elders hurried to mediate on behalf of Mirza Asadollah's good name. And they used their influence with Mirza, persuading him to go and kiss Mizanoshshari'eh's hand in front of the local populace after the evening prayers and to promise that in the future he would do his best not to meddle in such affairs openly.

As you see, Mirza Asadollah seldom came across a big, profitable deal. He would make a living for his wife and children by writing a

minimum of twenty or thirty letters, receipts, and petitions, and was content with that. Of course, in addition to being trusted by the local people, he had good handwriting and was skilled in calligraphy and colorful manuscript illuminations. And he had one or two wealthy customers per year who wanted him to copy Hafez's *Divan* or Rumi's *ghazals*, illustrate the quatrains of Khayyam or transcribe the *Zad al-Ma'ad* on a scroll. Such copying provided for the crushed charcoal for winter heating and the children's New Year clothing.

Dearest reader, this sums up the whole of Mirza's business. And he knew his business well. Depending on the type of client and to what sort of person the letter was being sent, he would use the appropriate titles and honorifics. He knew how to deal with everybody and how to address all sorts of people. He knew how to begin and end a letter to one's brother or sister or a complaint to the Chief Constable or even the Royal Court. He knew how to express a subject in a way that would offend no one, and he knew where in a letter to quote a poem, an Arabic proverb, or a verse from the Koran. And he had written so many petitions that he had learned all the ins and outs of the government, the ministry, and the jail-houses. He knew what the petitioner must do and whose palm he should grease in order to get an answer to his petition. And again, he had written so many receipts and promissory notes that he knew all the secrets of the local people. He knew how much property they owned, how many wives and children they had, and what sorrows or misfortunes each one had suffered. For this reason, if someone had a wedding or, God forbid, a funeral, or if anyone went bankrupt--may it never happen to you--or died, the first person to be informed was Mirza Asadollah. He would go to arrange the food and drink for the banquet, send for the pots and pans, or write out the invitations. Because of all this, the whole neighborhood, from the Grand Mosque to the government palace, knew and greeted Mirza. You might even say that they were fond of him. But, to be perfectly honest, one cannot easily pass judgment on the people of that day and age. With so many day-to-day problems, and at a time when doing anything, from making a living to marrying off your daughter, was such a hassle, they really could not worry about Mirza Asadollah. One can only say that Mirza was of vital importance to the neighborhood, like the washroom attendant of the mosque, whom they had to treat well, fearing the day when there would be an urgent call of nature and the washroom ewer would not be ready in time. Mirza Asadollah was treated the same, no more and no less. True, Mirza Asadollah's business was with the pen, which was the first creation in the world, and he knew poetry, and, after all, there was the difference between night and day when you compared him with the other man, whose business was to work constantly with a ewer and stink. But, for the local people of that day and age, the fact that a person had no mules or horses and had

no steward or doorman in his employ or groom to run behind his mule so that people would have to bow to him, praise him, and flatter him, was reason enough to consider him one of them and to treat him like everyone else. Well, so much for Mirza Asadollah. Now, let us go to the other scribe.

Dearest reader, Mirza Abdozzaki was a person of rank, so you could hardly have called him a scribe. However, since, after all, he made his living by his pen, we have no other choice but to consider him a man of the trade, as he had no choice but to accept being a colleague of Mirza Asadollah. In any case, this second scribe had a substantial chamber near one of the entrances to the Grand Mosque, where the Grand Bazaar begins. It was carpeted with Kurdish and Kashan rugs. He had placed large cushions for his customers. And as soon as someone entered his shop--depending, of course, on the sort of person he was and the nature of his business--Mirza would call his errand boy to fetch cold water from the mosque's reservoir or make him a drink of rose water sherbet. Yes, as you see, he even had an errand boy. At times, in gatherings of prominent people, where one could not go without pomp and ceremony, he would introduce this boy as his clerk, despite the fact that the boy was illiterate. And, later, when they had left the gathering, he would begin scolding the boy, "Shame on you, dimwit, if you could read and write, you might have made something of yourself, too" and so on.

In any case, despite the fact that Mirza Abdolzaki had no children, he was a man on whom fortune had smiled. He had a house with five or six rooms, with an antechamber and an inner chamber, two large cellars, and a covered pool and much comings and goings. The rooms were covered with all sorts of carpets and full of candelabra, chests, cushions, and jewelry boxes, large and small. He had a clever and skillful maidservant who took care of the housework. His wife, Darakhshandeh Khanom, carried herself with dignity, as the lady of the house, without getting her hands soiled with any kind of housework. And, to tell you the truth, she deserved it, because she was a distinguished woman and a relative of Khanlar Khan, who was a favorite of the court and who was to be appointed the poet laureate at the next royal audience. In other words, the grandson of Darakhshandeh Khanom's paternal aunt was a maternal cousin of Khanlar Khan. This relation was something to speak of in that day and age, well worth boasting about. Let the storytellers be blamed, but they say that on top of all this, Khanlar Khan had had eyes for Darakhshandeh Khanom. And although it is not proper to gossip, it was said that Mirza Abdozzaki could see what was going on, but he would turn his head, because, in doing so, he had established contact with the future poet laureate to the court, who, whenever he composed a panegyric poem about the sound

10

of the belching of the Minister of Stables after he had eaten sweet rice, or whenever he wrote an elegy--like the time His Majesty's favorite donkey died--would give the script to Mirza Abdozzaki to copy on a scroll in black calligraphic ink and decorate with saffron or lapis lazuli flowers and arabesques. And he was generous enough to occasionally mention Mirza to Khajeh Nuroddin, the Grand Minister, or to the Grand Treasurer and put in a good word for him, whenever possible, to the Civil Magistrate or the Chief Constable. And, of course, Mirza knew his business well. He never expected any wages or rewards from the certain future poet laureate for such insignificant services. It was enough for him that this door was open to him. After all, Khanlar Khan, emulating the Royal Court, used to give a sort of public audience on every first Friday of the month, which all his relatives attended enthusiastically. Mirza and his wife, too, would set out in the morning of every first Friday of the month to visit Khanlar Khan--the women to the inner chamber and the men to the antechamber. And at this monthly meeting one could accomplish thousands of things.

Dear reader, it is true that because of this kinship, Mizanoshshari'eh referred some work to our Mirza once in a while, and whenever there was a wedding ceremony among the prominent families, he would take him along as his scribe. After all, he was distinguished looking, wore a large, wide green sash and knew how to wear a cashmere gown and exchange pleasantries properly when he greeted the wealthy. He also could prepare a marriage certificate, write a prologue to it, and have it ready to be signed by his eminence and the wedding witnesses before the vows were done and the "I do" had been coaxed out of the darling bride. He was, after all, a *Seyyed*, and it has been said from times of old that this kind of affair is worthy of being handled by an offspring of the Prophet. That was why Mirza would never forget to wear his green sash and he had made the people understand that his hands would bring blessings and his prayers good fortune. And he was gradually making people accustomed to calling him "Aqa" or "Your Eminence," not because "Mirza" was an insignificant title for him, but because a prayer scribe should actually be a cleric.

In any case, Mirza Abdozzaki wrote prayers and sold amulets to evade military conscription, to guard against harm and the evil eye or snakes and scorpions, for good luck, for the survival of children in precarious health, and for thousands of other incurable diseases which the physician could not treat. For every prayer, he would receive two silver *qerans*. He too had a set rate, of course, if his customer was not a wealthy aristocrat who would place a gold coin on Mirza's desk without being asked. And the good thing about Mirza's business was that most of his customers were the rich, aristocratic women and prominent people of the city, who most often asked for talismans and charms or antidotes and snake charms, and once in a while, black magic. It was for

11

the sake of these customers that Mirza Abdozzaki kept the mandrakes, donkey brains, and leopard whiskers in his box and, in the cabinet in the back of his chamber, dried mice, monkeys, snakes and scorpions. It should also be pointed out that more recently he had acquired a rickety coffin, which he placed upside down in the corner of his chamber and covered with a Turkoman carpet so as not to frighten his visitors. Anyone who was possessed would lie down in the coffin. Those who wanted love potions would buy the mandrake and donkey brains. Those who had an enemy would purchase dead mice and dried scorpions, and so on and so forth. Of course, in order not to compromise his friendship with his colleague, Mirza Asadollah, Mirza Abdozzaki gave some consideration to the local physician and as far as he could, he would not put medicines in with the charms and spells. Or, if he ever did, he did so unobtrusively and asked his client to swear on the Holy Book that the medicine would not see the light of day. These medicines consisted of such things as the ashes of dead men's bones, the bath water used by a woman on the fortieth day after she had given birth, the roots of wild rue, soil from a cemetery, and the like, which were concocted with a solution of Indian magnesium, nutmeg and saffron and made into pills to be sold to the customers. The price of this medication was not two *qerans* but five.

Another source of income for Mirza Abdozzaki was preparing pamphlets for eulogists, those handsome youths who wrapped green shawls around their fezzes, put on cotton shoes trimmed in leather, wore cloaks over their shoulders, and went from one pulpit to another, from one mourning session to the next, killing or eulogizing all the imams with two couplets of verse. They would show up everywhere, whether it was a wedding or a memorial service, whether it was on the occasion of the birthday of the Prophet, a boy's circumcision ceremony, or a banquet honoring the return of a haji from Mecca. Or they would be found heralding the departure of pilgrims for Mashhad or Karbala. Since scrolls and books were necessary for such ceremonies, Mirza had made a deal with one of the bookbinders in the Grand Bazaar. He bought cashmere covered books and scrolls with illuminations and gold braid coverings at a discount. He would then fill the pages with poems by Mohtasham, traditional narratives from *Majales al-Boka* and *Behar al-Anvar* or the poetry of Kalim Kashani and Shaykh Baha'i and sell them. He would occasionally sell them on installment to young men he knew, because early every Moharram, anyone with one of those scrolls or books and a bit of a singing voice could make enough money during the first ten days of Moharram to last him four months.

It was for this reason that Mirza Abdozzaki's engraved desk was covered with inkpots of different colors, a glass container of saffrom solution, scrolls of various sizes and shapes, a Tabriz-made pen case, and several kinds of lining rulers. You see, paper in the old days was

not lined and scribes had to draw the lines themselves. For this purpose, they used to have a steel or brass marker which was pounded on the page to produce the imprint of lines and then they would begin to write. This was called a lining ruler.

In any case, this concludes a summary of the affairs and life history of our second scribe. Now, let us find out how it came to pass that this story was written and what happened in the lives of these two scribes that made the storytellers put aside writing lucrative stories about kings, chiefs, and prominent people, and delve into the affairs of these two scribes, a task which would bring them neither financial gain in this world nor any reward in the next.

EPISODE TWO

Dear reader, autumn was beginning to set in as Mirza Asadollah sat behind his desk preparing writing tablets for school children. He wrote: "Be truthful, for the truthful shall attain salvation" and "The punishment of a teacher is better than the kindness of a father." He wrote these sayings and proverbs in the *nasta'liq* calligraphic style--the proverbs which no student had listened to from his teacher and no boy from his father--not once or twice, but thirty-five times. His reed pen made scratchy sounds as he stretched his letter *sin* seven dots long and his letter *alef* three dots tall. The sun was setting and an incredibly cold wind blew in through the entrance of the mosque. Mirza intended to finish his work, pack up the tools of his trade and proceed home before the commotion of evening prayers. His son, seated next to him would take the finished tablets one by one from his father. The tablets would be dried by the flame of a candle held between the boy's legs. Occasionally, a few people hurrying to the mosque would pass by, and in their haste, their gowns would flap in the air, causing the candle to flicker and, thus, the corner of the tablets would take on a smokey tint. This caused the boy, Hamid, to grumble. After a few of his grumbles, Mirza said: "My dear son, why are you grumbling so?"

Hamid replied: "But, Father, how long are you going to work on these tablets?"

Mirza Asadollah straightened his back, took his eyes off the tablets, looked at the sun going over the roof of the mosque, changed his position on the sheepskin and said: "My dear son, do you think I ruin my eyes writing these because I am crazy? You are grown up now and have to learn the ways of the world. You know that these tablets are for your schoolmates. These are the tablets I write for the school mistress in place of your monthly tuition. Do you know how much the others pay each month?"

Hamid hesitated and said: "I don't know, Father. But, sometimes they bring a chicken, and sometimes there's something wrapped in a bundle."

Mirza said: "You are probably embarrassed that you never take anything, huh? No, dear son, there is no reason to be embarrassed. The others, even the well-to-do, pay no more than ten or twelve *qerans* a month. You give more than they do. Do you know why? Because the

payment for each tablet, including pen, ink and labor, is at least one *shahi*. Thirty-five tablets twice a week; how many does that make?"

Hamid answered: "Seventy!"

Mirza said: "Excellent. And in the thirty days of a month, that comes to a little under three hundred. This is supposed to be the work of the school mistress. Since her handwriting is not very good, she has made this arrangement with me. Each *qeran* is twenty *shahis* and that makes a total of fifteen *qerans* each month. So you pay a bit more than the rich kids. I am telling you all this so that you don't consider yourself beneath them. The problem is that your father is poor and cannot find another way to pay for your monthly tuition. It is true, my son; the problem is that we don't have any money."

He started to write again, but Hamid was not satisfied. Something was still lingering on the tip of his tongue. He finally asked: "Why, Father?"

Mirza, still writing, said: "What do you mean, why?"

Hamid repeated: "Why don't we have any money?"

Mirza answered: "How do I know, son? Each person's fate is predestined: They used to say that on the day of creation, all the wealth of the world was divided. Do you know what that means?"

Hamid proudly answered: "Yes, Father, we had it just yesterday in our reading. It said: 'From the dawn of creation till the end of time...' But, anyway, why can't we be wealthy?"

Mirza said: "Because my father was not wealthy and neither was my father's father. I went to school just like you, and so did my father. Except that my father had to work much harder. I remember him preparing a hundred and fifty copybooks a week so that the school mistress wouldn't kick me out of school. Those were hard times! You know, Hamid, it was at the beginning of the war with the Sunnis. It was horrible how they took the young people and forced them to be soldiers. That's why people used to hide their young. All the men had gone to war and the work of the schoolmasters was left to the schoolmistresses. As a result, teaching became women's work. Our schoolmistress had a hundred and fifty students. They were all little kids of different shapes and sizes. The class monitor, who was bigger than everybody else, was fourteen years old. The schoolmistress herself was absolutely illiterate. She was doing the work of her husband who had gone off to war, and there had been no news of him. God bless her soul, at least she had managed to keep her husband's business going. The others were boarded up altogether, I mean the other schools. That's why our schoolhouse was so crowded... What was I saying, Hamid?"

Hamid said: "Nothing. We were talking about our poverty and you keep telling stories. I want to know why we are poor. Didn't you say that it was time for me to learn the ways of the world?"

Mirza said: "Dear son, know this much: If money is made by legitimate means, it will not amount to any more than this. There is just enough to scrape by with one's wife and kids." Hamid asked: "So, where do the others get the money to send their kids to school on a fancy donkey, and most of them with a governess close behind?" Mirza answered: "How should I know, son? What do you and I have to do with other people's business? Probably an inheritance was left to them."

Hamid asked: "Inheritance? What is an inheritance?"

Mirza answered: "An inheritance is something that is left by a person's parents."

Hamid again asked: "What inheritance did your father leave to you?"

Mirza, who was running out of patience, groaned a little and shifted his weight on the sheepskin. He put some tablets that were under his arm away. He wanted to lash out at him, but couldn't bring himself to do it; after all, this was his son, and he wanted to learn. This is why he sighed and said:

"If you want to learn, listen well. My father told me this only once. Yes, my dearest, I am going to leave you the same inheritance he gave me--no more, no less. May he rest in peace, now that I am reminded of him. On the day of his death, he called me in and asked me, 'Son, with all your schooling, do you know how many letters there are in the world?' Obviously, I didn't know. Of course, I was embarrassed and I hung my head. Then, my father said: 'No, my dear, you know, but you didn't understand my point. What I had in mind was that all the letters in the world number thirty-two, from *alef* to *yeh*, from beginning to end. Now do you understand? I want to say that from the words of God, which have been recorded in the sacred texts of the prophets, to all that has been said by the philosophers, to the words with which the poets have filled their texts, even to that which you students read and which I have written in my lifetime for my customers, all the sayings and speeches of the world are made up of these thirty-two letters. In whatever language you write--Turkish, Persian, Arabic, or European-- their number might increase or decrease by one or two letters, but it is essentially the same. Whatever curses or profanity there are, or sacred utterings, even the grand secret name of God, which these Calenders claim to have discovered, are all written with these thirty-two letters. What I am trying to do is to warn you not to be blinded by this little bit of knowledge and deny the truth. Remember, too, that these thirty-two letters are also tools for the devil's work. The death sentences of the innocent and the guilty alike are written with these very letters. Since this is the way things are, heaven forbid that your pen ever write unjustly or that these letters in your hands or on paper ever become a tool for the devil's work.'"

16

Mirza took a deep breath after saying this and continued: "Yes, my dear son, this was my father's last will and testament. This was also the inheritance he left for me, his only son. But, when he told me these things, I was twenty-three or twenty-four years old. You're no more than twelve years old, but you wanted me to tell you now. You might not understand what my father told me. When you reach my age and you are in charge of this operation, you'll understand what an inheritance my father left for me that I am leaving for you. Now, get going, so we can finish this work quickly and go home."

Once Mirza had finished speaking, Hamid became contemplative. Mirza proceeded to write the tablets and hurriedly completed the unfinished ones. He wrapped them all up in a Yazd-made cloth that he had taken out of his pocket. He was about to set forth for home when Mirza Abdozzaki's errand boy appeared. They greeted each other and the boy said: "My master instructed me to ask you to come and see him for a few minutes on your way home." Mirza Asadollah said: "Give him my greetings, and tell him that I certainly will. I will have to buy some meat and bread on my way home, and then I'll come directly." Mirza proceeded to do this. He put his instruments away in the shoe place of the mosque and went to the bazaar. From the bakery and the butcher next door, he got the daily bread and meat. He wrapped them up in that same checkered Yazd-made cloth and gave the bundle to Hamid, who was to take it straight home. Then, Mirza went to see his colleague.

Dear readers, as you already know, these meetings occurred occasionally. But, since Mirza Asadollah did not have a proper chamber, whenever the two scribes had any business between themselves, they would meet at Mirza Abdozzaki's chamber, especially in the winter, when all the cold air collected in the atrium of the mosque and passed from the hall into the bazaar. It was also an occasion for them to console each other after a day's work, appropriate this day after the question and answer session with Hamid, which had made Mirza Asadollah quite weary.

Mirza Abdozzaki had lit the chamber's only lamp and had ordered refreshments to be brought in and also asked for a cushion to be placed at his side for Mirza Asadollah. They greeted each other and Mirza Asadollah sat down. After the usual pleasantries, Mirza Abdozzaki began:

"My dear friend, what's new? How do you think the business of these Calenders will turn out?"

Mirza Asadollah said: "How do you want it to turn out? For now, the people seem to have found a new saint and are awaiting a miracle."

Mirza Abdozzaki answered: "I don't expect much from them, my dear friend. All I know is that nowadays, our work load has really dropped. Now the Calenders' tekke has become like a prayer charm for the people."

17

Mirza Asadollah said: "You seem to be worried only about yourself. Isn't it a shame! How long do you want your thriving business to depend on the misfortunes and distress of the people? Of course, people come to you when all else has failed."

His colleague responded, "Then, when do people come to you, dear friend?"

Mirza Asadollah answered: "To me? When their troubles have just begun. Even the person who wants a letter sent to the village tells his troubles to me, not to mention the person who wants to submit a petition. If I'm at the beginning of their troubles, you're at the end of them, Seyyed."

His colleague followed with: "Here you go again with the same old thing, my dear friend. To hell with the people. Today is a fine day, because a wealthy customer has fallen into our web. You know, my dear friend, this afternoon, Mizanoshshari'eh's wife came here. I mean his first wife. I can't begin to tell you how much anguish her husband has caused her. Half of her wept while the other half bled. My dear friend, she wanted a love charm from me to make the second wife fall out of favor with her husband. I know that you are going to start lecturing me again. But, when people have these problems and they think something will come of these prayers, can you blame me, my dear friend? Anyway, you know about my business. She came and brought us good news."

In amazement, Mirza Asadollah asked: "Us? What do you mean?"

Mirza Abdozzaki said: "Hold on a minute, my dear friend. Remember, just last week there was a big squabble among the children of Haji Mamreza over the division of his inheritance? You do remember that, my dear friend? Well, you know that in the end, they made a settlement. Except, I don't believe you know who settled this matter. Since you have so much admiration for Mizanoshshari'eh, my dear friend, I can tell you that his eminence himself intervened and settled the matter. He had one condition, and that is at the heart of the matter. The condition was that one-third of Haji's wealth be contributed as a religious endowment. My friend, now do you understand? They consented. Mizanoshshari'eh's wife was saying all this. Just before you came, his steward came over to say that after the evening prayer I should go to his house to see him. I believe he wants me to go to Haji's estate to estimate his wealth and write up a settlement and so forth. Well, you know that whenever possible I have not cut you short of anything. You have no obligation to me, but I believe this will be a bread-and-butter deal. I thought it would please God if you got something out of this business to spend on your children. My dear friend, I am informing you of this now so that when the time for travel arrives, you can get your things together and we can go and finish off the job. Well, my dear friend, I think Haji's estate is one or two days

away. The good thing is that the local Chief Constable will be traveling with us and this will give the two of you a chance to settle your old grievances. Besides, my dear friend, this will be an opportunity to get on Mizanoshshari'eh's good side."

Having said all this, he stopped. Mirza Asadollah, who had become very contemplative, looked up, stared at his colleague, and said:

"May God grant you a long life, Seyyed; you are always thinking about us. But, I don't think Mizanoshshari'eh would approve of my involvement in such a matter, especially because of our little quarrel. I'm sure you have not forgotten the story of Haji Abdolghani's will."

His colleague said: "How could I forget, my dear friend? But my point is, you have to get involved in this affair for this very reason. And why should anyone else know about it? You are helping me. What does Mizanoshshari'eh have to do with this? Yes, my dear friend, once this task has been successfully completed, we can inform him. Then he will even be grateful to you. Besides, how can I do all this work by myself? The late Haji's wealth is in the millions."

Mirza Asadollah was like a person in shock, staring at a fixed point. He finally said:

"Tell me, Seyyed, who is the custodian of the endowment?"

His colleague said: "Well, it is obvious, my dear friend."

Our two scribes were deeply involved in this conversation when the door burst open and suddenly a dwarfish, distraught villager appeared. Instead of a hello, the man grunted. He placed both shoes under his arm and sat down right next to the door. Mirza Abdozzaki was about to ask something when the man shouted out:

"To hell with this town. It's been three days since they pressed my mule into service, and no one in this city will help me. And whoever hears about my misfortune says, 'Hush.' But why? What have I done?"

Mirza Abdozzaki, who had not expected such an intruder, reproached him: "Do you think you are out in the pastures? Or maybe you think this is a barn? You have the wrong place, my dear friend. Off you go, my dear friend, and God be with you."

The villager shifted a little and shouted: "Aren't there any real human beings in this city...?"

Mirza Asadollah, who realized that this fellow was very distressed, came forward and said to his colleague: "Let me see what his problem is; I think he came to see me. I deal with these kinds of people all day long."

Then he turned to the villager, who had calmed down somewhat, and asked:

"Okay, my dear man, what happened that they confiscated your mule? Were you in debt? Maybe you didn't pay the toll at the city gate? Well, what have you done?"

The villager took his shoes out from under his arm, put them on the floor and screamed:

"How do I know? I brought one load of cheese to town to trade for some printed cotton cloth. By the time I went to the bazaar and came back, the mule was gone. I grab the innkeeper and ask him where my mule is. He says he doesn't know. I say: Damn it, if you don't know anything, then why the hell are you the innkeeper? Then a bunch of people pounce on me and beat me up..."

And then he went on to say that for three days he had gone door-to-door searching for his mule, until tonight when he came to the mosque dead tired to pray to God and the Prophet. After the evening prayer, the person next to him said he should go find Mirza Asadollah. When the man finished speaking, Mirza Asadollah asked: "Do you remember what your mule looked like?"

The villager screamed: "Of course I do. I've had this mule for four years."

Mirza said: "Before you tell me what it looked like remember that this is a city. When you yell, people know immediately that you are from the country and they will take advantage of you. Talk in a quiet voice, like the city folk. Haven't you heard the expression to 'cut someone's throat with cotton'? Okay, now tell me what it looked like."

The man grinned, shifted his weight, and said: "God bless you. Your honor, let me say that my poor mule is a reddish color. He has a stump of a tail. I had marked his forehead with a spot of ink. Let me also add that one of his ears is pierced. His left ear. I pierced it myself when he was a colt. Also, his right front hoof is cracked. Let me add that...Ah, that's enough; not even the king's mule has that many marks."

Both scribes laughed and Mirza Asadollah said: "They've probably fixed the hoof for you by now, and probably shoed it, too. But they can't change the other features so quickly. You say it's been three days since it was taken? Fine. Now, tell me what you did with the cheese. Did you sell it or not?"

The villager said: "You're asking too many questions of a man who hasn't eaten in three days. I don't mean to offend you, but what kind of jackass would forget about his mule to go and sell cheese."

Mirza Asadollah said: "Alright, now, while I write you a petition, have a nice chat with this gentleman, who is the owner of this shop and whose guests we are."

He left the two to themselves while he drew up the petition for the villager. When the petition was completed, he read it aloud one time, as was Mirza Asadollah's custom, and then he folded it and gave it to the man and told him:

"Listen carefully. Sell half of your cheese to get some money. Get the money in change. One by one, from the watchman at the gate to the doorman at the Chief Constable's office, put an *abbasi* coin in their

hands so they'll let you through, and then state your business. Take the other half of the cheese straight to his honor, the Chief Constable. Give it to him with this letter to get your mule back. Just like I have written on this paper, tell him that your wife was sick and you brought her into town to see the doctor, and now you have no way to take her back, and that, hopefully, next time, you'll bring a load of raisins, and so forth. Of course, I have just written all this down, and all you have to do is repeat it. God willing, you won't have any business in the city next time."

The village man, who was stunned, screamed: "But why? Have I stolen anything from anybody?"

In the end, our two scribes made him understand that these were the ways of the city, and it was his misfortune that these days the government would grab anything with four legs. If he wanted to retrieve his mule, he would have to give up half of his cheese and so on. At last, the stubborn man was convinced. Getting up, grumbling, with the letter in hand, he was ready to leave when Mirza Abdozzaki looked at his colleague staring at the floral design in the rug. Rising up half way, he called to the man:

"Hey, what about a payment, my dear friend?"

Then Mirza Asadollah grabbed the hand of his colleague and said:

"Let the poor man go. It's no big deal."

Mirza Abdozzaki sat down and the villager disappeared into the darkness of the atrium of the mosque. Mirza Asadollah sighed and said:

"Don't you see, friend? Times are bad. These days, when the Chief Constable is involved in some business, one has every right to be suspicious and ask what is behind it. I believe that the Chief Constable has some part in this business you were talking about."

His colleague replied: "You're so skeptical, my dear friend. The custodian of the endowment is, as I said, Mizanoshshari'eh. The Chief Constable is coming with us because we might need his help. This kind of transaction nowadays is worthless unless it is put down on paper, my dear friend. Each one of the parties at any time can go back on their word. But, my dear friend, when a government official is with you, no one would dare pull such a stunt."

Mirza Asadollah contemplated a short while and then asked: "Are you positive that this is the way things work? But what share will the government people take?"

His colleague answered: "My dear friend, our hair has turned gray in this business. If I'm not positive, then who can be? Anyway, what does this business have to do with the government people, my dear friend?"

Mirza Asadollah said: "In any case, the deal is not in the bag yet. Of course, if things are as you say, there is no problem. I guess even if the devil incarnate got the notion to do some good then we must help him, right?"

21

His colleague said: "You know, my dear friend, this Mizanoshshari'eh isn't as bad as you think. What does it matter to us what is behind it all? Do you think people say one-hundredth of what's on their minds? You don't have to look far; take my wife, for example. God knows, my dear friend, I've just about had it with her. I don't know what she's up to. Now she is talking about divorce and has given me a week. I have no secrets from you, my dear friend. The devil is tempting me to take her to Mizanoshshari'eh and rid myself of her."

Mirza Asadollah exclaimed: "Come on, friend. What is all this? It is shameful to talk like this after some ten years of being man and wife."

His colleague said: "This woman knows no shame, my dear friend. No matter how much I say to her 'Maybe it was not God's wish' and 'Maybe it is better for us not to have children,' she doesn't understand. I tell her: 'My dear, look at Mirza Asadollah. Imagine that his kids were yours. See how after all the laboring he has done with his pen, he still doesn't have a chamber! Why? Because whatever he makes, he spends on his kids.' But, my dear friend, it doesn't sink into her head. Seven days a week we argue about being childless. Can you believe, my dear friend, that for two weeks I have not dared to eat in my own home. She puts so many weird concoctions into my food. I swear on my father's soul her food tastes different every day. She thinks she can fool the master himself. From the taste of each one of her meals, I know what kind of wretchedness she has put in them. For two weeks, I've been eating kabob from the bazaar. Day and night, kabob, my dear friend. I don't dare drink a glass of water at home. My dear friend, I cannot trust her. Is this living, when you don't dare eat a damn piece of bread in your own home? And now, she keeps insisting that we go see the court physician. Now that she sees I'm not budging, she plays this new tune, my dear friend. It is true that a physician is a physician, but this one has been hand-trained by Khanlar Khan, the court favorite. She wants me to go to him to have a witness for her divorce. She says that since I don't believe in her cures, I should look for a cure myself. She is right though, my dear friend. Since the beginning of this week, we've fought and quarreled. She's driving me crazy. She has given me one week before she goes back to her father's house. Now tell me, my dear friend, what should I do?"

Mirza Asadollah shook his head and said: "It's very simple. We'll go to our own physician. There is no harm in it. A physician is a physician, and it will appease your wife."

His colleague said: "You see, my dear friend, the whole problem is that I can't go to see your uncle. You know what an obstinate man he is, don't you? Don't you know how he resents me? My dear friend, what if I go to him and it becomes evident that...well, whatever, my dear friend. Remember the last years of school, when they gave me that servant girl as a concubine? God curse her! I'm afraid that it was she

who might have gotten me in trouble. The slut kept trying to seduce me. My dear friend, in the summer afternoons, she would bathe naked in the pool until I lost control, and you know what a scandal ensued. I wish she had disappeared somehow, and I wouldn't have had to put up with her in a temporary marriage for four months. As a matter of fact, it was during those four months that I knew something had happened to me, my dear friend. Later, when we sent her back to the damned village where she came from, my mother suspected something. Immediately she took me to your uncle, God bless him, who helped me with my problem. But I have no secrets from you, my dear friend. I am afraid this sterility might be a result of those four months. Now, my dear friend, suppose we go to the physician and it turns out to be as I say, then what the hell am I supposed to do? If it were you, would you have the guts to tell all this to your wife, my dear friend--a wife who is from the family of a person like Khanlar Khan and has thousands of suitors? Then, what the hell would you do if you lost your wife, my dear friend?"

Mirza Asadollah shifted his weight and, rubbing his right leg, said: "First of all, how do you know that this is the case? Secondly, it is said that the physician is one's confidant. What is done is done, and my uncle surely knows that it would not please God to ruin a relationship between a husband a wife with such matters. If you want, we'll go to see him together. You tell him the whole story, and I'll get him to promise to forget the past and treat you."

Mirza Abdozzaki said: "If you do this favor for me, your colleague, I will be eternally grateful to you, my dear friend. Believe me, you would be saving me from this predicament. God only knows what is wrong. The problem could be from my wife, my dear friend, right? The physician can determine this better than anyone else. Then maybe we can ask him to send her to a midwife, right? It doesn't always have to be the man's fault, my dear friend. Say, couldn't you invite him to your house?"

Mirza Asadollah said: "You know I only have two rooms in my house. Of course, I have nothing to hide from you. You know everything there is to know about me. As for him, he is my uncle. But he might want to examine you in private. Besides, when one has business with a physician, one ought to go to his office."

And then he became quiet, shook his head and said: "Okay. For your sake, tomorrow morning the house will be empty. I'll send the kids out and tell my uncle to come early. But don't you keep him waiting!"

And with this, their discussion was concluded and our two scribes said goodbye. When Mirza Asadollah left the chamber, he went to the physician's house. He greeted his uncle's wife, left a note for his uncle, who was out seeing a patient and wouldn't be back for some time, and then went home. After dinner, when the children had been sent to bed,

Mirza Asadollah related the whole story to his wife, from the lucrative deal which had come up to Mirza Abdozzaki's problems and his appointment with the physician. Then, asking his wife whether they had enough rice and ghee and such at home, and going over what she should do while he was away, he added:

"You know, woman, it is not good for my colleague's wife to be idle. Somehow, she must be kept busy. You should go to her and persuade her to set up carpet weaving in her home. You could even help her set it up, just so she starts on it, you know. Start tomorrow morning, because my uncle is going to examine Mirza here."

And then the couple went to bed for a good night's sleep.

EPISODE THREE

Now, dear readers, the next day first thing in the morning, Zarrintaj Khanom left the house with Hamid and Hamideh. Hamid headed off to school and Zarrintaj Khanom said a little prayer to safeguard the house, latched the door, and arranged for one of the neighbors to watch the house. She then took Hamideh by the hand and set out for the home of Mirza Abdozzaki. Mother and daughter passed through two or three side streets and a bazaar, and after a quarter of an hour, they found themselves in front of the door of a large house, which was decorated with copper and brass ornaments. They knocked on it, and while waiting for the door to open, Zarrintaj Khanom turned to Hamideh and said: "Now, dear daughter, you know what to do! I want you to win over Darakhshandeh Khanom. Just act like she is your aunt. And don't forget to kiss her hand, alright?"

When the door of the house opened, the maid in new clothes brought them into the sitting room, where a *korsi* had already been set up, even though it was early in the season, but was not yet being heated. The maid took Zarrintaj Khanom's *chador*, folded it, wrapped it in a bundle, placed it on the mantle, and brought her another one more suitable for wearing indoors. She offered her some sweets and went to fetch the lady of the house, Darakhshandeh Khanom, who showed up fifteen minutes later. They greeted each other. Hamideh did as she had been instructed. And after the usual "It has been such a long time since you have been to visit us" and other necessary formalities were over, Darakhshandeh Khanom placed a sweet in Hamideh's mouth and took her up on her lap. Zarrintaj Khanom began to speak:

"To be honest, since my children have started to get around on their own, they haven't required much care. And without much to do, I have begun to think a lot and even daydream. May it never happen to you, but I have been imagining things. I keep sitting at home imagining things, just worthless thoughts. I wonder, for example: 'Why is Mirza late tonight?' or 'Why did he bring home so little today?' or 'Why does he want to go on a trip?' God help me, it's just that I have been this way for some time. I finally sat down and thought to myself that this can't go on any more. I said to myself: 'Woman, you are still young; if you continue like this you will go to an early grave, if you don't drive yourself crazy first. Roll up your sleeves and do something. You know

25

how to weave carpets.' My poor late mother, you know, God rest her soul, went through a lot of trouble to teach me this skill. In any case, I have been thinking about this for some time. But I realize that in the mouse hole we live in, there isn't enough room for such grand ideas. Besides, Mirza Asadollah doesn't have two coins to rub together, let alone the money to buy the yarn and wool. So, again I sat down and said to myself: 'Okay, woman, get up and go to Darakhshandeh Khanom, greet her, ask her how she is, and then frankly explain the proposition. Thank God, she has the space and the money, along with a compassionate heart, and will certainly help you. Set up a carpet loom in one of her rooms--you supply the labor, she'll supply the capital--and establish a lucrative business.' So here I am."

Instead of answering, Darakhshandeh Khanom put a sweet in her mouth and offered one to Zarrintaj Khanom. She was just about to say something when Zarrintaj Khanom continued:

"I swear on my kids' lives, these bazaar merchants are just so persistent. And if you only knew what a rotten temper my husband has. No matter how much I tried, he would not give permission for me to go into one of their houses and set up a carpet loom so that I could keep myself busy. I keep telling him, 'Man, isn't it a shame for me to forget this skill? Besides, it will bring in a little money and will help us with the children.' But, do you think he would listen? In the end, it occurred to me to come to you. You know how close our husbands are. He couldn't say no in this case. So I decided to get up and come to you, Darakhshandeh Khanom, and come what may."

Darakhshandeh Khanom, who until now had been holding the sweet in her cheek while listening intently, swallowed and said:

"Well, I have no objections. However, my dear, I don't know what the hell I'm going to do with my idiot husband. With this spineless husband of mine, I'm utterly unsure of my future. And then with this sterile..."

Zarrintaj Khanom interrupted and said:

"Oh, sister, what are you saying? Just take a look at me. No one would even believe that I am only thirty years old. There is an old saying that the birth of each child takes so much out of you, and I have given birth to six or seven children, and with so much trouble. Besides, it takes the life right out of you before they reach the age when they've finally survived the threat of typhoid, whooping cough, and dysentery. And after all that, do you think my husband puts me on a pedestal? Well, there are no diamonds in the rough. From top to bottom, they are all cut from the same mold. All of them are like big empty leather bags sitting around at dinner waiting to be stuffed. At the very best, one of our husbands is a man with a hole in his pocket and the other has no pocket at all. If a person lives her life with her nose--if you'll excuse the expression--glued to her husband's ass, like me, she will go to an

26

early grave. Don't waste your youth, sister. You won't always have a husband. God only knows what will happen tomorrow. When my mother--God rest her soul--died, I was about to go insane because of that bitch of a stepmother I was saddled with. However, the minute I sat down at the loom, it seemed that all my frustrations and bad thoughts had shrunk down to the size of a carpet knot and were woven into the threads of the carpet. If it weren't for carpet weaving, I would have died of grief after my mother's death."

Darakhshandeh Khanom, little by little, was softening up. She said in reply: "But, Zarrintaj Khanom, people will sit down and gossip that now so-and-so has become a carpet weaver. Certainly such work should in no way detract from anyone's being a lady. But you know Khanlar Khan, the court favorite ..."

Once again, Zarrintaj Khanom interrupted Darakhshandeh Khanom and said: "Oh, sister, even Kaykhosrow himself, when he passed through Rome with all his pomp and ceremony, kept himself fed by working as a blacksmith. Besides, God willing, once you become a master weaver and can read the carpet patterns yourself, you will see how they will all come around and sing your praises. At any rate, as it is, I will be the actual carpet weaver and you will only provide the support. Praise be to God, you are neither needy nor wanting. May God protect your husband, one hair on his head is worth all the other husbands in the world. He is a seyyed, an offspring of the holy Prophet, and a blessing on all creation..."

And with these words, Darakhshandeh Khanom became compliant and finally agreed. Afterwards, the two of them got up to check out the rooms of the house. A room just off the covered pool was selected, which was both open to sunlight and out of the way. That very hour, a house servant was sent to fetch the neighborhood carpenter. He came, and they explained the situation to him. They struck an agreement that in two days time he would set up a loom. After that, they consulted with Mirza Abdozzaki so that he would check his astrological charts to select an auspicious day and hour for her to begin weaving the first pair of small medallion carpets.

Now, dear readers, let us return to the story of our two scribes.

Zarrintaj Khanom and the children had just left the house when Mirza Abdozzaki arrived. The door was unlocked, and he rushed inside. Mirza Asadollah was seated next to the only four-o'clock plant in the courtyard garden, picking its seeds. They greeted each other and Mirza Abdozzaki began to explain what had taken place during the meeting with Mizanoshshari'eh the previous night, that the day of the departure had been set. Then the door slammed and the physician entered, grumbling, and began to shout:

"Why is the door of this dump open like the door of a caravanserai? Is anybody home?"

Mirza Abdozzaki went into the sitting room, and Mirza Asadollah ran to the door. He closed the door behind his uncle and together they went inside. They greeted each other and made apologies about the past, then Mirza Asadollah brought up the subject. The physician, who was an old, small, nimble man, rubbed his knees and said:

"I knew it. I knew that in the end you would wind up in our little mortuary. But be thankful that you got here before Azrael came to you, and also that you came on your own two feet. Otherwise, I would show you that even if you were the prophet Elijah and had access to eternal life in your power, you would still not be able to escape either one of us."

When Mirza Asadollah saw that his uncle had started again, he intervened and said: "Uncle, you never give up! I swear to God it's been a long time since he has dispensed medicinal cures to anyone. I can attest to that."

The uncle frowned at Mirza Asadollah and said:

"How good of you to remind me, my dear boy. I have taken so much trouble to find a new remedy for your colleague, I sure have! It is a prescription for a love potion from the margin of a prayer book and comes highly recommended, too. Just let me find it."

Then he reached into the pocket of his cloak and took out a folded piece of paper. He looked at it and said:

"Aha, here it is. This is the cure. Listen. You need a shirt belonging to the other party. Wash it in water from the mortuary. Then spread it out on the grave of a murdered person until it dries. Then dissolve the dirt from the fingernails of a dead person in a saffron solution. Use the resulting concoction as ink to write this incantation in the sleeve and collar of the shirt and give it to her to wear. Here it is."

He then extended the paper toward Mirza Abdozzaki and said: "But, don't let it see the light of day."

Then all three men burst into laughter and the physician added: "Don't be upset with me, Seyyed, I was only kidding. Now, you, Mirza Asadollah, go get something for us to drink, and I'll see what's wrong with our friend."

Mirza Asadollah left the sitting room for the water storage chamber. Slowly, he brought the cold water and prepared a mint beverage in the living room. He was looking for a serving tray when the physician called him. When he entered, he saw his colleague slumped in the corner of the room. His face had turned pale and he was in a very sorry state. He set the bowl of refreshments in the center of the room and sat down. The physician said:

"I want to tell your colleague here right in front of you that there is not a damn thing wrong with him. He looks well fed and healthy to me. You know that you are like a son to me. You are all I have left of my brothers and sisters. Still, even if you were afflicted with this

malady, there would be nothing I could do. Do you understand what I'm saying or not? God only knows why your colleague cannot have children. I know all about his condition. But as far as a cure is concerned, nothing comes to my mind."

Mirza looked at his colleague who was still huddled in the corner, pale, his eyes glued to the flowers woven in the carpet. He said:

"But Uncle, I have promised Mirza that you would let bygones be bygones and do whatever you could..."

The physician interrupted and said:

"Are you crazy, my dear boy? While I was examining him, it didn't even occur to me that this was the same young man who had come to me twenty years earlier with his mother. Generally, my dear boy, when I take someone's pulse, it has become my habit to close my eyes and pay no attention to whose pulse it is. All I care about is the pulse that is beating under my fingers. This has been my practice for forty-five years. No doubt, you two scribes thought that I would get upset with this fellow who writes incantations and who feeds the people with sorcery and magic, and that my medical practice would suffer on account of the likes of him. Am I right? More than half of my patients are the very same people whose insides have been ruined by these old wives' cures. We physicians earn our living off precisely such ignorance. So what bone could I have to pick with him? Besides, it's not really his fault. If he didn't prescribe such things, someone else would. The people themselves are so ignorant that they don't understand that medicine is concerned with helping this world. Since they don't understand this, they place themselves at the mercy of charlatans. When the aides of the king of the country rely on palm readers, astrologers, and fortune tellers, what do you expect of the ordinary people?"

Mirza Asadollah knew that if he let his uncle keep going, he would never stop, so he interrupted and asked:

"Well, Uncle, what should be done? Is there a prescription, a remedy, a cure, something ...?"

The physician said: "My dear boy, the best physicians in the city would not be able to do a thing, let alone me. Sometimes we come upon something that illustrates the impotence of mankind. When the cause of an illness is not evident, what can a physician do? Your colleague appears to have nothing wrong with him. His wife could even get pregnant tomorrow."

Mirza Asadollah said: "Look, dear Uncle, this seyyed is in a terrible predicament. His wife is giving him a hard time because of all this. Something must be done for him. You know when one's wife is not satisfied, all sorts of things can happen."

Mirza Abdozzaki remained huddled in the corner, saying nothing. The doctor took a look at him and said:

29

"I could pacify him with a couple of placebos. But you are also involved in this, my boy. Medicine, good food, changing wives, nothing can necessarily solve his problem. This is what I said before. Only if God shows mercy, sometimes, after even twenty hopeless years, the problem takes care of itself. If everyone were fertile, then humanity would be just like thistles, their seeds scattering every time you touch them. There is wisdom in everything. In my opinion, it is better for Mirza Abdozzaki to rely on providence; and if he wants my advice..."

All of a sudden, Mirza Abdozzaki burst into tears. He had placed his head on his knees and was crying so hard that his shoulders shook. Mirza Asadollah and the physician exchanged glances and Mirza Asadollah ran out for some rose water. The physician said in a reproachful tone of voice:

"Shame on you, Seyyed. Be thankful that you have your health. Didn't I just say that, as far as I know, your wife could become pregnant tomorrow? Besides, if you want children so badly, go out and pick up one of the children abandoned on the street and raise him."

Then Mirza Asadollah came in with the rose water sprinkler. He sprinkled his colleague's head and face with rose water and had him drink up half a bowl of the beverage all at once. He lightly massaged his shoulders to make him feel better. Mirza Abdozzaki wiped the tears from his eyes, sat down cross-legged, and began to repeat what he had confided to his colleague the day before: How his wife had been nagging him, how she had shown such arrogance because she knew that she had Khanlar Khan to fall back on, how she had set a deadline of this weekend, and how she had worked to arrange for a divorce using the court physician as a witness. After hearing these words, the physician rubbed his forehead, turned to Mirza Abdozzaki and said:.

"It seems that your wife has got someone else. Send her to see Mirza Asadollah's wife for a little advice. And you, in my opinion, should go on a trip. Travel around the world a little. Your thoughts and fears will subside somewhat. God is most merciful. As the wisdom of His creature has failed, perhaps the Creator Himself will show mercy."

At this point, Mirza Asadollah, attempting to change the subject, began to narrate what had happened up to that time between himself and his colleague, including the story of the death of Haji Mamreza and his children's quarrel over the inheritance along with the interference of Mizanoshshari'eh, the endowment of a third of his wealth, and the agreed-upon journey which they were about to take. The physician, upon hearing all this, started thinking, stroked his beard a few times, finally turned toward our two scribes, and said:

"It appears that you two have got something cooking together. So they want to give a third of their father's property to a religious endowment? Well, tell me, do you know how Haji Mamreza died?"

Our two scribes looked at each other. Finally, Mirza Abdozzaki spoke:

"How do we know, my dear friend? All we have heard is that Haji is dead and that a quarrel ensued among his children over dividing the inheritance. How would we know how he died? He probably died because his time was up."

The physician said: "Did it ever occur to you to ask his children?"

This time Mirza Asadollah spoke:

"I went to his memorial service. But at that time, his sons were so upset that I couldn't ask them anything. Gatherings like that rarely lend themselves to such inquiries."

The doctor said: "You're right. He was getting old, anyway, and sooner or later my colleague Azrael would have paid him a visit. But the point is that he died before his time, of unexpected causes. He was poisoned. In fact, I know what poison was put in his food. You know that I was taken to his death bed, inside his chamber at the bazaar. The color on his face clearly revealed that he had been poisoned. His lips were so rent that they looked like they had been cut with a blade."

Mirza Abdozzaki interrupted the physician and said:

"Yes, my dear friend. Everyone says that his children poisoned him."

The physician said: "No, young man. Don't accuse people of anything you're not sure about. If his children had poisoned him, they would not be quarrelling over dividing his property. Moreover, one's own house is the best place for such schemes. The unfortunate Haji was poisoned with kabob bought from the bazaar. These are truely strange times! So, they have started all this commotion to pull the wool over the eyes of the public and try to fool God! Despite all this, take this trip. But you must realize that his children are innocent. And if you happen to see them, give them my regards. Well, that is enough for now. I have to go. My patients are waiting for me."

Dearest reader, here the meeting between our scribes and the physician ended, and they all got up together and left. It was still early in the morning and the neighborhood shops were opening for business. The beggars had just come out on the road, and the greengrocers were returning from the farmers market. The physician went to his office and our scribes separated at the fork in the road to the bazaar and the Grocers' Stretch. Mirza Abdozzaki went to his chamber and Mirza Asadollah took the Grocer's Stretch towards Haji Mamreza's house to check out the situation.

As he turned into the alley, he saw two guards sitting on the stone seats on either side of the door throwing dice. Mirza thought to himself: "So, it is not all that simple. My uncle was right. What am I to do now?" It was a dead end alley, with no one else in sight. He could neither turn back nor could he start knocking at someone else's door. At that moment, a thought came to Mirza Asadollah. He walked straight

toward the guards, who had stopped playing and were watching him. He went to the door of Haji's house and began to knock. One of the guards asked:

"What's up? Who are you looking for?"

Mirza replied: "This is Haji Mamreza's house, isn't it?"

The second guard burst out laughing: "You don't say. Check this fellow. Haji kicked the bucket eight days ago. Take your pen case out and write him a petition to the next world." And he burst into a loud laugh. Mirza assumed a distressed face and said:

"Isn't that something. May God rest his soul. So what happens to his outstanding debts to people? His heirs are still alive, aren't they?"

The second guard responded once again. "No. Now you've got to go in person and grab him by the collar on the bridge to heaven. It will do you no good to write him anymore." And he laughed again.

The first guard did not laugh at his friend's joke at all, but said:

"Brother, you are wasting your time. There is nobody in this house. All the doors and windows have been sealed by the government."

Surprised, Mirza said: "You mean he owed the government so much that they have confiscated his property? He didn't go bankrupt, did he?"

The first guard said: "We don't know anything about it, so don't ask us any details. Just turn around and go back the way you came. When Haji's memorial service was over, his wife and kin left the house and entrusted it to us."

Mirza said in a sorrowful tone:

"So, what happens to what he owes me? Where the hell are his children, anyway?"

The second guard burst out laughing again: "Didn't I tell you to go take him by the collar in the next world? You just don't want to listen to what you're told. An educated man like yourself shouldn't give his hard-earned money to a charlatan like Haji ..."

"That's enough. Don't talk behind a dead man's back," said the first guard to his colleague. Then he turned to Mirza and added:

"Don't be so insistent, brother. We don't know anything about anybody. Maybe his children are quarreling over the division of his inheritance. I suppose you too can wait if you wish. Perhaps in a week or two everybody will know where they stand. If you don't want to wait, write up a petition and go to the Chief Constable. And now, off with you. Good day."

On this note, Mirza Asadollah nodded to say goodbye and the guards returned to their game. Walking away, he held his head as if in despair and said to himself: "No, it's not possible. The day that I went to his memorial service there was no such talk. In a week or two, how could everybody know where they stand? Who could have poisoned him?" When he turned out of the alley, he thought of Mashhadi Ramazan, the grocer, who had a shop nearby, and headed off in that direction.

Mashhadi had just finished cleaning and sweeping his shop, under the warm sunlight of early fall. He looked preoccupied. They greeted each other and Mirza sat down next to Mashhadi, leaned against the wall, and said:

"Well, Mashhadi, what is the price of charcoal this year? Although it is still quite a while until winter, I must think of my children before the snow falls and blocks the road."

Mashhadi Ramazan said: "Last year, when you came to me at the beginning of fall, I didn't charge you much. I am indebted to your father, God rest his soul. Whenever you decide, never mind the money, just write down how much firewood and how much charcoal you need, and don't you worry about it. I will just get a mule driver and send him to you with bright shiny charcoal and fine firewood from the forest. All you have to do is instruct your family to clear out a place beforehand so that the porter and the mule driver will not have to wait."

Mirza said: "May God grant you a long life, Mashhadi. My two little children will be saved from the winter's cold thanks to you, and I am not ungrateful. Now, tell me, why have the guards been placed at the late Haji Mamreza's house? Is something wrong, God forbid?"

Mashhadi sighed and said: "I don't know. You don't know who to trust anymore. Rumor has it that his kids poisoned him. But, as God is my witness, they couldn't even harm an ant. As if he had been a bad father! The fact of the matter is, he spared nothing in taking care of his children."

Mirza said: "The guards were saying that no one is in the house. So, where are his wife and children? Nothing has happened to them, has it?"

Mashhadi replied: "His poor children have probably gone to the village. They say that Mizanoshshari'eh had a hand in this. They say that the late Haji had some kind of connection with the Calenders and that there was a quarrel between them and the government. There is a lot of talk, but I can't figure it all out. If all of this is true, why is the door of his house sealed and why does no one dare say a word? What a screwed up city this has become. If I were in the Calenders' shoes in a city like this, I would claim to be God Himself, never mind the Imam of the Age."

Mirza Asadollah also knew about the Calenders. When he was a child, his father had told him about them and he himself had, just like all the people of the city, gone to their tekkes and sat in on their speeches. Although he didn't have much of an opinion regarding the things they said and did, he had nothing against them. He thought they had their own business, just as he, Mashhadi Ramazan, Mizanoshshari'eh and his colleague Mirza Abdozzaki had theirs. But he was surprised that a man like Haji Mamreza, with all of his wealth, would fall for them. Suddenly, he remembered that Haji--God rest his soul--was a cattleman as well and had brought cows and sheep from his

property to the city, to the sixty or seventy butchers who bought the carcasses from him. So he asked Mashhadi Ramazan:

"Do you know whether the late Haji was in the business of selling animal hides and intestines to the Calenders?"

Mashhadi Ramazan said: "God only knows. It is said that recently he had set up a leather shop in one of the Calender tekkes and that he was a partner with them. If this is the case, it would be safe to assume that there has been a quarrel between them and the government. I suspect that the government poisoned Haji, God rest his soul. By the way, what does your uncle think?"

Mirza said: "I was just with him. He said that the children are not to blame. Anyway, you never said what the price of charcoal is."

Mashhadi Ramazan said: "Never mind the price. If you have the money, pay me and be on your way. I'll handle the rest."

Mirza said: "I don't have any money yet, but who knows what tomorrow will bring? Now, send me four loads of firewood and three loads of crushed charcoal. Give the bill to the porter. If I'm there, I'll pay in cash, if not, send it to my uncle. The old man always takes care of us."

Mashhadi Ramazan said: "Are you planning to take a trip somewhere? I hope it will be a good one."

Mirza said: "I might go check on Haji's estate and see how his family is doing. I might be able to help. I am very worried about them. As you know, his eldest son and I were playmates."

He then said goodbye to Mashhadi Ramazan and turned towards his uncle's office, to inform him of what he had seen and heard. He thought something smelled fishy about all of this and he wanted to know what his uncle thought. So, first he went to his place of business in front of the Grand Mosque and informed his neighbors that he would be busy that day and would not be open for business. Then he headed straight to the physician, who still had several patients. He waited half an hour until all of them had finally gotten their prescriptions and left, and he was left alone with his uncle. He then told him what he had learned, offered his own opinion, and asked the physician for his. The physician stroked his white beard and said:

"You are right, my boy. Lately, others besides Haji Mamreza have died in the same way. I feel that more trouble is in store, and it would be better if you weren't in town for a week or two. With your record with the Chief Constable and Mizanoshshari'eh, they might make trouble for you. I really don't think your young colleague can do much. And it seems that the powers that be are involved in the settling of the late Haji's estate. In any case, get your things together and go with this Mirza, and don't worry about your children."

EPISODE FOUR

Dearest reader, as fate would have it, in the same city and domain where our scribes lived, a group of Calenders with peculiar beliefs had appeared some thirty or forty years earlier. They had brought new ideas and had gradually established themselves as a sort of organization. Of late, that is, at the time of our story, they had turned the tekkes of the city into "sanctuaries," which no one was allowed to enter without their permission. Much whispering and many rumors about them went on among the people. For a storyteller to begin to delve into this story would be sticking his nose where it does not belong; however, since the tale of our two scribes is in one way or another related to the business of the Calenders and the general situation of that day and age, while our scribes are getting ready for their trip, we will try to find out who was really in charge, who the Calenders were, and why there was a rift between them and the government.

Let me say, dear reader, that these Calenders believed that the center of the world of creation was the "dot." They had relieved the people of all religious obligations. They spoke in secret codes and metaphors. They considered the "Abjad" letters to be a greater solution to all problems than any talisman. Instead of "In the name of God," they would say, "I seek help from myself," and instead of "There is no God but God," they would say, "There is no God but the Most Clear Compound," thinking that they had discovered God's Grand Name. Their religious books were full of dots and single letters, like "F," "S," and "D." And they had an interpretation for every letter or dot. Their password was "battle-axe," something which every one of them owned, or if they happened not to, they would tattoo a picture of one on the back of their hands. Although this might smack of blasphemy, in short, they believed that instead of worshipping God--Who is in heaven, Who has no need for the prayers and fasting of rickety humans, and to Whose greatness all the prayers and praise of mankind (who is made of dust) are as insignificant as the wing of a fly. It is better to worship the two-legged human being in order to attend to his needs a bit more and serve him better. These were their ideas, which if not resulting in blasphemy had been justification for excommunication and the cause of much bloodshed.

As fate would have it, such was the case in that city and domain. In other words, the mullas and preachers had excommunicated the Calenders and expelled them from the mosques. The government was secretly keeping an eye on the situation. Since the government saw that the people were otherwise occupied, it would not meddle in such disputes.

On the other hand, at the time of our story, there had been a long Shi'i-Sunni war with the neighboring government, and the people had really grown weary of the Sunni killings in the cities and provinces. Although the war had ended and for now there were no killings, the effects of the destruction and killing were still visible, and it would take a long time before life would return to normal. For the life of you, you could not even find a hefty mule in any village, and the weapon shops in the cities were doing a brisk business. There was also an abundance of crippled, disabled, and blinded people begging in the streets. And once every four or five years, famine would strike or disease would kill the cows and the people in the villages and such calamities would spread. In such an age, the Calenders had begun to flourish.

The way the Calenders started was that at first, one by one and later group by group, they gave up wandering in the deserts and came to the cities, because nothing could be found in the villages and the villagers themselves could scarcely make ends meet. As the number of Calenders grew in the cities, they wanted to make a living, so they took to the business of storytelling and panegyrizing. As their audiences grew, little by little they would become more courageous and would speak of the people's misfortunes. In this way, they gradually attracted the people and kept doing so until finally they became established. They then spread their rags and bags in the tekkes and were there to stay.

Dearest reader, the reason the Calenders had thrived was that their leader, Mirza Khuchek Jafrdan, thirty or forty years before the time of our story--that is, about the time that our scribes were going to school-- had jumped into a vat of acid and disappeared. His followers had started the rumor that he had gone into occultation, and would soon reappear to establish justice and equity throughout the world. Each one of the Calenders would make sure to refer to this story in their eulogy sessions or storytelling. Many people now believed the story and were in a constant state of expectation.

Furthermore, in another effort to boost up their business, the Calenders had spread the word that should the war resume, those whose names were drawn in the lottery to serve as soldiers and who did not want to go to war could take sanctuary in one of the tekkes. The Calenders would pay their blood money and pay off the government for their lives. They had also greased the palms of sixty or seventy of the elders in the city to swear on the Holy Book whenever they had the chance that Mirza Kuchek Jafrdan had paid their blood money and

bought their lives before he went into occultation. Otherwise, they would claim, only God would know on which battlefield their bones would be tilled and turned under by the shovel of which peasant. In this manner, they had gradually filled the people's ears, had gathered the hungry beggars of the neighborhood into the tekkes, and had established quite an organization with much hustle and bustle.

As fate would have it, at the time of our story, the chief of this group was a man by the name of Torab Tarkashduz. What a daredevil! Fifty years of age, with a salt-and-pepper beard and a long white cloak, tall as they come, the epitome of a Calender. Torab Tarkashduz was known for having brought back from the battlefield the head of Ashtar Pokhtor, the commander of the enemy, in forty days. This incident had occurred ten years before, at the beginning of the Shi'i-Sunni war. At that time, Torab Tarkashduz had just come to the city and taken up residence in a tekke. Through the mediation of the Grand Vizier of the time, he had remained in seclusion for forty days, living on only one almond a day. Each day he had drawn a life-size portrait of Ashtar Pokhtor on the wall, his throat slit with a red line. On the forty-first day, the Royal Courier arrived with the shrivelled, bloody head of the man and threw it before His Majesty's feet. This had put fear in the people, who not only no longer bothered the Calenders, but even gathered around them and gave them alms. True, His Majesty had been frightened from that point on, had exiled the Grand Vizier abroad, and would no longer butter up the Calenders. But the name Torab Tarkashduz was on everyone's lips now, and nothing could stop the Calenders any longer. Torab Tarkashduz had instructed the Calenders to give sermons in seven of the tekkes of the city every Friday eve, where banquets were held afterwards. So, every Friday eve a new group of people would gather around them. Now, in addition to the Calenders and the poor and hungry of the city, any fugitive from the government, any ruffian, anyone who had been wronged and unable to take revenge, those who had quarrelled with their parents, those who could no longer put up with their wives and concubines, or those who had fled their creditors, all had taken sanctuary in the tekkes and brought along their rags and bags. Because the number of Calenders had grown out of hand and idleness could very well result in boredom, since two years before, Torab Tarkashduz had made every tekke the center of one guild and put all the Calenders to work: the Saddlers' Tekke, the Cannon Makers' Tekke, the Bakers' Tekke, the Cobblers' Tekke, the Packsaddlers' Tekke, and so forth. As for himself, despite the fact that he had been a quiver maker--and he was stuck with the name--before succeeding Mirza Kuchek Jafrdan, he now associated mostly with the cannon makers. In every tekke, the work was divided. As for those who did not know a trade, some cooked and catered for the Calenders, others did the sweeping and cleaning, and others still did the bazaar shopping, dealing

with those bazaar merchants who were loyal to the Calenders and who bought products made by the Calenders. Those who had a specialty or knew a trade were engaged in doing their trade in a tekke, and they sent whatever they made to the bazaar to be sold. Since they sold their products below the market price, they always had customers. Women were absolutely forbidden from entering the tekkes, since in the Calenders' beliefs, intercourse with women was prohibited. The Calenders were all single or celibate. It was said--let the storytellers be blamed if it is not the truth--that many of the Calenders indulged in smoking opium and hashish. And pederasty has always been widespread in these regions.

Dear reader, that was the way things were up to the time our story begins. One day, one of the secret agents of the government informed Khajeh Nuroddin, the minister who was the Grand Vizier of that day and age and who had replaced the exiled Grand Vizier, that unbeknownst to them, Torab Tarkashduz had been casting cannons. The government officials were suddenly panic-stricken, since firearms had just recently become common in the European lands and had not yet been introduced in these regions. The reason for the government defeats in the Shi'i-Sunni war with the neighboring country stemmed from the fact that they had not yet been able to cast cannons, and only one in every ten soldiers had a rifle.

In any case, up to that point there had been no harm in the Calenders' activities: The people were kept busy and thought that the Calenders were capable of accomplishing something. As for the government, whenever it wished, it could eliminate one of them easily by poisoning his food, having him excommunicated by the religious court, scalding him with burning candle wax or blinding him. But now there was something fishy about this business. So the notables, the rich, and the ministers got ants in their pants, and spies, reporters, and detectives disguised in the Calender garb were sent one after another to the Calenders' tekkes and hangouts. Also, in order to leave no room for doubt, Khajeh Nuroddin, the Grand Vizier, asked Khanlar Khan, the court favorite, to check out the premises personally in disguise. Khanlar Khan, who desperately wanted to become poet laureate, did as he was told. He reported back that Torab Tarkashduz was paying good money to buy the brass mortars of every family. He had set up a kiln and other equipment in the Falconet Casters' Tekke, and had so far cast three cannons exactly like those of the Sunnis.

At this point, Grand Vizier Khajeh Nuroddin got wind of what this quiver maker was up to. With these three cannons alone, he could in one day make a hole the size of the city gate in the wall of the government palace. Hence, he summoned the ministers. After a few days of consultation, it was decided that His Majesty should be informed. To do this, they called on Khanlar Khan, the favorite of the

court, to compose a panegyric poem in which there would be some hint of these events. Thereupon, His Majesty's ears would be sharpened, and he would wish to know the meaning of such allusions. At that time, Khajeh Nuroddin could explain to His Majesty the whole story in a nutshell. This they did. But His Majesty did not at all get Khanlar Khan's hints. He thought the man's intention, once again, was to become poet laureate. So, out of boredom, he commanded that he be given fifty gold coins as a prize and dismissed everyone. None of the ministers had the courage to go into the inner chamber to give the news to His Majesty. What was to be done now? Again, they held a few more days of consultation. Finally, the best solution they could come up with was to plead with the king's favorite wife for help through the eunuch of the court harem. And so they did. But, since it had taken thirty-three days for the turn of His Majesty's favorite wife to come up, she just could not make herself tell the news to His Majesty early in the evening and ruin her own pleasure. Therefore, she decided to wait until the next morning. But the next morning, His Majesty was asleep, and it would have taken the courage of a lion to wake him up. Another month passed in this way, during which not one of the ministers had the courage to open his mouth in the royal presence, nor did anyone else volunteer for the task. And, of course, the ministers did not dare to even take a drink of water on their own. They were quite helpless. Meanwhile, Torab Tarkashduz cast three more cannons.

On the other hand, Grand Vizier Khajeh Nuroddin, who realized that all this was getting nowhere, decided to risk everything and make up a plan himself to take care of the business at hand. He sent for Khanlar Khan, the court favorite, whom we already know, and the astrologer to the court, who had recently succeeded his father and who had not yet had the opportunity to render his services and show off. He told them the whole story and added that as the government daily reports from the provinces indicated, similar events with minor differences had occurred in other cities as well. If they did not do something immediately, the Calenders in other provinces would also learn how to cast cannons, and the situation would get out of control. Then not only would it be the end of His Majesty, but it would also be the end of the poet laureate as well as the astrologer to the court. He then explained his own plan to them and made the astrologer promise to study the astrological charts and observe the stars for three days in order to draw up a plan for this matter. As for Khanlar Khan, he was to compose a panegyric poem in such a way that the similies and metaphors would not be too difficult for His Majesty to understand. After this meeting, he sent for the court physician and gave him a list of seven persons to be eliminated before the end of the week. These seven consisted of bazaar merchants who dealt with the Calenders and who gave them financial assistance. One of them was the same Haji Mamreza, concerning the settlement of whose

estate our scribes were to make a trip. Also let me add, he had instructed Mizanoshshari'eh on how much of each person's property was to be confiscated and how much was to be given over to religious endowment. He had also told the Civil Magistrate how many of the people's horses and mules were to be pressed into labor. In short, he had arranged everything single-handedly. In addition, he instructed all the government spies and snitches to spread the rumor in the tekkes that soon a miracle was to occur: Mirza Kuchek Jafrdan would come out of occultation, and, doing this, that, and the other thing, he would establish equity and justice in the world. Meanwhile, spies who arrived from the provinces bringing bad news were given new instructions and sent back before the sweat on their horses had a chance to dry. In short, during those days, the rattle of couriers' horses was heard constantly, and there was an indescribable hustle and bustle in the alleys of the Royal Palace.

Dearest reader, the day on which all the preparations were ready coincided with the day that our scribes were to set out on their trip, the day of the Grand Palace public audience. All the wealthy and the aristocracy were gathered. There were so many people, you could not drop a pin. First, Khanlar Khan, the court favorite, who was quite fat and heavy, came forward panting. He took out the scroll on which he had written his new poem, which he recited eloquently and in which he made clear hints in two or three places to the insolence of the Calenders. In one place, he had even inserted the word "cannon" in his poem. Those present expressed their admiration and "bravo"s. Then, the astrologer requested permission to speak, and in a verbose language, with which you are all familiar, began a long introduction. Finally, he got to the point, as follows:

"Let me be the dust under your blessed feet. Even though the position of celestial bodies and higher planets, each of which is a bondservant, nay a lowly slave, to Your Excellency, the Shadow of God, is total proof and indubitable evidence of the health and good fortune of Your Honorable Royal Eminence, yet, because the protection and preservation of this divine presence is incumbent upon every subject, this unworthy subject, the lowly dust under your feet, has perceived with the passing of days and nights, from studying the planets and stars, that in the coming days and nights, from the seventh of the month, for three days, the inauspicious lunar quadrature will be in ascendance and the star of luck in the nadir of destruction and mischief, and in those three days during which this sinister confluence will occur, the being of Your Most Just Highness and Blessed Excellency, the Shadow of God, will be the target, God forbid, of the disaffection and ingratitude of the treacherous heavens and pernicious firmament."

As he was outpouring this pompous verbosity, His Majesty's patience ran out and he shouted:

"Has this bastard's jaw come off its hinges? Grand Vizier, what do you think about having his chin and jaw soldered with molten silver?"

Khajeh Nuroddin, the Grand Vizier, who realized the plan was falling apart, rushed forward, took a deep bow and said:

"Sire, forgive his excellency the astrologer for his loose tongue, for the sake of this lowly servant. This is a habit with scholars. I beg your pardon, but I believe, out of his fervent devotion to Your Royal Highness, he would like to speak of certain issues of which he has spoken to me. If Your Highness would grant permission, I believe he has foreseen some danger for Your Exalted Royal Highness in the position of the stars. Khanlar Khan, the court favorite, also mentioned this point in his poem, but it went unnoticed by Your Majesty."

His Majesty shifted positions on his imperial throne and spat in the direction of the golden spittoon held by a royal court attendant. Then, he said: "I could not make head nor tale out of what this jabbering young man was saying. He speaks his father's language. You'd better explain it yourself, Grand Vizier."

Again, the Grand Vizier took a deep bow, stepped forward and said:

"As it is known to Your Royal Highness, the season for your residence at the Winter Palace is near. Although your kingdom's capital is the envy of amber-scented Paradise, it does have a harsh autumn chill. Your Imperial Majesty needs to sun his bones. In addition, it is in the interest of the country and the nation that we begin the winter residence earlier this year, because, as the Court Astrologer has seen in his study of the planets, it is not in the interest of the exalted presence of Your Most Royal Highness to repose at the seat of the kingdom from the seventh to the tenth of the month."

Not the sound of one breath could be heard from the audience, not even the fluttering of a fly's wings could be heard. His Majesty shifted his position on the throne once again, issued another cough, and said:

"Tell me, Grand Vizier, what trick are you all up to? You had better watch out. I will have your hide stuffed with straw. Now, tell me what has come to your defective mind?"

The Grand Vizier glanced at the astrologer and Khanlar Khan, took another step forward and said:

"The humble servants to Your Royal Threshhold have already contemplated the matter and have come to the conclusion that during these three days, the magnanimous presence of Your Highness must be away from the throne of your kingdom so that should some misfortune befall, God forbid, the life of another would be sacrificed for that of Your Imperial Majesty."

His Majesty rose up on the imperial throne, blood ran to his face, and he cried:

"You, whoresons. You have really cooked up a plot. Do you expect to get rid of me so easily? Executioner!"

The executioner, dressed in red from head to toe, with a shiny, wide-bladed machete, appeared like a bolt of lightning, prostrated himself in front of His Majesty's throne, and remained motionless in that position, just like a statue, waiting for his command. But the Grand Vizier was not one to be shaken so easily. He took yet another step forward and said:

"Sire, permit this devoted servant to finish his humble remarks. Then, if I have committed any offense, here is my neck." He then recited an appropriate verse.

His Majesty signaled to the executioner, who arose and went away and found a place somewhere in a corner. He then nodded to the Grand Vizier to speak. The Grand Vizier said:

"Your Honor is aware that the humble servants to your court have not had any entertainment for some time. Since Haji Mirza Qomqom said farewell to this transient world, there has been no opportunity to bring gaiety to the spirits of Your Imperial Majesty. With your permission, your slave-born servants have arranged the affairs in such a way that both the heavenly dangers will be rendered ineffective and a new means provided to bring gaiety to your honorable spirits." He then recited another appropriate verse.

His Majesty stroked his beard and said:

"Well, well, tell me, Grand Vizier. This is getting interesting."

The Grand Vizier became more courageous now. He took another step forward and continued in this vein:

"And then, I must bring to the attention of Your Highness that, despite all the beneficent favors Your Highness has granted them, little by little, this band of Calenders is causing trouble in the sovereign territories. In addition to the officials of the court who have kept a constant watch over their words and deeds, the distinguished personage Khanlar Khan has also gone among them to observe them closely. They have now become so impertinent as to nurture fanciful ideas in their minds and to cast cannons."

Upon hearing the last word, His Majesty half rose, his face aflame, and said:

"Is that so! They cast cannons? How? Why has that bastard, the Minister of the Cavalry, not gone to learn from them, so that we would not be so helpless in time of need? In fact, you stupid bastards, why have you not informed me before? What do you think I am in this country anyway?"

The Grand Vizier assumed a mournful pose and said:

"May I be sacrificed for the dust under your feet. Your devoted servants did not want to disturb Your Honor's peace of mind. However, it is not yet too late. What would you command us to do with this band? Should we go and buy their cannons? Do you think the matter can be settled so simply?"

His Majesty pounded his fist on the cashmere cushion armrest and said:

"How should I know? You stupid idiot, you are just now telling me the story, and you ask for an immediate solution! Then what are you and the likes of you doing wasting so much money?"

And then he sank into thought and, as if talking to himself, said: "So this bastard of a quiver maker is getting big ideas! Ungrateful wretch! I gave five thousand coins as a reward to two of those vagabonds to take that damned dog by surprise, and they brought me his head. Now, this bastard is taking all the credit for it."

Then he turned to the Grand Vizier and shouted:

"Now, you idiot, can you tell me what the shit you are going to do?"

The Grand Vizier said: "This depraved band believes that soon a miracle will occur, and they are preparing themselves for this miracle. Their casting of cannons indicates that this miracle involves in the least the taking over of the government. Your most humble servants have planned to strike two birds with one stone: to help the manifestation of this miracle and at the same time to dispel the heavenly calamities during the course of those three days. We shall proceed by making it appear to these people that we are leaving the scene and moving Your Majesty's court to the Winter Quarters. Since the Imperial Winter Quarters are located in the southern provinces and near the borders of the sovereign territories and since the dispatch and exchange of couriers and envoys is easier from there, perhaps the magnificence of your blessed presence will bring about peace and friendship with the belligerent neighboring government and serve as a means to eliminate the resentment between the two." He concluded his statement with yet another appropriate verse.

About this time, a murmur was heard in the audience and here and there the words "bravo" and "well done" came to the ears of His Majesty, who contentedly and cheerfully said:

"Well said, Grand Vizier. Our magnanimity has not been wasted. Not a bad plan. I had heard that they were a nuisance to our government measures, but I did not know that they had gone so far as to cast cannons under our very nose. Ungrateful wretches. Well, now, what other plan have you devised for them, cursed one?"

The Grand Vizier said joyfully:

"May it be the eternal fortune of your imperial court, seven of the bazaar merchants who did business with them were honored last week with a visit from Azrael, through Your Majesty's court physician. And we confiscated their wealth with a religious decree issued by Mizanoshshari'eh, who is well known to Your Majesty. We will make arrangements to ensure that in the absence of Your Majesty, these gentlemen will dig their own graves with their own hands. And later,

43

when the earthly and heavenly dangers have been eliminated happily and favorably, and when we return from the Winter Quarters with your imperial retinue, we will have seven of their leaders sacrificed before your imperial feet, scald seventy of them with burning candle wax, and send the rest to prison and exile. I think the trouble will then subside."

Laughing cheerfully among the "bravos" of the personages and prominent people of the country, His Majesty called the Royal Court Attendant and instructed him to bring a thousand gold coins in two separate bags. He threw one in the lap of the Grand Vizier and counted the second one in his own blessed hands, halved it, gave half to the Court Astrologer and the other half to Khanlar Khan, the court favorite, and the royal audience ended.

EPISODE FIVE

Dearest reader, at dawn on the day of the public audience at the Grand Palace, our scribes, unaware of all the events, mounted two well-bred donkeys, which had been hired for a week from the Livestock Bazaar, and made their exit from the city gate. The local Chief Constable had been unable to accompany them, but he had sent his deputy along with seven guards, four of whom were armed with spears and bows and arrows and three with rifles, to accompany them. All, on horse or mule, followed the scribes with pomp and ceremony. Until sunset that day, they did not stop anywhere for long. At noon, by a stream, each took out a piece of bread from their saddlebags to eat and set out again in order to travel a two-day journey in one day. At sundown, they arrived at a caravanserai which was both a government garrison and a relay station. There they spent the night. The caravanserai was so crowded and there was so much traffic all night that our scribes could not sleep a wink. The next courier would arrive before the one before it had left, all in a hurry, panting, towards the city or the provinces. It was obvious that something out of the ordinary was taking place. All night, the horses neighed, the mules stomped their hooves on the ground, the couriers cursed the relay-station officials, and Mirza Asadollah kept thinking and imagining things, while all the bedbugs and fleas in that caravanserai crawled up his pant legs and sleeves, found a comfortable place, and took up residence there until the next morning. As for Mirza Abdozzaki, he was not much better off. Finally, when the cock crowed, they got up and pleaded with and coaxed the deputy of the Chief Constable to wake up. Then they made the guards go and draw water from the well, groomed the horses and the donkeys, ate a bite on their feet, and set out on the road. God knows whether it was the effect of the sleepless night or for some other reason, but every village they passed seemed to Mirza Asadollah that it had just been through a famine or that the people had fled the village for fear of plague. Desolation was everywhere and the people were all thin and starving. Some time had passed since the harvest season, but once in a while when they passed by a large village, the straw heaps left from the harvest, which had not yet been gathered, seemed so small and poorly colored to Mirza Asadollah, as if they were small piles of dirt the children had made at play. They continually passed by ruined villages and collapsed *qanat*

45

wells until finally they arrived at their destination a little before noon. First a ruined fortress appeared from a distance. Then the branches of a bunch of poplar trees that had cast their shade on one corner of the fortress appeared, and then a large elm tree, which stood before the village gate like a big cannonball on top of a stick. Neither did anyone come to welcome them nor was a cow or sheep sacrificed upon their arrival. Of course, our scribes did not expect it. But the deputy of the Chief Constable, who had taken the lead one parasang from the village, ahead of the others, was truly offended. He cursed all the ignorant peasants and himself for having come on such a mission. Here and there, when a villager could be seen plowing the fields or returning to the village, he would run away or hide as soon as he saw the group. Fortunately, one of the guards had made a quick trip to this village the previous week and knew the way. Otherwise, they would not even have known if this were the right place. They entered the village through a gate and reached the square in the center of the village. But they did not see anyone. The place seemed uninhabited. However, from the fresh dung on the walls and the dust floating in the air, it was obvious that every house door had just then been shut, and the people were standing behind the doors watching through a crack. Even the deputy realized this. All of a sudden he lost control and burst out:

"Stupid jackasses! Are you afraid we will eat you up? Good-for-nothing bastard peasants!"

Mirza Asadollah, who was riding his donkey behind him, heard someone behind the door, which had served as a target for the curses, saying in a low but harsh voice:

"Damn executioners . . ."

The guard who was right behind Mirza Asadollah seemed to have heard this. He turned the head of his horse and kicked that door with his boots so hard that it scared the devil out of Mirza Asadollah. In fact, from the moment he had set foot in the village, Mirza had been worried. He did not know for what reason, but he was expecting something to happen every moment. Until they reached the village square, nothing else occurred. An old man with a white beard, apparently the village headman, and two of the late Haji Mamreza's sons were standing under a solitary mulberry tree in the middle of the village square. The villagers were sitting crouched in various corners of the square in small groups. As soon as the riders dismounted, Mirza Asadollah made a move towards Haji's elder son, with whom he had been a schoolmate as a youth. He wanted to say hello. But both of the sons looked away and ignored him. The deputy of the Chief Constable dismounted his horse and instead of answering the greetings of Haji's sons, he turned to the village headman and shouted:

"There's probably no straw or barley to be found in this dump either, huh?"

Haji's eldest son rushed forward, bowed slightly and said:
"You are being unkind, sir. Make yourself at home."

He called to several villagers, who ran forward from different corners of the square, took the bridles of the horses and the mules and led them away. The whole company, following behind the deputy, entered the landlord's house, which was in better shape, since it had been swept up and had no dung on the walls. It had a small garden and a little pool. While the room by the entrance was being prepared for the guards and the others were walking to the large five-door room, Mirza Asadollah went to freshen up by the pool, hoping to exchange a few words with his old schoolmate. He was splashing some water on his face and head when one of the villagers, pretending to help pour some water over Mirza's hands, came to him and put a piece of paper in the pocket of his gown. Mirza dried his hands and asked the same villager where the privy was. As the man went to fill the ewer for him, Mirza went to the privy and took the piece of paper out of his pocket. He recognized the handwriting of his old schoolmate, who had written: "As for your colleague, there is no need for explanation, but why you?" A cold sweat covered Mirza's forehead. He took a deep breath, took out his pen case, which he kept tucked in his sash, and, squatting down, wrote on the back of the same piece of paper: "I swear on your father's soul I have absolutely no idea what is going on. I am going crazy. Find a way to see me." When the man returned with the ewer, Mirza Asadollah gave him the piece of paper, shut his pen case, put it in his sash, and returned to the others. Then a lunch was brought in, which everyone ate in silence. After lunch, excusing himself for being tired from the trip and the sleeplessness of the previous night and on the pretext that he snored in his sleep, Mirza Asadollah went alone to the small room next door to lie down, hoping for a visit from one of Haji's sons. After about an hour, the door was quietly opened, and Haji's eldest son came in. Without an introduction and in a scolding but quiet tone, he said:

"Very kind of you, Mirza. You are turning over a new leaf. Now you go so far as to become the fuel carrier for other people's quarrels? And you pretend you don't know what is going on? Then, what about your old ideals? And your honesty? And all the learning, schooling, principles, and what not?"

Mirza answered in a similarly quiet tone: "I don't understand all these hints and innuendos, Hasan Aqa ..." Then he told Hasan Aqa all that had happened between himself and Mirza Abdozzaki. He also told him what he had witnessed at the door of his father's house, what he had heard from Mashhadi Ramazan, the grocer, and his consultation with his uncle. Finally he added:"And even now, while enjoying your hospitality, I have no idea what is going on and what I should be doing. You may not believe me, but I consented to come on this trip mostly because there were signs of unrest in the city. And then, I told myself I

47

would come and if there was really a quarrel over the inheritance, I would make peace between you as a well-wishing arbitrator and would prevent someone like Mizanoshshari'eh from taking advantage of the quarrel between brothers."

Hearing all this, Hasan Aqa sat down more at ease and said:

"These are strange times! You cannot even trust your own eyes and ears."

Mirza Asadollah said: "You are free to trust me or not to trust me. I have never done anything that would require justification. Everything must justify itself. Now, tell me, why have things turned out the way they have?"

Hasan Aqa said: "How do I know? You probably know that our father was poisoned. After the memorial service, they took the three of us to the Civil Magistrate's Office, my two brothers and me. They put a long document in front of us and told us we should sign it, otherwise, we would be sent to jail and left there to rot. They put my little brother, Asghar, in jail as a hostage, so to speak. Last week, they sent me and my brother along with two officials to come to the estate and wait for the civil and religious representatives--that is, you people--to come and settle the matter, so that we could return and then they would free our brother. You should have known this whole story, Mirza. After all, how could anyone set out on the road without knowing ..."

Mirza Asadollah interrupted him: "Then, what about this business of quarrels and reconciliation?"

Hasan Aqa said: "What quarrel? What reconciliation? This has all been fabricated by that freeloading, roughneck son of a bitch, Mizanoshshari'eh. They are trying to force us to give one-third of the property to a religious endowment with Mizanoshshari'eh as its custodian. Of the remaining two-thirds, one-third should go to Khajeh Nuroddin, the vizier, one-sixth to the Chief Constable, and the last one-sixth to your excellency and your colleague. And how large do you think the entire estate is? Four villages with seven *qanats*. As for my children and those of my brother, they can go begging. Do you understand now? The quarrel is over this free-for-all estate, not between my brothers and me."

Mirza Asadollah dropped his head and said:

"Stupid of me to have been duped by this cursed seyyed. The good thing is that Mizanoshshari'eh does not know that I am involved in this business. As a matter of fact, because of our old disputes, I thought I had better not stay in the city. I knew if I stayed he would make trouble for me. If he finds out that I have interfered in this kind of affair once again, this time, he will have me exiled."

Hasan Aqa said: "Oh friend, you are truly simple-minded. You have been sitting at the entrance of that mosque seeing this big shot come and go for so long that you think all things end with Mizanoshshari'eh.

Besides, Mizanoshshari'eh has intended for you to be involved in this affair, because he knows that your friend's signature is not worth the paper it is written on. They have duped you, Mirza. Stupid of me to have thought they had blinded you with worldly gains. Now, are you really telling the truth?"

Mirza, who was on the verge of bursting into tears, said:

"What can I say, Hasan Aqa? You had better talk. Tell me, why did they poison your late father? Who did this, anyway?"

Hasan Aqa said: "In the end, his good intentions caused his death. Once a week, he would not come home for lunch. He would have kabob from the bazaar in his chamber. He said, since he was giving meat to the butchers, he wanted to find out what the kabob vendors were feeding the people. You see, he finally found out what poison was being fed to the people. This was his habit every Thursday. After lunch he locked the door of his chamber from the inside, sent his errand boy to lunch, and went to lie down. That afternoon, when I went to his chamber, I saw his errand boy sitting behind the door, which was locked from inside. I felt my stomach drop. Finally, we broke down the door and found him, black as tar. His lips were cracked. Your uncle has probably told you the rest. It was obvious that they had put something in his kabob."

Mirza asked: "But, who? Who would do such a thing?"

Hasan Aqa said: "It is obvious. The kabob vendor swore that he had fed more than a hundred customers from the same meat mixture that day. He even mentioned them all by name. As fate would have it, the custodian of the Merchants' Chambers had also had kabob for lunch that day. In fact, my father's errand boy had brought it from the kabob shop. But only my father's kabob was poisoned. Nothing happened to the others."

Again, Mirza asked: "You've got to have some idea who has done this. What could he hope to gain? Did you just let it go at that?"

Hasan Aqa answered impatiently: "How simple-minded you are, my friend. It was obvious from the beginning. That day, at my father's memorial service, the custodian sat by me. He said that when my father's errand boy returned from the kabob shop, he delivered his tray first and he started eating. Then he saw that the boy put my father's tray on the counter of his office and went to get some cold water from the water tank. At the same time, one of these Calenders appeared in front of Haji's shop with a wild rue incense burner in his hand. He bent over the counter to bless the shop with the smoke. Haji came out of the shop, gave him some money and the man went away. Then the errand boy returned and put the bowl of water next to the tray of kabob and went about his own business."

Mirza said: "Well, it is obvious that it was the Calender's doing. Didn't you do anything to him?"

Hasan Aqa said: "What could we do to him? They all look alike. They all have a beard and a long white shirt. Which one were we supposed to catch? Do you think there was a chance of an investigation? The memorial service was barely over when the situation turned out as you see now. Besides, I can swear that the man was not a Calender. When they are plundering his property the way they are doing, how could anyone say it was the Calenders' doing? Didn't you say we should see who stands to benefit from killing Haji? Here you are: the Chief Constable, Mizanoshshari'eh, and Khajeh Nuroddin. What do the Calenders have to do with it? If the Calenders had anything to gain, it was when my father, who helped them so much, was alive. We think it was the government's doing. They sent someone in disguise to poison Haji. Besides, it was not our Haji alone. Six others among the well-known people in the city died about the same time. One died of apoplexy in the bathhouse; one slit his own artery; another fell from a second-story window; still another disappeared all together, and so on. We also know that the other six were in a situation similar to Haji's. In other words, they were all prominent people who were well-off. Furthermore, they were all loyal followers of 'Number One.'"

Mirza Asadollah asked: "And who might this 'Number One' be?"

In a hushed voice, Hasan Aqa said: "The Reflection of Truth, his excellency, Torab Tarkashduz."

Mirza said: "Aha! You are talking about the chief of the Calenders. Then it is true that the government has cooked up something against them? Well now, what am I supposed to do? What should I do?"

Hasan Aqa said: "How do I know, Mirza? Everyone has to do what he thinks is right. You are an adult of sound mind. With your education and experience, you don't need advice from someone like me. What my brothers and I have to do is to save our lives even if we lose all of this property."

Mirza Asadollah interrupted Hasan Aqa and said:

"This can't be. Then, how will you live? You know that defending one's property and life is considered as important as holy war."

Hasan Aqa said: "No, Mirza. Those times have passed when it was believed that a person who is killed defending his property will be a martyr. This belief was fabricated by the *nouveaux riches*. Worldly possessions are not worth the spilling of human blood. Nowadays, a martyr is a person who is martyred for his beliefs and who sacrifices his wealth for his beliefs. My father did it, and so will we. We don't worry about our wives and children, because we have sent them to various relatives. Besides, we are not alone. We have Torab, the Reflection of Truth, along with all the other People of Truth."

Mirza Asadollah looked at him for a while and then asked: "But, what could your late father have done to upset Mizanoshshari'eh?"

Hasan Aqa said: "Oh, friend, where have you been? He had gotten into an argument with him concerning the People of Truth. In fact, towards the end of his life, my father was not even concerned with appearances. He refused to go once a year, like others, to have his wealth cleansed and blessed, so to speak, by one of the mullas in order to placate Mizanoshshari'eh. I myself was there when in the presence of one of them he said: 'A person is a slave as long as he does not know himself, because he is a slave to ignorance. But once he knows himself, he becomes God, since godliness is to come to know one oneself.' For this very statement, they almost excommunicated him. Then it would have been worse. You know that he had founded the Tannery Tekke only to aid the People of Truth. God rest his soul, he gave his life for his beliefs. True, we are incapable of such bravery, but there are as many ways to attain Truth as there are people."

They were silent for a few minutes. Mirza Asadollah shifted his weight and said: "Well, Hasan Aqa. It is clear what I must do. I don't believe in these new ways and ideas of yours. But, under the old ways and ideas, I know what I must do. In order to have faith, one does not have to look for new ideas and beliefs. The older the beliefs the better. I am, after all, the master of my own writing and my own signature. If I am able, I will also make Mirza Abdozzaki agree. If not, he will pay the consequences."

Hasan Aqa said: "As I told you, we have all been coerced into giving up this estate. By the same token, you, too, have been forced to come here. Be careful not to get yourself in trouble. We have heard that the government has plans for the Calenders. After all, you have your wife and kids to worry about. They have nothing to do with all this ..."

Mirza Asadollah interrupted his childhood friend and said:

"Dear Hasan Aqa, one's wife and children can be no excuse for all the wrongs one commits. If you listen to the complaints even of executioners, they make you feel so sorry for them that you might begin to believe that for the sake of their wives and children their job of killing people is as noble as a pilgrimage to Mecca, or holy war. They tell you their children would die of starvation, that you have no idea how they suffer, and similar excuses. They are unaware of the fact that if you make a living for your children through being an executioner, you should not be surprised if each one of them turns out to be a bloodthirsty murderer, because with every bite they eat, they are gulping down the people's blood. They would think the spilling of blood is a necessary means of survival. This is what the ancients meant by the unlawful morsel. God is great enough to take care of our few little children. Now, get up and go away and let me sleep a little."

But, Mirza Asadollah could not sleep at all after Hasan Aqa left. He kept tossing and turning and thinking until the others awoke. The villagers brought the afternoon snack of fresh bread, cheese, and walnuts

51

on large trays. Then they all went out riding, both to take some fresh air and to look over Haji's estate.

The animals had rested now and seemed lively. The late afternoon sun was pleasantly warm. The armed guards were getting ready to hunt some game. When they were some distance from the village, Mirza Asadollah caught up with his colleague and made an attempt to keep some distance behind others. He then began as follows:

"Well, well, Seyyed, offspring of the Prophet! I never thought you would get your friend involved in a mess like this."

Mirza Abdozzaki stiffened and said in a surprised voice:

"What mess, my dear friend? What has happened?"

Mirza Asadollah said: "Don't pretend you know nothing about it, Seyyed. They want to confiscate the property of these helpless people and you expect me to sign the deed, after a whole life of friendship to rubber stamp a document to confiscate the property of these creatures of God! That is all I need to do!"

Mirza Abdozzaki said in an irritated tone:

"My dear friend, what is it with you and your signature? What is so precious about it? I wanted to do a good deed; I thought this would provide you with a loaf of bread for your children. There are people who would give an arm and a leg for such opportunities, my dear friend. What is all this nonsense about? Every day you dream up something new. Has your sitting behind that pitiful desk of yours gone to your head? What do you think you are, my dear friend? With all due respect ..."

Mirza Asadollah interrupted him angrily: "You ought to be ashamed, Seyyed. Neither have I ever held a position nor have any of my ancestors ever entertained the desire to confiscate people's property. As far as I can remember, our forefathers have made a living by their pens. We have never, any of us, dipped our pens in the blood of the people or their belongings. Now you, unworthy offspring of the Prophet, have brought me here to sign my name so we can become the owners of one-sixth of Haji's property? Seyyed, you might have to stoop so low to shut your wife's mouth or tie her down, but my wife and children are content with the simple life of bread and cheese ..."

Mirza Abdozzaki, crazed with anger, shouted:

"Have you gone mad, my dear friend?" It was such a loud shout that the deputy of the Chief Constable and Haji's children, who were some distance ahead, doubled back to see what was going on. When our scribes realized that they had caused a stir, they calmed down. They rode quietly for a while until they increased their distance from the others. This time, Mirza Abdozzaki began to talk. In a trembling voice, he said:

"I swear on my holy ancestor, I am hearing this for the first time from you. Nobody ever mentioned such things, my dear friend, as what

we are to gain or not to gain from this business. One-third of the estate will be given to a religious endowment. The rest will be divided among the children to settle the quarrel. As for you and me, my dear friend, if they wish, they can give us something, a piece of cashmere, some money, a horse or a mule, or nothing at all." Mirza Asadollah asked with a sarcastic grin: "Then, is this the profitable business that had made your mouth water so? And what need is there for all these armed officials? And what need is there to involve the Chief Constable?"

Mirza Abdozzaki said: "My dear friend, how many times must I say that Haji's children have a dispute. Haven't you seen, my dear friend, one brother dig out another brother's eye for worldly possessions? The Chief Constable has interceded since religious endowments are in the public domain. Where have you come up with all these ideas, anyway, my dear friend?"

Mirza Asadollah said: "Nothing to fight about. Tell me, Seyyed, if they put the document I was telling you about in front of you, will you sign it or not?"

His colleague asked: "I don't understand, my dear friend; what document?" Mirza Asadollah said: "That one-third be given to a religious endowment; another third, meaning two-sixths, to Khajeh Nuroddin; and of the last third, half for the Chief Constable and the other half for the two of us. Will you sign such a document?"

Mirza Abdozzaki pulled the reins of his mule and stopped. He stared at his colleague and said: "No, my dear friend. That was not the deal at all. I will sign the document I spoke about with Mizanoshshari'eh."

Mirza Asadollah said: "Good. Now, suppose Mizanoshshari'eh has duped you; what will you do then?"

His colleague said: "My dear friend, I don't know what sort of grudge you have against Mizanoshshari'eh to be so suspicious of him. I don't understand, my dear friend."

Mirza Asadollah said: "We are not talking about suspicion, Seyyed. We are talking about facts. The Chief Constable's deputy and all the guards have not come along just to keep us company. In fact, there is no dispute among Haji's children. Mizanoshshari'eh has given written instructions to the deputy and has told him line by line what to do ..." Then, he repeated exactly all that Haji's eldest son had told him. As Mirza Asadollah was telling all this, Mirza Abdozzaki was changing color. Finally, he was as pale as the plaster on the wall. By the time Mirza Asadollah was finished, Mirza Abdozzaki almost fell off his mule. He was so upset that he almost passed out. Mirza Asadollah, who was watching all these changes, said sympathetically:

"What's wrong, Seyyed? Has Mizanoshshari'eh duped you, huh?"

His colleague said: "It is not simply a matter of duping me, my dear friend. I just remembered that when I was leaving him, he told me at the door, 'Of course, you know what to do. But lest, God forbid, justice

would not be served, I have given a note to the Chief Constable that you should look at, if you have any problems.' Now, I understand what he meant by the note, my dear friend. He had really devised a good scheme and tied our hands. The unfortunate thing is, my dear friend, that at a time when I was being tormented by that woman, this bastard should send for me."

Mirza Asadollah said: "Nothing to fear, Seyyed. I know what I must do. I don't know about you, but I will not put my signature to such a document. Do your thinking, and make your decision. You can carry on even without me. That note is probably in the hands of the Chief Constable's deputy. We will ask him to show it, and we will set his mind at ease tonight. In any case, you know best."

Mirza Abdozzaki said: "What are you saying, my dear friend? What do you mean, I know best? If I were able to do this by myself, why would I drag you into it, my dear friend?"

Mirza Asadollah said: "I told you right from the start that when Mizanoshshari'eh and the Chief Constable are involved in a matter, there is obviously something fishy going on. Surely Mizanoshshari'eh trusted you, so he sent you to handle this affair. He did not send me. I have only been involved for your sake. Thus far, we have been friends and colleagues. And, we will remain so. But, don't expect me to get involved in such affairs."

His colleague said: "Don't you start lecturing me, now, my dear friend. You and your sermons! Let's see what the hell can be done, my dear friend. Do you think that if we don't do this the world will stop turning? I promise you others would jump at it, head first, my dear friend. So, why should a person get himself in hot water?"

Mirza Asadollah said: "If there is any hot water, it would be worse for me, with my kids and all. However, my uncle, may God keep him, is there. As for that pitiful desk of mine, as you call it, it is not such a big deal, anyway. In any case, you've got fewer complications."

Mirza Abdozzaki said: "Why, my dear friend, who says so. How can you measure complications? Complications are complications, my dear friend. True, I am not tied down with children, but I have other things. Besides, I say, my dear friend, what difference does it make to these villagers whether the owners are Haji's heirs or someone else? And now, since the business is rotten to the core, why should you and I get ourselves into trouble? The people who have something at stake, my dear friend, are these villagers and you see that they have no objection."

Mirza Asadollah said: "Didn't you hear them, how they were cursing us from behind the doors yesterday when we arrived? The people are helpless. Do you think they would let us enter otherwise? You are right in saying that the whole affair is rotten to the core and you and I might not be able to do anything about it. But you and I haven't created this situation. Let those who have done so make it worse. I am not going to

argue about the fact that when the owners of a village are people like Haji's children, the people are better off than when their owner is a person who would collect the landlord's dues from the people by force of government armed guards, at twice the amount. As for the notion that 'the land belongs to he who cultivates it,' that is an old saying. But all this aside, let me tell you that when you are not able to do something for the people, the least you can do is to preserve your own honor. Our duty is to not take part in this miscarriage of justice. But to say that whether we do this or not it will eventually be done is exactly like the work of executioners. The truth is that with this type of government, there is always need for executioners, right? But is it right that with such rationalization everybody should become an executioner? With such rationalizations as 'That person has spilled blood and must ultimately be killed, so what difference would it make if I carry out the verdict or someone else does?' one could satisfy one's greed, but could hardly satisfy one's conscience."

Dearest reader, here the conversation between our two scribes ended. They galloped to catch up with the others and pretended to make a list on paper of the farms, the amount of cultivated land of the property, and the water level of the *qanats*. Meanwhile, they could hear shots being fired by the guards, who returned later with a few rabbits, which they themselves would not eat, and they threw the white carcasses with long floppy ears to the village dogs. They had also shot a dozen or so wild pigeons, which they roasted for their supper. No discussion took place that evening, since a couple of villages that were some distance from the main village still remained to be measured and assessed. So they had to spend the next day taking care of this business. In the meantime, our scribes got to the bottom of the whole affair. They also found occasional opportunities to whisper to Haji's sons when the deputy and his guards were not looking and make them understand that they would have nothing to do with this scheme. There were consultations to figure out how to rid the people of the guards, who had during their visit pretended they were hunting and shot a heavy, fat goat that had fallen behind the herd. Later on, when it became known that the mistake had been purposeful, no one said anything to them. In the meantime, Mirza Asadollah was constantly thinking about the Calenders and about the fresh, vital faith they had awakened in the heart of Haji and his sons. At the same time, Mirza Abdozzaki was mad as hell whenever he was left alone and did not know why he wanted to blame all this on his wife. However, he could not bring himself to talk to Mirza Asadollah about the subject. And he did not know anyone else in the village. The thought even passed through his mind, "The worst thing that could happen is that I would let go of this woman and save my own life." But he kept silent and did not speak a word of what was on his mind to anybody. Early that evening, a secret messenger arrived from the city

who went to see Hasan Aqa right away. He had brought certain news which we shall presently learn.

That evening, after the dinner was over and the supper cloth had been cleared, the Chief Constable's deputy, unaware of what had passed between our scribes and Haji's children, and unaware of the events in the city, began to talk. He said:

"Well, it seems that our work is done. Secondly, we should not be troubling the sons of the late Haji, may God illuminate his grave, by overstaying our welcome."

He then called two of the guards, whispered something to one of them, who left the room, and told the other one to sit by the door of the room. He then continued as follows:

"Yes, as I was saying, we should not impose on our hosts more than we have. Secondly, his honor the Chief Constable is expecting us in the city. We must return as soon as possible. Thirdly, while the gentlemen are writing up the document, I have sent for the village headman and village elders to come and sign it. What do you think?"

He then reached into his pocket and took out a folded piece of paper, which he placed before Mirza Abdozzaki. Mirza, who had turned quite pale, picked up the paper, unfolded and read it. Then he handed it to Mirza Asadollah, who, shaking his head, also read it, and handed it to Haji's eldest son. Hasan Aqa read the paper, rubbed his hands together several times and said:

"Well, yes, of course. It is all in your own hands, gentlemen; who am I to say anything?" He then remained silent. Then Mirza Asadollah began by saying:

"The day that this honorable seyyed sent for me and asked for my help in this affair, it was said that the heirs of the late Haji had decided to make a settlement through the mediation of his honor Mizanoshshari'eh and that in order to preserve their father's good name, they wanted to bequeath one-third of his wealth to religious endowment. But, according to what has been written on this piece of paper, in addition to giving one-third to religious endowment, the rest of the property is to be divided among other people. We did not have such an agreement."

The deputy of the Chief Constable, who had not expected the slightest hint of a "but," said:

"Even if what you say is true, here we have his honor Mizanoshshari'eh's own handwritten instructions. And what you say is inadmissible personal opinion which goes against the text. Secondly, the heirs of the late Haji are alive and present here, and they need no representative to speak for them."

Mirza Asadollah said: "If they had taken my brother to jail as a hostage, I too would have had no choice but to submit to coercion."

Mirza Abdozzaki followed with: "My dear friend, not all of Haji's heirs are present. One of them is in jail, my dear friend. And he has four daughters, too. And their mother is also alive; she gets a share, too. Of all the heirs, only these two are present, my dear friend."

Then he turned to Hasan Aqa and asked: "Tell me, my dear friend, do you have power of attorney from the others? In that case, of course, it would be a different matter, my dear sir."

Hasan Aqa said: "We didn't know what they wanted from us; otherwise, it would have been a simple matter to arrange for power of attorney."

The deputy of the Chief Constable,who listened dumbfounded to all this and who realized the situation was turning sour, interrupted with:

"Mirza, don't you remember what Mizanoshshari'eh told you at the door? Secondly, are you bargaining to get a greater share for yourself? Even if Haji's heirs would consent, I wouldn't allow it. Thirdly, didn't you know before that all of these things were necessary for the settlement to be signed? Why didn't you say anything in the city? Besides, there is no problem. You write up the document, all those present will sign, and we will easily obtain the signatures of those absent when we return to the city."

Steaming with anger, Mirza Abdozzaki said:

"We will neither write such a document, my dear friend, nor will we put our names to one."

The deputy said: "Is that so? How come all of a sudden you are losing your temper, Seyyed? Secondly, you might be pulling my leg or trying to appear more catholic than the pope."

Mirza Abdozzaki said: "Neither, my dear friend."

The deputy of the Chief Constable, who could not yet believe that the situation had changed, turned to Haji's children and said:

"What do you say? Secondly, you might also be in on this conspiracy."

This time, Mirza Asadollah spoke:

"What is all this secondly, secondly? Why do you try to set people up? Do you think these helpless people dare say anything?"

And Mirza Abdozzaki followed it up: "My dear friend, honorable deputy, I said before that these two are not the only ones involved. I promise that if you put a written document before them, they will sign it right away. Of course, Hasan Aqa can write it up better than we can, my dear friend. But, since he is an involved party, what he writes is not admissible. It would cause your honor problems in the future, God forbid. They might say you forced them to sign the document. It is not in your best interests, my dear friend, to use haste in this matter. Wait until power of attorney is obtained from the others or have them all present, my dear friend, then the matter will be concluded. At least we might get a share of all this, my dear friend; but you have nothing to

gain from it. Why do you want to appear more catholic than the pope? Isn't that right, my dear friend?"

The deputy said: "Is that so! Now you are even telling me what to do? Secondly, it looks like you've all conspired together!"

Mirza Asadollah said: "That is the way it is. There is nothing that either of us can do."

The deputy, who was running out of patience, said:

"Look, Mirza Abdozzaki, as for Mirza Asadollah, he is known for what he is. And he doesn't have a clean record. But why are you being duped? Secondly, do you know where you will end up if you follow this fellow's lead?"

At this moment, seven of the elders of the village entered, accompanied by the village headman. They greeted those present, and each took his place in one or another corner of the room. The Chief Constable's deputy, who having heard the footsteps of the guards in the yard felt more confident, turned to the elders and, pretending that nothing had happened, said:

"As you probably know, God has recently bestowed his favor upon the inhabitants of these villages. Soon you will be among the charges of a number of good men, such as the honorable Grand Vizier and the respected personage of the Chief Constable. God willing, a better life awaits you. Secondly, these gentlemen, the scribes, representing the Chief Constable, have come here to write up the document for the transfer of this estate. Thirdly, I thought you who are the local elders should be present to see and witness that no one writes a word or does anything other than what is right."

When the deputy concluded his statement, no one said a word. While everyone in the gathering remained silent, Mirza Asadollah got up, went to the door, picked up the two rocks used as doorstops and returned to his place. Everyone watched as he took off his ring and took out a seal from his pen case, placed them one at a time on one of the rocks, crushed them with the other and threw the broken silver pieces toward the guard sitting by the door. The deputy of the Chief Constable, who realized the situation was turning even sourer, was sorely afraid that the whole village had learned of what was going on and might all attack that very evening and kill him and his seven guards. He was thinking of what he should and should not do, when one of the old men, as if nothing had occurred, said in a deliberate, grandiloquent tone:

"I must say to your honor, the deputy, that we are peasants. We neither own property nor have any claim on anyone. And none of us, unfortunately, is literate, to be able to sign anything. Allow me to say that thus far, the owner of these villages has been the late Haji, may God rest his soul. And from now on, allow me to say, no matter who will be the landlord, we will remain the same obedient subjects. And

may God grant you a long life for having considered us worthy to be present as witnesses to such a meeting."

Again silence reigned, such a silence, as though no one were there. Our scribes had nothing else to add. The old men and elders of the village knew from the previous day what would happen. As for Haji's children, they, of course, could not say anything. There remained only the deputy of the Chief Constable, who had fallen into a real trap. In this tiny village, with seven guards, not all armed, what could he do against three hundred families? So, after some silence, he got up and, pretending to answer the call of nature, left the room. At this time, Mirza Asadollah started:

"In any case, you can bear witness that a man called Mirza Asadollah broke all his seals in your presence and decided that he would no longer make a living by the pen."

As he was finishing his statement, the deputy of the Chief Constable returned. He had gone to check on the guards to make sure that their guns were loaded and to see that those without guns were armed with a bayonet or a bow and arrows. He had also given them new instructions and returned to the gathering with the same pomp and ceremony. All rose out of respect for him and then sat back down. Again, as if nothing had happened, they kept silent. The deputy, whose mind was at ease from all the respect they had paid him, said:

"It seems that some problems have arisen in writing up the document. Secondly, you are tired. You had better go home and sleep, and wait and see what tomorrow brings."

Hearing this, the old men and elders got up, said goodbye and left. The scribes and the Chief Constable's deputy lay down to sleep without saying another word. However, that night until dawn, three guards stood watch in two-hour shifts, one on the roof, one behind the door of the house, and one in the yard. The deputy of the Chief Constable could not sleep at all, and several times he jumped up from sleep at the sound of the footsteps of a cat, the distant howling of a jackal, or the clucking of a chicken in its coop.

Dearest reader, before the first light of dawn, the guards hurriedly tied up our scribes and set them on mules to return to town as soon as possible. Although they could not see very well in the darkness of the final hours of the night, they tried not to make any noise. Each took his horse by the bridle, quietly left the landlord's house and went to the closed village gate. But as they were busy unlocking the wooden latch, with the deputy of the Chief Constable displaying much impatience, suddenly twenty strong men armed with clubs jumped down from atop the walls. Before the guards could reach for their guns, the blows of the clubs had done the job and every one of the guards had fallen in a corner. The villagers first collected the guns and other weapons, then they tied up all eight of the government officials, dragged them to the

first stable on their way, threw them in and locked the door. Two of them stood guard in front of the stable and the rest returned laughing and out of breath to untie the scribes as they sat on the mules. Then they took them with all due respect to the house of the village headman. Now, the whole village was awake and people were going from house to house with tallow burners to spread the news.

Our scribes kept silent all along the way, listened to the villagers bragging to one another, and watched their joyful celebration. They finally arrived at the house of the village headman, where all the elders and old men of neighboring villages had gathered, along with the village mulla and Haji's sons. As soon as they arrived, Mirza Asadollah greeted them and said:

"Hasan Aqa, why didn't you let us know? We might have been able to lend you a hand."

Hasan Aqa said: "No, brother, this wasn't the kind of thing you could handle. Besides, did you let us know that you were coming?"

The village headman continued: "What the gentlemen can do remains to be done. First, sit down and have a bite to eat."

Then they sat the scribes down to breakfast and they all ate together. The mulla of the neighboring village explained that Haji's sons on behalf of all the heirs of the late Haji have agreed with the people of the villages to divide all Haji's property among the local people, to give everyone the land he has been farming, and to keep only the mills and the landlord's house for themselves. After breakfast, Mirza Asadollah drew up the document, which everybody signed. Then they fetched the deputy of the Chief Constable from the stable and made him witness that the deed had been written without any force or harassment. They agreed that the deputy and his guards would remain the guests of the village in that stable for one week, then give up their horses and arms to the field watchmen, who could use them, and, as if nothing had happened, leave for any place they liked with a bundle of bread and a jug of water. As soon as the sun came up, our scribes mounted their mules with Haji's two sons and set out for the city amidst the joyful cheering of all the villagers, who escorted them some distance from the village.

60

EPISODE SIX

Dearest Reader, now hear the other side of the story and of all that was going on in the city. A week after the public audience at the Grand Palace, one morning very early, at dawn, the rumor spread throughout the city that His Royal Majesty, along with all the ministers, his army and retinue, and his harem had fled the city that night and that the Calenders would soon come to power, plunder the city, kill all the people with their swords and store the blood of the children in bottles. Here and there, men who were returning from the bathhouse or the mosque or curious people who had set out at dawn to get the latest news from their relatives, friends or acquaintances recounted all their guesses and suppositions as reliable reports when they met each other on the road, or they would report what they had heard as though they had seen it with their own eyes. Each person would relate to others good or bad, agreeable or disagreeable news reports that were nothing more than the result of their fear of the future or a desire they were nurturing in their hearts. But those who lived near the city gates had seen the royal carriage with their own eyes when, before the cock began to crow, His Majesty had left speedily with his guards and retinue. Furthermore, those who brought fresh fruit and vegetables from the nearby villages to the city market early in the morning had seen the royal entourage galloping behind the mountain outside the city.

Gradually, as the day wore on and the people, one or two here or there, left their houses with much fear, trepidation and caution, they saw that the gates of the government palace were shut and in the whole city you couldn't find even one patrolman or guard. The bazaars were closed, but around the tekkes and gathering places of the Calenders, there was a great deal of commotion. Then, when they realized that there were no killings going on, a larger number of people got up the courage to come out of their houses. A cautious, idle crowd shouting, "*Haydar, Haydar*" and "*Safdar, Safdar*" headed towards the Calenders' tekke. Hour by hour, more people appeared. Suddenly, the shouts of "Allah, Allah" filled the city. The people, led by the Calenders, marched in the streets, and not long before the sun rose, they took over all the guard houses. But no more than a few old decrepit guards were taken by surprise in the guard houses. As for these few guards, they had never bothered anybody, or if they had, no one had remembered to avenge it

now, so they were stripped down to their shirts and released. A group of Calenders camped in each guard house. It was during the course of these events that three of the government secret agents who had participated in the elimination of the seven bazaar merchants were captured. Right or wrong, all three were mutilated, put backwards on henna-dyed donkeys and marched through the streets and the bazaar with bugles and drums.

With the guard houses taken care of, the people, led again by the Calenders, went through the city to loot the weapons shops. They broke down the doors of the shops and stole all the guns, bows and arrows, clubs, and shields they could lay their hands on. Then they went to the city gates. At every one of the seven gates to the city a group of burly Calenders was placed to control and keep tabs on the traffic to and from the city. The sun had just come up when for no apparent reason, there was a fire in the Grocers' Bazaar. The first person to lose everything he owned in the fire was none other than Mashhadi Ramazan, the grocer, who with his clothes and hair singed went to take sanctuary in the Cannon Makers' Tekke. Later, the rumor was spread that government agents had set the bazaar on fire because they wanted to take revenge against the people by starting a famine. The fire in the Grocers' Bazaar was still burning when, on the other side of the city, the government storage houses were plundered and all the rice, oil, wheat and barley were pillaged by the people.

The fear of famine, hunger, and chaos began to anger the people. They all poured out of their houses to look for some news, take part in some event, or find food. Meanwhile, a group of people attacked the government jail-house and freed the prisoners with life sentences from the dungeons. Just before noon, town criers went through the city, and, on behalf of Torab Tarkashduz, called for the people to keep the peace, officially announcing that His Majesty had fled with his entourage and army under the pretext of going to the Winter Quarters and that the city was left to the Calenders. From now on, everyone was free to practice his own religion, no one was permitted to encroach upon the rights of others, and anyone guilty of pilfering, philandering, or looting anyone's house or shop would be decapitated immediately. Friends and adversaries alike were given amnesty, provided that everyone who owned a gun or a brass mortar would bring it to the Cannon Makers' Tekke in return for cash. Otherwise, the Calenders claimed the right from the next morning on to confiscate these two items in any house wherein they found them and to take the owners to jail. At noon, the sound of cannons was heard from all seven city gates and the news of the conquest of the city was thereby taken to all the nearby villages. Later, drums were played for an entire hour from atop all seven gates.

From noon on, the city calmed down. At lunch time, the people sat down to eat. With their chatting after lunch, they began to doze off. The

fire in the Grocers' Bazaar was put out, and the Calenders appeared in the streets from that afternoon on armed with sabers and guns. Here and there tradesmen, whose minds were set at ease by now, opened up their shops. The town criers, promising peace and security, went around the city, each with two saber-carrying Calenders at their sides, to set everyone's mind at ease, even in the most out-of-the-way alleys of the city. Like a sick man on his way to recovery who first perspires then feels drowsy and falls asleep, the city, after a fevered pitch, first perspired and then calmed down, to wake up the next day in good health.

Dearest reader, that afternoon, when even the most cowardly people in the city felt safe enough to get out of the closets in which they had been hiding, a man who had the appearance of a servant, frightened and trembling, arrived at the Cannon Makers' Tekke and was asking everybody where he could find the leader of the Calenders. But in that commotion, nobody paid any attention to him. Finally, one of the Calenders, suspicious of the man's secretive manner and whispering to different people, came forward to find out who the man was and what he wanted. When he learned whom the man wanted to see, he asked:

"If you are not going to soil your breeches first, state your business."

The fellow answered: "Sure, brother, say what you want. But the situation won't always remain the same."

The Calender said: "Don't philosophize. I asked what your business is with Number One."

The fellow said: "I don't have any business with Number One. I want to see your leader."

The Calender said: "Well, he is our leader. Spit it out; tell me what your business is."

The fellow said: "What a foul mouth. I have an important message for him."

The Calender said: "Maybe you have come from His Majesty?"

The fellow said: "No, brother. What would I have to do with His Majesty? I have come from Mizanoshshari'eh and Khanlar Khan."

The Calender said: "Aha, now you're talking. Then you can follow me."

They both entered the tekke. In one corner was a pile of brass mortars and in another corner, a big pile of firewood. The deafening roar of the blacksmith's billows came from behind the wall. A thick smoke rose to the sky from the chimney, and each Calender was busy doing something. Some took the firewood to the cellar, some drew water from the well, and some sorted the mortars according to the quality of brass. The Calender guide ahead and the messenger behind climbed the stairs and went into one of the upstairs chambers, which was covered with a straw mat with three sheepskins spread around it. Three old Calenders of

63

the same age were sitting on them. There was a map before them and they were talking. The messenger said hello, took a bow and stood at the door with his arms folded over his chest. But the Calender guide said, "Allah, Allah," and went to one of the three people, who was Torab Tarkashduz. He leaned over, kissed his shoulder, and whispered something in his ear. Torab Tarkashduz turned around and said: "Is that so! I didn't think these fellows could be so courageous. How come they did not accompany His Majesty to the Winter Quarters? Tell me, what do they have to say?"

The messenger said: "Sir, they said if you grant them amnesty, they will come to pay their respects, sir.".

Torab said: "Is that so! The town criers have been shouting amnesty since noon."

The messenger said: "No, sir. They are asking for a written amnesty, sir."

Torab said: "That will depend on what they are able to do. What do they want to come here to tell us?"

The messenger said: "What can I say, sir? I guess it concerns the Palace, sir."

Torab Tarkashduz became thoughtful for a moment. Then he turned to one of the two Calenders in the room and said:

"What do you say, Mowlana? It is strange that Khanlar Khan has also stayed behind."

Mowlana said: "I don't think there will be any problems. We can give them a conditional amnesty. In the absence of the government, Khanlar Khan has probably stayed to render some service deserving of his future position as poet laureate."

Torab Tarkashduz turned to the next man and asked:

"What do you think, Seyyed?"

The seyyed said: "In my opinion, we should give amnesty to Mizanoshshari'eh, provided he follows the Congregational Imam we appoint, stops this game of excommunication, hands over the religious endowments of the seminaries and city hospitals, and stays at home as a respected person. As for Khanlar Khan, he is a poet and requires no conditions. We will ask him for five thousand gold coins."

Torab Tarkashduz said: "Well said! Get a piece of paper and write it up."

They wrote up the letters of amnesty and handed them to the Calender guide, who left with the messenger. The Calenders resumed their conversation. Mowlana said:

"I believe they will bring along the conditions for surrendering the Palace."

The seyyed said: "There is no need for conditions for surrender. One more push and the matter will be over. Two cannonball shots at the Palace Gate and that is it."

Torab Tarkashduz said: "Is that so! Do you think the Government Palace is like the jail-house and can be broken into so easily? Dear Seyyed, every government, even if it is a Utopian government, requires concealment to protect its secrets in order to instill awe and fear in the hearts of the people. We should wait until night falls and then take over the Palace quietly, not with cannons and guns. In any case, it would be better to wait until these fellows show up."

The seyyed said: "Suppose by the time these gentlemen show up, the remaining government troops come out of the Palace and undo all that we have accomplished. We don't know what is going on in the palace, do we?"

Torab Tarkashduz said: "At the present time, there remains one part of the harem in the Palace, which can only cause trouble and future provocations. Other than that, there are two or three warehouses of gunpowder and food, which we need badly. As you know, we are still incapable of making gunpowder. All that the Government Palace means to us is gunpowder and food supplies."

Mowlana said: "I didn't know this."

Torab said: "Is that so! You knew that the Court Executioner was one of the Followers of Truth. All the details of the last public audience that I told you were reported by him. Since that meeting, there have been things going on that he also reported to us. With all their trickery and the hasty escape to the Winter Quarters, they were supposedly setting a trap for us. They have set the trap and are sitting in hiding, waiting for the birds to come out of their nests to get seeds, so they can jump and spring the trap."

The seyyed said: "In this case, should we have come out in the open at all? How can one stop the people now?"

Mowlana said: "You mean we should have just sat by idly and watched?"

Torab Tarkashduz said: "Do you realize what would have happened if we had not taken the initiative? If we had just sat by watching, the people would have taken the initiative. When you open the door to a cage, the bird must fly away, or that would be it for the bird. They had planned it so that if we were to do nothing, Mizanoshshari'eh, with the money from the religious endowments and with the help of the secret agents who had stayed behind, would incite the people to rebel against us and finish us off once and for all. In a sense, they were playing a game.

The seyyed said: "Well, well, what else?"

Torab said: "The rest is that meanwhile, the government army would make it to the border, sign a peace treaty with the neighboring government, and exchange something or other for cannons and gunners with which to crush us."

Here, the door opened and in came Hasan Aqa, Haji Mamreza's eldest son, who had just arrived with the dust of the road on his face. He greeted them with "Allah, Allah," came forward, kissed the shoulder of Torab Tarkashduz, and sat down. Torab offered condolences for the death of his father and asked what had happened. Hasan Aqa briefly reported all that had passed in the village, the support given him by the two scribes, the news of the city which had reached the village in time, the capture and tying up of the deputy of the Chief Constable and the guards, and the distribution of land. He then stood up saying:

"With your permission, I shall take my leave."

Torab sat him down next to him and said: "Why hurry? Wait. We have some business with you." And then he continued what he had been saying earlier.

"Yes, the government has set a trap for us in this way. Now we must transform the trap into a refuge. In the meeting at the Grand Palace, there had been talk of an inauspicious three days of lunar quadrature and sacrificing us. But it will take at least one month for the government army to reach the border, the ceremonies for offering gifts to take place, and the negotiations with the neighboring country to begin. If we are able during this period to cast one cannon a day and collect as many guns as possible, we will have won the game. At the same time, if we could spread the rebellion to the provinces and keep the villages along the road, which the government army will take back, empty of food supplies, then the government will not be able to challenge us, even if it returns with a thousand fortress-crushing cannons."

Then he turned to Hasan Aqa and asked him about the details of the lives of our scribes. Hasan Aqa explained what he knew. Then Torab Tarkashduz said:

"Is that so! Then we can be hopeful that they will give us a hand. I'll leave this to you. Furthermore, I have left you the task of taking care of the bread and meat for the city. You should pick up where the late Haji left off. I have given instructions to furnish you with two hundred armed devotees. Take care of the people's provisions any way you see fit. Give orders to stop the tolls at the city gates and to lower prices. Buy as much food as you can from the villages along the army's route. Pay two or three times the regular price. We should at least have a three-month food supply for the city in storage. Now, go and seek your two friends, the scribes."

Hasan Aqa took his leave and the three Calenders continued their discussion. The seyyed said:

"Have you thought of doing something to stop this peace agreement?"

Torab Tarkashduz said: "I am waiting for a signal from the Court Executioner, who has accompanied the army. When necessary, we can

send a group from the harem to follow the army or welcome it with pomp and ceremony. Tomorrow, we will dispatch Seyyed with seven envoys to the border. We are also capable of making a deal with the neighboring government. Let us first take care of the Palace. Seyyed, you must convince them that even though they have been led to believe that the cannons and gunners will be used to crush us, they will, in fact, be used against the neighboring government."

Dearest reader, the discussion was interrupted at this time by the panting of Khanlar Khan, the court favorite, and the sound of Mizanoshshari'eh's cane on the steps. The door of the chamber opened and Mizanoshshari'eh entered followed by Khanlar Khan. Then entered the Calender guide, who placed a bag of money with the written pledge rolled up in a scroll in front of Torab Tarkashduz and left the room. As a sign of respect, the Calenders stood up to welcome the guests, greeted them with a nod and offered the two the most prominent place in the room, on the sheepskins. Mizanoshshari'eh, who had a long face and was fingering his prayer beads from the moment of his entrance, kept murmuring and playing with his prayer beads instead of greeting or responding to anyone or going through the usual pleasantries. When everyone was seated and the room was quiet, Torab Tarkashduz asked Khanlar Khan:

"What is his reverence murmuring?"

Mowlana said: "He is probably reciting the 'And lo! Those who disbelieve' verse."

The seyyed said: "No, it must be, 'This is the hell which was promised you.'"

At this joke, everyone laughed, the mood of hostility left the room and everyone sat back more relaxed. Torab Tarkashduz began:

"Very happy to see you, gentlemen. I hope the Followers of Truth have not caused you gentlemen any trouble."

Khanlar Khan said: "I do not believe that it is in the interests of the Followers of Truth to cause such troubles." And he proceeded to recite an appropriate verse. Torab Tarkashduz continued:

"With this letter of amnesty in your possession, gentlemen, even if you were to bother the Followers of Truth, amnesty would be extended to you. But you gentlemen know very well that once the people get excited about something, it is very difficult to stop them. The presence of you gentlemen safe and sound among us is in the interests of both the government, which for some reason has not taken you along, and ourselves, to prove that we are not bloodthirsty barbarians. And since you gentlemen have stayed behind, you will have to cooperate with us."

Then the seyyed asked: "Now, tell us what made you gentlemen honor us with your visit?"

Khanlar Khan was so heavy that he could hardly move. He struggled to free his right foot from underneath him, replaced it with his left and said:

"In the absence of His Majesty, and in accordance with a royal decree, his holiness the Congregational Imam and this humble servant are charged with the responsibility of the affairs of the Royal Palace and the Royal Harem. However, since during these distressing times, these two lowly individuals before you are incapable of such a grave responsibility, we have come to seek assistance." Once again, he extemporaneously recited an appropriate verse, took the scroll on which the decree was written from the sleeve of his gown, unrolled it and placed it in front of Torab Tarkashduz.

Mowlana said: "You know better than we do that thus far, no one has raised a hand against the palace. But, really, why did you gentlemen not accompany the entourage?"

Mizanoshshari'eh, who had thus far remained silent, fingering his prayer beads, turned red in the face and said: .

"There is no god but God. In any event, this humble propagator of the faith at least knows what his duty is. This humble propagator of the faith has been instructing the people in religious affairs all his life. In any event, for sixty years, the inhabitants of this city have paid the living expenses of this humble propagator of the faith. In these distressing times, where do you expect this humble propagator of the faith to go?"

Angrily, he recited another "There is no god but God," and then remained silent. At this time, Khanlar Khan produced a cough and began:

"And besides, the doors of the Palace cannot be kept locked until Judgment Day. The ladies and wives of His Majesty have eyes and ears. God knows how many of them may have died of fright already."

Mowlana said: "Then, are we not actually dealing with two deposed rulers of the city--a religious ruler and a civic ruler?"

The seyyed said: "In fact, why did the ladies of the harem not accompany the entourage?"

Torab said: "I suppose the Calenders' practice in this matter has been agreeable to His Majesty, is that not so?"

Mizanoshshari'eh said: "God knows. Who knew what would happen? In any event, here is the key to the Palace. From this point on, this humble propagator of the faith relinquishes all his religious and civil responsibilities."

With this, he took out a large engraved silver key from inside his gown and placed it in front of Torab Tarkashduz. The seyyed said:

"Now, what do you say we should do with this harem? Do you think we have extra food to spare?"

68

Khanlar Khan spoke this time: "Do you think a palace this large was built just to house a harem? If the gentlemen pledge to take care of the Royal Harem in exchange for taking over the Palace, our duty is done."

Mowlana said: "How about asking Khanlar Khan to content himself with the position of eunuch to the harem instead of his position as poet laureate for the time being?"

Torab Tarkashduz said: "Not a bad idea. How about it, your honor? We will open the Palace Gate tonight in your presence, and in order to put your minds at ease, we will ask Khanlar Khan to move into the harem with his family and take the ladies under his wing. Then, we will have the news of your amnesty announced throughout the city by the town criers and will inform everybody of Khanlar Khan's new position. We also expect your reverence, the Congregational Imam, to follow the new Congregational Imam in this evening's prayers in order to set the people's minds at ease. Also, instruct the muezzins to continue as before. People's beliefs cannot be changed overnight by force." With this, the meeting ended.

The Calenders moved their business to the Palace that night and left the tekkes for the management of public affairs. One of them was set up as a religious and judiciary court. The second one became a center for provisions. The third was set up as the state accounting office. The fourth became a place for collecting and melting the mortars, and so forth. From the next day on, the city was calm and quiet. The people went about their daily trade. The price of bread and meat was lowered one *shahi* per *man*. Taxes, tithes and other governmental taxations were abolished. And the Calenders, with books and notebooks under their arms, set out to record the names and property of those who had lost their businesses and shops in the fire, or had been pillaged in the course of the previous day's events. The carts of the Calenders standing at every street corner and crossroad were full of stone mortars. The Calenders knocked at the doors of houses and collected the brass mortars in exchange for stone ones. Furthermore, they had mounted seven of the Calender-made cannons on heavy carts, each of which were pulled through the city constantly by two agile mules with clipped ears and tails. The people, who had never seen cannons, pushed and shoved each other to take a look at them. On the top of each cannon stood a tall town crier with a good voice encouraging the people to exchange their mortars and reciting a verse once in a while about the cannon he was riding: how the ball would travel faster than a meteor, how its powerful blow would put fear in the hearts of the unbelievers.

On the other hand, I should tell you, most of the people in the city did not know what was going on. But so far as they understood that His Majesty had retrieved his sovereign protection and left town, that the price of their bread and meat had decreased, that they no longer had to

69

face the government guards at every moment, and, most importantly, when they saw that the Calenders were not murdering or pressuring them, or ripping them off, they were quite content, even happy, and they eagerly ran to watch the Calender-made cannons. They breathed easier, as if a load had been taken off their backs. They felt freer to joke around and took their time, even more than before, to haggle in their transactions. But despite all this, they had one small concern: Why should they have to exchange their brass mortars, which had been abandoned in some corner of their kitchens, for the bulky Calender-made stone mortars? They had inherited their mortars from their fathers and they in turn from their fathers and so on. Now that the mortars were gone, they realized what memories they evoked and how strongly they had grown attached to the sound of their clanging. So, on the second day of the Calenders' takeover, a rumor gradually spread through the city that a bad omen comes to a house from which a brass mortar has been taken, since every mortar takes with it the blessing of the house. It even went so far that some people refused to exchange their mortars and did not let the Calenders into their homes. Despite the fact that the Calenders were instructed to use moderation in their treatment of the people, at times, they had to break down the doors of houses and use force to enter and confiscate the brass mortars, which caused a great commotion. Such commotions occurred again and again until, just before noon that very day, three persons from the Shagreen Cobblers neighborhood set out to go and see Mirza Asadollah, who was still sitting, as usual, at his desk by the door of the Grand Mosque, with a brazier of burning charcoal at his side, copying an anthology of poetry. The trio consisted of one woman and two middle-aged men with salt and pepper beards. All three greeted Mirza and sat next to him. One of the men began as follows:

"Mirza, we would like to find out who we're supposed to send a written complaint to."

Mirza shut the anthology of poetry and set it aside, put the lids on his inkpots of different colors, which he had arranged around the fire in the brazier, and said: .

"To tell you the truth, I don't exactly know. So far, we have had the Civil Magistrate, the Chief Constable, and the jailhouse. How foolish of me to have thought the business of writing petitions was over. I suppose one should now write to Number One."

The woman who had come to complain, a clump of black hair sticking out of her scarf on her forehead, pooh-poohed and said: .

"My, my, what a name! You'd think human beings were a book of calculus. Was there a shortage of names?"

The men laughed, and Mirza Asadollah asked: "Now, what is the nature of the complaint?"

Again the woman spoke: "Nothing. These bastards came this morning and confiscated my mortar, my precious brass mortar. It was like a jewel. If my husband were alive, he would teach them who they were dealing with. He would break the shins of whoever forced his way into my house. But, alas, I am nothing but a defenseless, veiled woman. I couldn't stand up to three roughneck Calenders." And then she stopped.

Mirza asked: "Well, have they paid you for it or not?"

The woman said: "They can drop dead with what they pay for it! This precious mortar was the only memento from my mother. My grandmother with her own hands had put it on one of the trays which carried my mother's dowry. And my mother did the same for me. You just wouldn't believe what it was like. I want you to write to them and ask them: Don't people own what belongs to them? Bastards! They can't get to the mule, so they beat up the saddle. I want you to write a petition to really knock them dead."

Then the second man, who had so far remained silent, began:

"You know, Mirza. All three of us have the same complaint, that is, about the mortars. It might seem trivial, but injustice always starts with small things. My mortar was not an heirloom from my father and I was not particularly attached to it. It wasn't that valuable either. But you know, Mirza, to tell you the truth, I don't like them putting gunpowder in something that my wife used to pound meat in. I just don't like it. That's right, Mirza, you see, after all, this hot cannon ball they say is shot out of the cannon can't be eaten, right? They say it kills people, right? You know, Mirza, I have never hurt anybody. It is true that His Majesty and his government were responsible for a lot of injustice. It is also true that the Calenders are giving lots of promises. But what do I have to do with this quarrel? You know, Mirza, this business of the mortars is not a good sign. It is the beginning of injustice, and that from the corner of your kitchen."

After hearing all this, Mirza Asadollah said:

"What if I just write one petition for all three of you?"

The man who had begun the discussion said:

"No, Mirza, I agree that the three of us have the same complaint. But the mortar in my house was given as a religious endowment. You could pound a whole calf in it. There was an engraving around it as wide as the palm of your hand. It had a date on it. It was four hundred years old. It took three of them to move it, and with great difficulty. It was sunken half a meter into the ground in the corner of the yard. Nothing is sacred to these people. Now, you tell me, would it please God for them to take something which is part of a religious endowment without even paying for it?"

71

Mirza smiled and said: "You might think I am sticking my nose where it doesn't belong, but I have to know exactly what to write. Tell me, what was religious endowment property doing in your house?"

The man answered: "Well, the problem was that it was endowed to the male offspring. Otherwise, we would have melted it down a hundred times over by now. Our great grandfather had endowed it to a *hosayniyyeh*. We had cooked for charity with this mortar for five generations. Then, not only did the fathers die, but the *hosayniyyeh* was demolished and the land became part of the Royal Palace. I don't know whether you remember it or not, but, ten years ago they enlarged the palace stables. At that time, our family *hosayniyyeh* was demolished, and not a penny was paid for it. All that was left of that elaborate center was this mortar. Like a door to a mosque, we couldn't do anything with it. We put it in the corner of the yard and once a year we used it on the Night of Holy Prisoners. We would pound a great deal of meat in it all at once and make enough meatballs with rice to serve to the people. Now they have taken it away. You could make two cannons with this one mortar. Then they ask us: How much? I say: You can't put a price on something which is religious property. So they left three stone mortars, each one no bigger than the palm of your hand, and went away."

When the complaints of the petitioners finished, Mirza Asadollah said:

"Given all that you have said, we can still write one petition. And it would be better to do so. When a petition is collective, it can reach even a deaf ear. And then this endowed mortar might safeguard the other mortars."

Then he began to write the petition. He had not yet finished the first line when the woman petitioner said:

"By the way, Mirza, don't forget, my precious mortar had a fluted edge."

Mirza finished writing the petition and was reading it for the petitioners when Hasan Aqa, the son of Haji Mamreza, arrived with two Calenders carrying rifles. After greetings, the Calenders went into the mosque and Hasan Aqa sat down.

Mirza said: "You've come at just the right time, Hasan Aqa. Listen to this. You might want to write a couple of words of recommendation at the bottom of this petition to help these God-fearing folks." He read the petition from top to bottom. The woman petitioner listened and kept saying, "That's the way to do it. What penmanship!" The two men kept stroking their beards and nodding, while Hasan Aqa was deep in thought. When the reading of the petition was finished, Mirza handed it to Hasan Aqa, who wrote at the bottom, as was customary with the Calenders, "I seek help from myself and as for the request: To forfeit the First Family for three mortars! 'Hasten to do the best of deeds.' Hasan."

He handed it to one of the male petitioners, then called one of the Calenders from the courtyard of the mosque and instructed him to accompany the petitioners to find which group of Calenders had confiscated the mortars, find the mortars, return them to the houses of their owners, get receipts for them, and bring them to Mirza. Then, the petitioners got up to leave. While the woman was searching for money wrapped in the corner of her veil, one of the men placed the money for writing the petition on Mirza's desk. They all said goodbye and left with the rifle-bearing Calenders.

Dearest reader, when Mirza Asadollah and Hasan Aqa were left alone together, they asked after each other's health once more and Hasan Aqa said:

"Have you rested from the trip?"

Mirza Asadollah said: "The trip didn't tire me. But my left arm is bothering me. I guess the guards had tied it too tightly."

Hasan Aqa said: "What would you have done if they had taken you all the way to the city in that condition? Now, get up, let's pay a short visit to your colleague. I have some business with both of you. It is too cold here. Besides, we can't talk in front of people."

They both got up. Mirza Asadollah covered his desk with the sheepskin and asked the grocer across the street to keep an eye on things. He also told him where he was going. Then, he set out with Hasan Aqa through the mosque. It was nearly noon, but there was not the usual crowd of people around the pool. The washroom attendant, who was sitting idly where he usually sat, lowered his head not to catch Mirza's eyes.

Mirza Abdozzaki was alone in the corner of his chamber, crouched over a brazier of burning charcoal. They greeted him, sat down, asked how he was, and reminisced about the events in the village. Mirza Abdozzaki complained about slow business and then, as if it had suddenly occurred to him, he turned to Mirza Asadollah and asked:

"My dear friend, why didn't you make me think of this sooner, huh?"

Mirza Asadollah asked: "Think of what, Seyyed?"

Mirza Abdozzaki said: "My dear friend, the border of the carpet is finished." And turning to Hasan Aqa, he added: "My dear friend, this Mirza knows a lot. He has my spouse so preoccupied that she hardly has time to scratch her head, my dear friend."

Then he explained the story to Hasan Aqa and all three laughed. Hasan Aqa said:

"Let me say without further ado that we need both of you. Torab, the Reflection of Truth, has extended an official invitation to you. Yesterday afternoon, in his blessed words, he said, "Then, we can hope to count on their help.""

Mirza Asadollah remained silent and Mirza Abdolzaki, delighted by the proposition, asked:

"My dear friend, how can we be of service?"

Hasan Aqa said: "Recording and documenting all these weapons and all this food will require an army of clerks. The ministerial clerks have either left with the troops or each one has found a hole to hide in. I thought to myself, this is a job for Mirza Abdozzaki, to come and organize the books, with the help of some people. And then, there is the Judicial Ministry, which we cannot manage ourselves. It is a job for someone who is trusted by the people. I thought perhaps Mirza Asadollah would accept it."

Mirza Abdozzaki moved the ashes in the brazier, changed his position and said:

"I have no objection, my dear friend. But let's see what Mirza Asadollah says."

Mirza Asadollah said: "This kind of work is over my head. I was born to be a scribe at the entrance of the mosque."

Hasan Aqa said: "This is no time for humility and refusing to be involved."

Mirza Abdozzaki followed: "My dear friend, why are you being so humble? This job was made for you. Who could be more competent than you are, my dear friend?"

Mirza Asadollah said: "I am neither being humble nor trying to find excuses. But you both know that I am not the kind of man to do anything he gets his hands on. For me, any action is based on faith and principles. First beliefs, then action. You probably know about what is called 'sincere intent.' Maybe others do only their religious ceremonies with sincere intent, but I must have sincere intent in everything. I don't even know what you have in mind. Of course, I won't call you infidels, but I don't have faith in you either. Under such circumstances, what is it that I can do?"

Hasan Aqa said: "How is it that you don't know what we have in mind? We have pulled the rug out from under the government."

Mirza Abdozzaki said: "You haven't done it, my dear friend. His Majesty left for the Winter Residence, and you found the opportunity and jumped in. But, of course, we don't begrudge your accomplishments, my dear friend."

Mirza Asadollah said: "Even the people say that the government has set a trap for you."

Mirza Abdozzaki said: "My dear friend, maybe you are afraid, huh?"

Mirza Asadollah said: "Seyyed, I am quite content with what I am, and I don't need to rack my brain to think up a new scheme every day."

Mirza Abdozzaki said: "My dear friend, no need for sarcasm and innuendo. It is true that I am adventurous, but about the kind of

74

adventure which took place in the village, I think you have more of an itch than I do."

Hasan Aqa said: "Look, Mirza Asadollah, it is true that the government has set a trap for us, but we will change this trap into a refuge for all those people who fight tyranny. When you gather together all the oppressed people, you can easily destroy oppression at the root. Tell me, you are not upset about this business of the mortars, are you? The times when the sound of mortars was sacred have passed. Now the destiny of the world of sanctity is tied to the sounds of cannons. Besides, you know that our cause is right. We are tired of this slaughter of Shi'is and Sunnis. We have set out to serve the people."

Mirza Asadollah said: "The government, too, used to make such grand claims."

Hasan Aqa said: "But you know that we do not just talk. My father's shroud has not yet dried. We are playing with our lives. We have pledged our very heads. We are convinced that we will win."

Mirza Abdozzaki said: "My dear friend, today Khanlar Khan, the court favorite, sent a message to me to return the draft copy of all his poems to him. Apparently, my dear friend, there is something bad in the air."

Mirza Asadollah said: "This is exactly why I am hesitant. Suppose you liberate one city or even two more, you know the main wheel is still turning. The government is alive and well, with all its servants, functionaries and arsenals. And you still think that you have cut off the water that turns the mill wheel. With this feudal system we have before us, first the main wheel under the water must be stopped."

Hasan Aqa said: "Then, you have no quarrel in principle. You are arguing about whether we are going to succeed. Naturally, you are right to be apprehensive."

Mirza Asadollah said: "Well, when you invite me to do a job and I know nothing about the conditions, do you expect me not to look ahead? Suppose I am a coward. But what is the purpose of doing something if it is doubtful that it will succeed in anything but bloodshed once again? All of this aside, I said that I do not share your fundamental faith, and you know better than I that only on the path of faith can people walk with their eyes closed."

Mirza Abdozzaki said: "My dear friend, why think so far ahead? How many years have we left to live anyway? My dear friend, when I think about spending the rest of my life in this chamber with these customers and all this junk which smells like a mortuary, I get sick to my stomach. We need some action, my dear friend, some change, some variety..."

The rest of what Mirza Abdozzaki was saying was drowned in the shouts of five or six men and women, who were carrying a bloated man

and wanted to get into Mirza Abdozzaki's chamber all at once. A woman was repeating:

"Oh, dear sir, save me, help me. I am losing my husband. Oh, dear sir, save me..."

A man was saying: "I told you when you go to sleep at night you should recite the 'Shajan, Shajan' prayer."

Another said: "Take it easy, man. You are breaking his leg."

Mirza Abdozzaki, who saw that they were about to break down the door, got up and went forward. He asked:

"What is it, my dear friend? What is going on? Do you think he has been wounded by a sword or something?"

One of the women said: "A snake, dear sir, a snake! Where the bite is has opened up larger than a sword wound."

Mirza Abdozzaki asked: "My dear friend, shouldn't you have come sooner?"

The same woman said: "Oh, sir, I beg you. We have come all the way from the other side of the city. All the prayer scribes have closed up their shops and become Calenders."

Mirza Abdozzaki said: "Well, my dear friend, you have ruined my work. I had labored and had just summoned the ghost of the father of these folks. Now, where can I find him again, my dear friend?"

One of the men said: "Hey, my brother is dying and you're worried about the ghost of somebody's father? Give us some medicine, a prayer, a charm, or something! What have you set up this business for, anyway?"

Mirza Asadollah got up, handed them a piece of paper on which he had scrawled something and said:

"Don't be angry, brother. This gentleman doesn't have his faculties together. The presence of the ghost has confused him. Take this note and your sick man to the local physician. His office is nearby. He is my uncle."

He walked outside the chamber, gave them the address of his uncle's office, sent them on their way, and returned. Once they were alone again, Hasan Aqa shifted his feet and said:

"Mirza, I understand well that you are a man of principles. But what were these principles devised for anyway? They were devised for human beings, right? The basis of your work is faith and principles. Fine. But the kind of faith which allows the slaughter of human beings is not right. It is wrong. Now, do you understand what we have in mind? Protection of people's lives even at the cost of losing faith and principles. You know better than I do that this has been the foundation of every faith since the beginning. However, when times change, faith and principles turn around and change, too."

Mirza Asadollah said: "If principles are true, they should not change with the times. A principle is always constant. Of course, I do not

support the slaughter you are fighting against, but I know how to preserve the principles with my same old beliefs."

Mirza Abdozzaki querried: "I don't understand, my dear friend. Then what is your quarrel about?"

Mirza Asadollah said: "About the fact that every new religion or ideology renews the old worn out quarrels between the Haydaris and Ne'matis and becomes a new excuse for excommunication, and then bloodshed and settling old accounts with the people. This is a violation of the principles we both believe in. The times when religions were the main factor in bringing about change have passed."

Hasan Aqa said: "Then are you suggesting that in the face of such injustices we should just sit idly by and watch?"

Mirza Asadollah said: "I don't know what should be done. I am neither the leader of the nation, nor do I claim to be the imam of the people, nor have I introduced a new religion. But I know that I, for one, am unable to do anything about it, and your efforts are not going to get anywhere. You are preparing the grounds for new bloodshed."

Hasan Aqa said: "As long as you think you are unable to do anything, of course our efforts are not going to get anywhere."

Mirza Abdozzaki said: "After all, my dear friend, you and I are not alone. Have you forgotten what an example our small resistance became in the village?"

Mirza Asadollah said: "I know. I also know that if one were to choose between these folks and the government, I would choose these folks, not for their new religion, but for their bravery. However, the business of a country is not the same as that of a village. So we succeeded in a village, how do we know that we will succeed in a country?"

Hasan Aqa said: "This depends on the help that you and the likes of you can provide. If the help of the two of you was sufficient in the village, in a city, we need two hundred or two thousand like you. In fact, let me give you the bottom line. For me--but who am I to say -- for us, it is not important whether we win or not, because in the end, Truth will prevail. From Zoroaster to today, all the prophets and guardians have lived with this hope and have died with this hope. You probably know about the millenniums. At the beginning of every millennium, the truth appears once again. And this continues until the appearance of the new guardian. What is important to us is to keep the core of resistance alive, the core of human nobility--in me, in you, in the man who was bitten by the snake, in Mirza Abdolzaki's wife. You know, Mirza, only the bazaar merchants should think of the end and the profit to be made. You and I are not bazaar people."

Mirza Abdozzaki said: "My dear friend, I cannot get into a philosophical discussion like you two. But I only know that His Majesty has not run away with his servants and his entourage for

77

nothing, my dear friend. Something must have happened. There is some sort of fear, my dear friend, that has made Khanlar Khan send for the draft of his poems lest it fall into someone's hands. Our parents never witnessed such incidents, my dear friend. Every five or six generations, something like this may happen. My dear friend, to tell you the truth, nowadays, I think of myself as rather important, especially my eyes, which have witnessed the flight of a court with all its pomp and glory. My dear friend, who among our fathers ever witnessed such events?"

Mirza Asadollah said: "Don't get sentimental, Seyyed. Supposing that these folks win and take over the government. Still, in my opinion, nothing serious will have taken place. One rival will have gone and another replaced it. You know, I am against any government in principle, because it is necessary for every government to exercise force, which is followed by cruelty, then confiscations, executioners, jails and exiles. For two thousand years, mankind has been daydreaming about the government of the learned, oblivious to the fact that a philosopher cannot govern. That is nothing, he is not even able to pass simple judgments or give rulings. Government has, from the beginning, been the business of the brainless. It has been the business of the riffraff, who would gather around the standard of an adventurer to beat their chests and fill their stomachs. It has been work for people who are able to leave conscience and imagination to books of poetry and, on the basis of their animal instincts, rule, kill in retribution--an eye for an eye--avenge, punish, shed blood, and govern. However, the main affairs of the world go on in the absence of governments. In the presence of governments, the affairs of the world are postponed. Any human problem which is not resolved by arbitration and personal understanding and in which a government gets involved will provide the grounds for the enmity of future generations."

Mirza Abdozzaki said: "My dear friend, do you know you are using the logic of failures, the logic of those who have never had a chance in government?"

Mirza Asadollah said: "Then, do you want me to use the logic of those who have had a chance in government? History is full of their logic. The first chapter is on slaughter, the second on slaughter, and the last, as well, on slaughter. We have seen what a mess they have made of the world of humanity through their gilded pages! I do not accept this logic."

Mirza Abdozzaki said: "Obviously, my dear friend. That is why your statements are stale. In fact, my dear friend, your statements smell of helplessness and failure."

Mirza Asadollah said: "Better than the smell of worldliness and of blood. In fact, what you call helplessness, I call honor."

Mirza Abdozzaki said: "The same type of honor that wretched old women possess? Well, of course, my dear friend, when you don't get

involved, the least result is that you remain honorable, just like an old woman."

Mirza Asadollah said: "No, Seyyed, honor and helplessness belong to two different categories. A helpless person has no ability to act. An honorable person, on the other hand, is a person who has the ability to act, but restrains himself."

Hasan Aqa said: "Well, what does this have to do with what we are talking about?"

Mirza Asadollah said: "It is related in this way: This seyyed thinks a person like me is incompetent to take part in government and that one must be the Galen of his age or have the ability to move mountains to be competent for government. And that is precisely where he is mistaken. Seyyed, in order to float on water, you must merely be light. A pearl always remains at the bottom, unless you send a pearl diver after it. To take part in the government, it would be sufficient to be a bit smart and understand which way the wind is blowing. And you must know when to shut your eyes--in the beginning, of course, because later on, it becomes a habit and even the open eye of your conscience will see nothing. But it takes a man to turn his back on this banquet of spoils."

Hasan Aqa said: "After all, even Aristotle took part in Alexander's conquests. Nezamolmolk was a vizier. Biruni followed Mahmud to India. And the caliph of Baghdad was wrapped in felt and squeezed to death in accordance with the instructions of Khajeh Nasir. What do you have to say about all of them? And there are thousands of others that you know about better than I do."

Mirza Asadollah said: "Every one of these learned men whom you mentioned, despite all their knowledge, were people like other people. They weren't infallible. They all committed one sin and paid for it. Aristotle left his book on logic to his student successors to ask forgiveness for his sins eloquently and efficaciously. Biruni washed his hands of the blood of all the Hindus that Mahmud killed with *Mal al-Hend*, his book on India. Khajeh Nasir really tried hard to absolve himself in his book on ethics. And as for Nezamolmolk, he was a man like Khanlar Khan right here in this city, who has sent after his poems because he has realized that the situation is sticky. I promise you, if the situation returns to what it was and history is written by those who have written it thus far, in two hundred years, these compositions of Khanlar Khan's will be a well-known volume of poetry, perhaps even written in gold. To me, all of these people you have enumerated were parasites of power. They are like ticks stuck under the tail of the unruly mule of power, power which is based on tyranny and not on justice. The power of truth and justice is found in the words of martyrs. That is why I look at history through the eyes of martyrs, through the eyes of Christ, Ali, Hallaj and Sohravardi, not the gilded writings of

79

philosophers-turned-rulers, who call a man like Anushirvan just, despite all the molten lead he poured down the throats of the Mazdakites."

Hasan Aqa said: "Then, are you looking for an infallible person?"

Mirza Asadollah said: "What else? Everybody looks for things one does not have."

Hasan Aqa said: "After all, those who await the Imam of the Age say the same thing."

Mirza Asadollah said: "You know, Hasan Aqa, infallibility is relative. To attain it or to choose it, at every moment you have to make a choice, a choice between truth and falsehood. You don't have to wait for it for many years. But he who awaits the coming of the Imam of the Age would at least consider these types of government 'oppressive,' that is, he would not accept them."

Hasan Aqa said: "But as you see, this type of government exists and is alive and well. And to quote you, all of them rely on the power of oppression."

Mirza Asadollah said: "That is why I look at the world through the eyes of martyrs."

Hasan Aqa said: "And that is why anyone who awaits the Imam of the Age sits idly by with his arms folded without doing anything against oppression. People like this are content with your type of logic, with honor, with purity, awaiting the Infallible Imam. You see that the talisman of this vicious circle must ultimately be broken somehow. Besides, weren't you saying that the times have passed when religions are the main factors in change? And don't you think that outside religion, martyrdom becomes meaningless?"

Mirza Asadollah said: "No, it doesn't. In fact, I don't agree that martyrdom belongs exclusively to the domain of religion."

Mirza Abdozzaki said: "You people, my dear friend, are talking over my head. In fact, Mirza, I don't believe in what the Calenders say either, my dear friend. But when the knife digs down to your bones, when the world is falling apart, and when happiness is nowhere in sight, well, my dear friend, everybody has the right to say to himself that happiness might be found on this new path, and perhaps we just didn't understand it before. So, let us go and give them a hand. Life might become more comfortable."

Mirza Asadollah said: "Life is always comfortable for the man who doesn't think. All is merely eating and sleeping, an animal's way of life. But when you think, you are not comfortable, even in Paradise. Why do you think our forefather Adam escaped from Paradise? Because he wised up a bit and began to ask questions. What do you think was the burden of the trust that the mountain could not tolerate but Adam accepted? Adam left the animal life in Paradise to come to this world, which is full of questions of knowledge and duty, a world full of human fears and anxieties."

Hasan Aqa said: "Since the dawn of creation, we have spoken so much of Adam, the father of mankind. Don't you think this is enough? Why should we not talk about the suffering human beings of today? We know what the first ancestor of man did and why he did it. But what is his unfortunate great-grandson to do, sit and watch wickedness? Adam fled Paradise because he was dominated by animal instincts. We are caught in a hell dominated by passions and wickedness. The same right and duty that you are talking about instructs me to move, act, hope, resist and refuse injustice, as do other human beings. And I should become a martyr so that at least you can look at the world through my eyes. Anyway, you don't need my martyrdom: Was the First Point not martyred?"

Mirza Abdozzaki asked: "My dear friend, are you talking about Mirza Kuchek Jafrdan? He jumped into a vat of acid on his own, Hasan Aqa."

Hasan Aqa said: "Why do you talk like Mizanoshshari'eh? What do you mean, vat of acid? Haven't you heard that when the Imam of the Age appears, people will think that he has brought a new religion? Haven't you? How do you know that Torab the Reflection of Truth is not the Imam of the Age?"

Mirza Asadollah said: "Rest assured that it makes no difference to me. I am not one of those awaiting the Imam of the Age. For me, everyone is his own Imam of the Age. The important thing is that every person should carry out the responsibility of leadership in his own time. This is the meaning of the burden of trust."

Mirza Abdozzaki asked: "Then, my dear friend, what do you think should be done? You are opposed to government. You don't support these new ideas either. And you are not expecting the Imam of the Age. Then, my dear friend, you have abandoned any kind of resistance. After all, you can't just let the flood carry you away. Even those who, to quote yourself, sit with their arms folded awaiting the Imam of the Age are preferable to you, my dear friend, because, at least they have kept resistance alive in the form of expectation."

Hasan Aqa said: "Look Mirza, these are not ordinary circumstances. None of us is living a normal life. Why? Because something has happened. Because something has stood up against injustice. This thing is comprised of the offspring of Adam, the father of mankind, plus a new faith. And you do not have that faith. But you do have faith in your own principles. And on the basis of these old principles and beliefs of yours, this situation is unbearable. Then, what are you waiting for? Don't you see that the fate of this balance could be changed even by one person? Change it to one side or the other, this side of the coin or the other."

Mirza Abdozzaki asked: "I, my dear friend, want to know: If you consider everyone his own imam of the age, then what is it exactly that

you are doing in the middle of all this? What do you consider as your duty?"

Mirza Asadollah said: "Seyyed, I have not created this situation. And whoever did create it has not made it to my liking. I don't accept this world at all, with this human condition, neither this side of the coin nor the other. My world is not so petty as to fit on two sides of a coin. My world has thus far materialized only in the imagination. That is why neither prison, hell nor paradise makes any difference to me. I live through my imagination in any place and under any circumstances."

Mirza Abdozzaki said: "My dear friend, again, what you say smells of failure. Maybe you want to say, 'Such a cage is not deserving of a such a sweet singer as I.'"

Mirza Asadollah said: "If great statements were supposed to be uttered only by great people, truth would not spread."

Hasan Aqa asked: "You have not finally told us. Will you sit by idly with your arms folded and watch the number of martyrs increase or move and give us a hand?"

Mirza Asadollah said: "Look, Hasan Aqa. When someone revolts, he certainly has a goal. He is interested in something or hates something else, or he has faith. I neither have the necessary faith in what you are doing nor am I interested in anything in this world."

Hasan Aqa asked: "Don't you at least have any hatred?"

Mirza Asadollah said: "I do hate and I hate deeply. I am the epitome of hatred. I am the epitome of the negation of the status quo. Naturally, I must also be the epitome of rebellion, but..."

Mirza Abdozzaki interrupted him and said: "Do you remember, my dear friend, when we were in the village, you said that when there was nothing you could do, you had better retain your honor? And do you remember that I accepted what you said? Well, suppose there is something we can do, my dear friend. In this case, how can a person retain his honor? Well? Only by negation of everything? And is this the meaning of the 'burden of trust'?"

Mirza Asadollah remained silent for a while and bowed his head. Then he lifted his head up and looked at his two friends who were waiting for him. Then he shook his head and said:

"Alas, alas, for this body is indebted."

Hasan Aqa said: "Well?"

Mirza Asadollah said: "Nothing. I was thinking that if this body were not indebted, indebted for all the gifts that it wastes, how easily one could sit by, watch, imagine things and take refuge in poetry and mysticism. But alas, one cannot repay all these gifts with inaction. This air, this friendship, this moment, my son Hamid and the little carpet whose border has been woven--one has to compensate for all of these with action, not with inaction. Inaction and silence do not compensate for anything. You, Seyyed, are naturally a man of action

and after adventure. How fortunate you are! And you, Hasan Aqa, have faith. What can be better than that! But I must act in a situation that..."

Mirza Abdozzaki interrupted him and kissed Mirza Asadollah's forehead. Hasan Aqa was struggling to keep back his tears when he heard Mirza Asadollah say:

"Very well, Seyyed. Very well. I will consent, the while knowing that we will not cure any of the afflictions of the world."

EPISODE SEVEN

Dearest reader, in a week, our scribes closed their shops and went in pursuit of the new business. Mirza Abdozzaki sprinkled camphor on the odds and ends in his chamber, shut the door, and placed a big lock on it. From then on, he had one foot in the Bakers' Tekke and the other in the Palace every day. He supervised the work of the ministerial and nonministerial scribes, whom he had gathered from here and there and put to different kinds of tasks. Mirza Abdozzaki had chosen scribes from among the Calenders to keep count of the mortars, cannons, guns and other weapons. He had instructed them to keep the accounts in code and, as was customary with them, to write the numbers and figures in dots and letters so that others could not figure out their business. In fact, some of the storytellers believe that the *Siyaq* system of accounting began to be commonly used from this time and that it was Mirza Abdozzaki who changed the forms of the letters, made a code book of sorts, brought it to the attention of Torab Tarkashduz and spread it among the accountants. However, to keep the accounts of the city's provisions, he sought the help of relatives, friends, acquaintances, and old colleagues. He particularly sent for all the prayer writers, fortunetellers, snake charmers and palm readers he knew of in town. He then placed groups of ten with a ministerial scribe to teach them bookkeeping and the codes and to supervise them. True, some of these people had now opened up tattooing businesses with twenty to thirty customers every day. For this reason, they had given the excuse to Mirza Abdozzaki that they did not want to have any hand in the people's daily bread. But there were also many of them who enthusiastically went to help Mirza, because the business of writing prayers was slow.

All morning long, Mirza Abdozzaki would inspect the provision warehouses and all afternoon until sundown he would examine the inventory of the weapons in one of the rooms in the Government Palace. With his own money, from the Mule Bazaar he had bought the same mule he rode to Haji Mamreza's property, with its saddle and harness. Whenever necessary, and without having to wait for the saber-carrying Calenders, he would travel like a hawk from one end of the city to the other or from one warehouse to another. He had arranged it so that at noon every day he would know the amount of the supplies in every warehouse, how many loads of wheat, barley and legumes had

come into the warehouses and from where, and how many had been distributed among the bakers and grocers. And he had made a similar arrangement for arms. With the help of seven Calender scribes who had set up their desks in a room in the Palace, he would have the itemized inventory of every weapon every evening. His wife, Darakhshandeh Khanom, was quite busy with carpet weaving, and neither he nor his wife had to worry about their old problems. True, Darakhshandeh Khanom had not advanced from the margin designs to the central design of the carpets; however, with the help of Zarrintaj Khanom, she had now set up three carpet looms in her house and had fifteen carpet weavers as hired hands. Three men worked with the carpet designs, and the rest, little girls from the neighborhood, were the daughters of friends and acquaintances who were tired of staying at home and would not even complain if they were not paid wages. Every morning, Zarrintaj Khanom would send Hamid to the schoolhouse, take Hamideh by the hand and set out for Darakhshandeh Khanom's house. There, she would wrap the bottom edges of her veil around her waist and work uninterrupted until sunset. She was the supervisor. You would not believe how well the two women's business was going and what close friends they had become.

Now, about Mirza Asadollah. Instead of writing petitions, he would spend his days handling people's grievances. His office was the Packsaddlers' Tekke, where he had the prayer hall cleaned up and carpeted with straw mats and set up his old desk by the door. Aided by ten clerks in a circle with similar desks, they attended to the people's affairs. Twenty Calenders armed with sabers worked as his functionaries, always hanging around in the yard or the vestibule to summon the people to the judicial court if necessary. True, Mirza Asadollah was officially the secretary of the Judicial Court, but he neither had a boss to stand over him as a judge nor was there a need for him to boss over others. He had arranged affairs in such a way that everything was resolved fair and square, through arbitration and consultation, without shouts or threats. Since he had divided all the responsibilities, he would send the person with a property dispute to the colleague sitting next to him, the one with a marriage or divorce quarrel to the second colleague, the family honor case to the third one, and so on. Three of his colleagues were among the trusted scribes of the city, in fact, they were mullas, and would resolve any sort of religious problem, such as weddings and divorces, whenever necessary right then and there. In any case, there were few occasions on which armed Calenders would be sent after summonses or serve persons with prison rulings, fines or retributions.

Dearest reader, as fate would have it, most of the complaints of the people in that day and age during the rule of the Calenders concerned refusals to pay alimony and child support. After the story of the mortars

had subsided, most of the plaintiffs consisted of women whose husbands had abandoned them to put on the Calenders' garb, leaving their homes and families to God. It was on one of the first days of Mirza Asadollah's new profession when some forty women of all sizes and ages, from twenty to sixty, poured into the Packsaddlers' Tekke and filled the whole prayer hall with their screams and shouts. Mirza, who found himself in an unpleasant situation, shouted:

"Quiet! All this chatter is of no use. Have one of your elders come forward and speak her mind like a civilized human being."

Everyone became silent. A tall, thin woman broke away from the crowd, entered the prayer hall, sat right in front of Mirza Asadollah and said:

"My good-for-nothing husband is Mashhadi Ramazan, the grocer--may God strike him dead. That good-for-nothing abandoned seven dependents and took off. What could the Calenders want with him? He couldn't even wash a corpse!"

Mirza Asadollah asked: "Well, what do you have in mind, now, sister? What do you want?"

Mashhadi Ramazan's wife said: "It is quite obvious, Mirza. Either send these good-for-nothings back to their homes and businesses or let us become Calenders too, and we'll show that we can do anything these spineless men can do."

Mirza Asadollah, who realized that he did not have an answer, consulted his colleagues and asked the woman to give him one day. They cleared the tekke and by noon that very day, they helped draft a piece of legislation which they entrusted to Hasan Aqa to present to Torab Tarkashduz. Before sundown, a new proclamation was announced by the town criers to all the Calenders and people in the city: "To become a Calender means to give up the pleasures of the flesh, but to abandon wife and children is not worthy of a Calender." The next morning, when the women returned, Mirza summoned each and every one of their husbands and made them sign a pledge to visit their wives and children at least one night a week. It took about a week until the men began to complain. One of them finally reproached Mirza Asadollah:

"If this at least isn't one of the advantages, then what's the use of becoming a Calender?"

But nobody paid attention to him. Mirza Asadollah issued instructions to inquire into the financial situation of those who were unable to provide for their families, and they would be given Calender stipends. And thus the problem was resolved to everyone's satisfaction.

Mirza Asadollah was fortunate, since the old quarrels for which he used to spend all day writing petitions no longer existed. Neither were people's horses or mules pressed into labor, nor was there a Civil Magistrate or a Chief Constable with their eyes on people's property,

nor was there a fear of Mizanoshshari'eh any longer. Of course, robberies and other disreputable acts occurred since, if you will recall, on the first day of the Calenders' rule, the people had broken down the gates of the jailhouse and all the prisoners had been let loose in the city. There were also occasional brawls and knife fights, or all of a sudden some neighborhood bazaar would be closed off because, since the Calenders had come to power, the ban on wine drinking had been lifted, the opium dens and taverns had started operation, and the price of hashish had come down. However, Mirza Asadollah knew how to handle these problems. Anyone who committed theft would have to either return the stolen property or pay damages, or else a large tattoo was hacked on his forehead and he was driven out of the city. Anyone who committed adultery would be forced to marry the woman then and there, and if there was a third person involved, the woman could choose one of the two men and the other would have to pay damages, and so forth. However, a new problem had been created in the city, which the Calenders wanted Mirza Asadollah to handle. It concerned keeping the city clean and handling the affairs of those who passed away. In other words, from the time when the Chief of Protocol had fled the city with the government army, the supervision of the city cleaning and the affairs of the mortuary had been left unattended. For some twenty days, filth had been piling up in the city, up to the roofs. However, since the weather was getting colder, the problem was less noticeable. Later, Mirza Asadollah sent for Hosayn the Fiddler, to whom he had listened and whose *Shur* and *Mahur* melodies he had enjoyed in the past. He pleaded with him to take over these two jobs. Although the Chief of Protocol had signed a contract with His Majesty to do this job for two thousand gold coins per year, Hoseyn the Fiddler even pledged to pay the treasury of the Calenders two thousand gold coins per month, because the sale of both the city trash and the clothing and jewelry of the dead was profitable. For this reason, Torab Tarkashduz personally sent a plaque in appreciation to Mirza Asadollah, especially given the fact that since the right hand of Hosayn the Fiddler had been chopped off by the order of Mizanoshshari'eh in order to prevent him from playing the fiddle any longer--and this had happened five years earlier--Hosayn the Fiddler had really begun to brandish a saber, and heaven and earth had had it with that remaining hand of his. He had become one of those gang leaders who instigate great riots in the city between the various gangs and he would spend forty days out of the thirty days every month in the jailhouse. Naturally, it was necessary for the Calenders to have him on their side somehow, because since the day that the people had destroyed the jailhouse, Hosayn the Fiddler had been freed along with the others, and until the day when Mirza Asadollah thought of the solution and put him to work, Hosayn had started saber fights five or six times and had really caused trouble. When this problem was also

resolved happily, there were no longer any new troubles. And so, by the end of the first month of the Calenders' rule, of all the people in the city, there were only three in the jailhouse. Two were murderers and the third a hoarder. They could neither be set free nor would Mirza Asadollah issue a decree for their execution.

Now, about Hasan Aqa: He had selected seventy Calender devotees, who continuously traveled on horseback from one village to another, purchasing food supplies, cows and sheep, and would bring them to the city on camels or large Calender-made carts and make deliveries to the warehouses or the slaughterhouse. Hasan Aqa had put each of his two brothers in charge of one area. He had sent his younger brother in the direction of his father's former estate to purchase, with the aid of the inhabitants who by now had all become Followers of Truth, all surplus food and livestock from all the villages in the vicinity within a radius of ten parasangs, and dispatch them to the city. He had also sent the elder brother to the villages along the route of the government army. Fortunately for Hasan Aqa, within forty parasangs around the city all villages were the feudal property of one of the high officials of the government who had escaped. Until the feudal landlord's return, the land had been entrusted to one of the village elders, who would collect half as much as the landlord would have received in livestock and foodstuff. The people of the villages could have asked for nothing better. Furthermore, in order to keep everybody satisfied, he had obtained from Mizanoshshari'eh a detailed religious decree stating that: "As for the rest, the revenues of all that has been put at the disposal of a person as feudal land by His Majesty may be used for the public welfare in the absence of said person." He had this decree announced throughout the city and in all the villages by town criers and everybody learned about it. Of course, in order to obtain such a decree, they would have to agree not to include the personal property of Mizanoshshari'eh and all religious endowments under his supervision. Hasan Aqa had taken care of this and eventually the news of the Calenders' accomplishments spread throughout the country. In a large number of the villages, the landlords were kicked out, and every day there were new reports from some corner of the country or other concerning the uprising of the Calenders.

Dearest reader, among the other people in our tale, there was Mashhadi Ramazan, the grocer, whose wife, as we already know, had registered a complaint against him. As soon as the fire in the Grocers' Bazaar had started, he not only took refuge in a sanctuary, but also became a full-fledged Calender. He had a battle-axe tattooed on the back of his hand and was put in charge of supplying charcoal and firewood to the newly-built kilns in the Palace where the Calenders melted down the mortars and cast cannons in large sand molds. Another person in our story was Mirza Asadollah's uncle, the physician. His life had not

88

changed much. He had the same office where he attended to thirty or forty patients. Once a week, he would also go to the private quarters of the Palace and examine and write prescriptions for the sick women in His Majesty's harem. In fact, early on, through the mediation of Mirza Abdozzaki, Khanlar Khan had sent for Mirza Asadollah's uncle and asked him to take on this responsibility in the absence of the court physician, who had left with the entourage. The physician had consented, and so, life in the city went on. The Calenders were quietly preparing themselves to confront the government army and they continued to do so until, by the end of the second month of their government, they possessed thirty long-range cannons, three thousand five hundred rifles and an unlimited supply of bows, arrows, spears and swords. It was at this time that news arrived of the government army. They had camped in one of the border towns, and His Majesty had declared that town the capital of the sovereign territories. He had ordered the minting of new coins, appointed a Congregational Prayer Leader for the city, and did not intend to return for a very long time.

The third month of the government of the Calenders coincided precisely with the last month of autumn. The winter cold took the upper hand and before the people of the city could prepare for it, three heavy snows had fallen and ice storms and blizzards had stopped all activities in the city. What was more, they also had closed the roads. There came neither any further news of the government camp nor food to the city. Now, the minds of the supporters and the opponents were set at ease, for the government army could not reach the city for a long while. The plots and provocations of the government secret agents subsided by necessity. But, it was towards the end of the third month when around noon one day the rumor was spread throughout the city that ten of the Calender-made cannons had exploded, blowing away thirty Calenders and maiming some fifty others. The truth was that only two cannons had exploded, killing three Calenders.

Dear reader, it was customary with the Calenders, after they built each cannon, to put it on a cart pulled by two nimble mules, carry it through the streets with bugles and drums, and test it by a large ditch next to the city moat. This in itself was entertainment for the people of the city, especially for the children, who had no other entertainment except throwing dice and playing leapfrog. So, men, women and children would follow the cannon caravan, clapping their hands and singing:

"God bless my sweet life/ And the Calenders' cannon, too/ For it has ruined the king's house/ Don't you know it's true?"

On the day of this mishap, Calenders had taken five cannons to be tested. As the children sang along and the artillery men filled the mouth of the cannons with gun powder and lit the wick, before they could take cover, a strange sound was heard, stifling the song of the children and

making a lot of dust. And before the people knew what had happened, the saber-brandishing Calenders had chased them away and dispersed them with whips. But you could hear the moans of the injured Calenders all the way to the city gate. The onlookers, who rushed into the city horror-struck, each reported to the first person they saw:

"You know what happened? I saw it with my own eyes. Ten of them were maimed."

"You can't imagine, each one of the cannons was broken into hundreds of pieces."

"Yes, all five cannons exploded and each piece killed three people."

"We must have been stupid to think these Calenders could do us any good."

"What a sound! May God protect us! The blood was a sight to behold!"

"The arm of one of them was flying through the air like a bird."

As the news spread, it became public property. And since everybody had a share in it, they embellished it and added to it as the news traveled from mouth to mouth, from this woman to that man and so on. In any case, the news of the explosion of the cannons spread throughout the city, and the people became frightened. Thus far, they had been happy with the low prices and the abundance of food, with having been rid of the Civil Magistrate, the Chief Constable, the guards and the night watchmen. Furthermore, they would see the cannons several times a day, and since the cannons were made with their brass mortars, they felt part owners of them. And to the degree that they felt they were owners of the cannons, they felt more courageous, precisely like a man who has more gold in his bag and therefore becomes more daring. But now, all of a sudden, the cannons had fallen apart, and everybody felt justified in doubting how sound the cannons that had passed the test were. So everyone began to fear that, if the government army returned, they might find him guilty and make him accountable for the whole affair! That is why the people became quiet once again. They began to have second thoughts and lose their appetites. Some said it was due to the cold weather; some said there must have been black magic at work; and another group said that the government's secret agents had infiltrated the Calenders' organization. The truth of the matter was that the cannon makers had melted the mortars without measuring the percentage of copper used in the alloy for each one and had cast the cannons too hastily.

In any case, fear throughout the city immediately resulted in crowds of people rushing to the bakeries from the next day on, just like in the times of famine. The bakers, who had had a hard time selling one loaf of day-old bread with five loaves of freshly baked bread to the customers, were now so busy that they did not have time to scratch their heads. In fact, not only did weighing the bread become obsolete,

but before the dough had time to rise, it was hastily spread flat by the bakers, half baked, and sold to the people, who were climbing over each other in front of the store. Similar crowds and commotions were witnessed in front of the shops of grocers and rice merchants. Two days after the explosion of the cannons, you could find neither legumes nor any other kind of food in the stores. Of course, after a week, the greed of the people subsided, the bakeries were once again quiet, the grocers received fresh goods from the warehouses, and bread was left on the bakery counters to go stale. But the people were still worried, and the government agents had found an opportunity to exploit. So, a week after the explosion of the cannons, late one afternoon when it was snowing, a crowd of five hundred people from Palace Gate District, who were mostly the wives and families of the soldiers and guards who had left the city with the army, marched with Korans on their heads to the Palace Gate in order to make the Calenders take an oath on the Holy Book to ensure the safety of the lives and honor of the women in His Majesty's harem. Of course, Torab Tarkashduz could not be informed, because he had gone into forty days of seclusion since the explosion of the cannons and no one was allowed to visit him, except for a few of his intimate followers. Hence, the Calenders had to plead with Mirza Abdozzaki, who usually hung around the Palace in the afternoons. Mirza pleaded with Khanlar Khan, who finally came out of the inner rooms and lectured the women for an hour. Finally, he set aside Monday of every week as a day on which the women in the city could visit their relatives in the harem, and thus the commotion subsided. Subsided .. well, that was not quite the case, for that very day, three infants were trampled under the feet of the crowd, and on the next day, twenty men divorced their wives. Before Mirza Asadollah and his colleagues could manage the business of these divorces, one cloudy morning, some two hundred seminary students poured into the Packsaddlers' Tekke with dishevelled turbans and torn shirt fronts, crying, "Oh calamity" and "Oh, our teachers." What else could have happened? The Calenders finally calmed them down, chose five of their elders and leaders, and took them into the Prayer Hall. The eldest, who wore a black turban and a white beard, shouted as soon as he sat down:

"One cannot talk to these infidels, my dear sir. But you who have made your living for a long time from scholarship might know what 'Those who practice injustice will learn...' means. Do you, sir?"

Mirza Asadollah looked at his colleagues, who were all looking down, pretending nothing had happened, and said:

"The apparent meaning of the verse can be understood with a little knowledge of grammar. As for its interpretation, that is not my job. However, if you are threatening us, you have the wrong party."

Then, one of Mirza Asadollah's colleagues, who had gathered up some courage, said:

"In this court, no violation of the lives, property or family honor of the people has ever occurred."

One of the seminarians said: "What is the use? Who would listen to us?"

Mirza Asadollah said: "If there is a religious or civil dispute, we are at your service."

The first old man said: "The stipend of the seminary students has been cut off since a week ago. We asked the custodian of the endowments about it. He says that they have stripped him of his authority. These gentlemen do not understand the word *justice*. My dear sir, you are the protector of the seed of Islam and are acting as the Religious Magistrate. Tell us what we are supposed to do. They are weakening the Islamic theological center."

Mirza Asadollah turned to one of his three colleagues who wore the garb of a seminary student and asked:

"Do you know who the custodian of the endowments for the seminaries is?"

"Mizanoshshari'eh."

The name was uttered by several people at the same time. Mirza Asadollah nodded and said:

"When and how was he stripped of his authority? As far as I know, this is not the case."

One of the students said: "In any case, Mirza, you should know this better than we do. All we know is that the stipends of the seminary students have been cut."

Mirza Asadollah pondered for a moment and said: "I do not think that is the case. I will have to investigate the matter. Until the results of the investigation are obtained, we will take it upon ourselves to give the stipends to the gentlemen from the Palace treasury."

One of the seminary students observed: "Of course, if there is a treasury, it has certainly been usurped and is certainly in the illegal possession of these gentlemen."

Another colleague of Mirza Asadollah responded:

"Each one of you has made your living for forty or fifty years off Islam and should know by now how to cleanse usurped property. Besides, is it worse than making a living off the dead?"

Another colleague of Mirza Asadollah who was not dressed in religious garb said:

"In fact, how long do you intend to be seminary students? May God protect you, each one of you is old enough to be our father. Why don't you go help the people?"

Mirza Asadollah said: "Do you really believe that the property which is in the possession of these gentlemen is more questionable than the property which was at the disposal of the government? During this

whole time, not one *'abbasi* has been taken from anyone by force, not one four-legged animal has been pressed into labor."

The first old seyyed said in a trembling voice: "Very well, dear sir. We accept it. But the basic issue is that with these tekkes, secret sessions and the Calender ways, for three or four months now no one has been able to preach the truth from the pulpit. They will not let the people listen to us."

One of the seminary students continued: "All the mosques have been deserted. No one preaches from the pulpits any longer. How will you answer the Prophet on Judgment Day?"

Mirza Asadollah said: "In that regard, there is nothing we can do, of course. And, besides, since you say you have contented yourselves with some corner in the seminaries, how could you expect the people to come and listen to you? All we know is that the truth does not need to be blurted out with horns and bugles .."

One of the seminary students interrupted Mirza: "Of course, particularly when the horns and bugles are at the disposal of the servants of Satan."

The same colleague of Mirza Asadollah who wore the clerical habit said:

"Tell me, do you mean we are the servants of Satan?"

"Even worse, the willing and unpaid servants of Satan."

It was not clear which one of the seminary students ventured to say this, but as soon as it was uttered, Mirza Asadollah's colleagues started to protest loudly, with blood rushing to their faces. When the representative of the seminary students saw the situation turning to their disadvantage, he consented to what they had been offered and left the tekke along with the rest of the crowd they had brought along.

Dear reader, such is how life in the city went on, more or less. The government secret agents would create some new trouble every day. The people, who had already lost their courage as the result of the explosion of the cannons and who would hear of all these new troubles by word of mouth when they had already been made to sound forty times worse than they actually were, became even more frightened. In any case, mid-winter was just about over. Towards the end of the fourth month of the Calenders' rule, Hasan Aqa, the son of Haji Mamreza, invited our scribes and their families for lunch on a Friday. The lunch was at the house near the Grocers' Stretch where we once took Mirza Asadollah to the closed door of the house where he wanted to find out what was going on. Our scribes no longer had any idea whether it was Friday or Saturday. They were working all the time, which is why they did not show up very early. But a little before noon, Darakhshandeh Khanom and Zarrintaj Khanom arrived with Hamid and Hamideh.

It was a very large house, with the door open. They passed through the vestibule, which led on one side to the stable; then they went

through the outer courtyard, which was not the place for women, and entered the inner courtyard, which had its own pantry, its own bath, and even an exercise hall. Women were coming out of and going into various rooms. Large and small children, who were having snow fights, stopped to look at the newcomers. The guests, who were walking rather aimlessly, did not quite know to which room they were supposed to go. Darakhshandeh Khanom said:

"May God bless, sister! May God bless. What are all these women and children doing in this house?"

Zarrintaj Khanom, who was walking alongside Darakhshandeh Khanom, said:

"You haven't seen anything yet, sister. The late Haji Mamreza's house was not a house, it was like an inn for dervishes. There were enough people in it to fill a caravanserai. All sorts of people would come and stay for weeks and months."

Darakhshandeh Khanom asked: "How did they feed them? Not even Khanlar Khan had such comings and goings. It was not like this even in the houses of the rich and famous."

Zarrintaj Khanom said: "Oh, sister, to the rich and prominent sort, their money is more important than their lives. It wasn't for nothing that Haji Mamreza had such a reputation. Besides, what you see of the comings and goings is only half of what it used to be. Since the Calenders have come to power, all the men have gone to the Palace and the guard houses..."

At this point, Hasan Aqa's mother and sister arrived to greet them. They sent the children off to play in the snow, and the ladies went to the large five-door room with velvet curtains. There was a large *korsi* heater in the upper part of the room covered with embroidered cloth with cushions of different sizes around it. The guests were given more comfortable veils and then seated. Darakhshandeh Khanom turned to Hasan Aqa's mother, who wore a white scarf on her head clasped under her chin with a large emerald pin, and said:

"May God protect your sons for you. And may God increase your life for the years your late husband has lain beneath the ground. But with an open house in these strange times..."

She swallowed the rest of what she was about to say, because Hasan Aqa's mother was one of those old women who would make you stop talking when they look into your eyes. In order to pretend that she did not hear what was being insinuated, Hasan Aqa's mother said:

"May God preserve Number One to protect all of us. My late husband gave his life for this cause. My own life is worth nothing. I thought I should spend his wealth for this cause."

Zarrintaj Khanom interceded: "May God illuminate his grave. But you know, dear lady, to tell you the truth, Darakhshandeh Khanom would be pleased if you would permit her to set up several carpet looms

in this house and have all these women and children learn a skill. After all, dear lady, life is not all eating and sleeping. Not only is it an act worthy of reward, but they will learn a skill besides. And they would be grateful to you and your sons. May God protect you, you are wiser than a hundred men. You know that if you begin to spend your capital, it will eventually be finished. It is true that the home of your late husband was like an inn for dervishes, but there is nothing wrong with the people earning their daily bread in this house in addition to learning a skill .."

The guests and hostesses were making these business arrangements when our scribes and Hasan Aqa returned from their daily work, exhausted, and made themselves at home around the *korsi*. Apparently continuing a conversation they were having, Hasan Aqa said:

"No, the cold and the freeze alone are not to blame. Number One was informed that the overseers were showing up in the villages and giving all sorts of promises to the people, so they would break their agreements with us. This is the cause of this artificial famine."

Mirza Abdozzaki said: "This was bound to happen, my dear friend. I told you from the very first day, my dear friend, that you should load up all that you could in every village and bring it to the city all at once. You've got to be decisive, my dear friend."

Hasan Aqa said: "You know yourself that we couldn't. We had no horses or mules and we didn't want to press the people's animals into labor. What would the difference have been between us and the government then?"

Mirza Abdozzaki said: "Well, it is precisely this kind of puritanism, my dear friend, that ruins everything."

Mirza Asadollah said: "No, Seyyed, in such confusion, even if you were one of those officials, you couldn't have found more. The people were right to be quite frightened in those days and to hide everything."

Hasan Aqa said: "Well, sir, now how long do you think the food supplies in all the warehouses of the city will last?"

Mirza Abdozzaki answered: "About two months; until early spring, my dear friend. By that time, the spring crop will be ready and the people's fear will have subsided, my dear friend."

Mirza Asadollah said: "But it has not subsided yet. Frightened people become greedy. My father--may his soul rest in peace--used to say that fear is like a disease. Only it is a disease that neither kills you nor weakens you. It rather makes you greedy. You know, my father had gone through three famines. He used to say, a person who is afraid of famine tries to get twice as much as he would in the days of plenty. He even eats twice as much. Have you thought about these things, Seyyed?"

Mirza Abdozzaki said: "Tell me, my dear friend, which one of you anticipated this situation? In fact, once you exempted

Mizanoshshari'eh's property and you relinquished the endowments of the Grand Mosque, the whole business was ruined, my dear friend. Now, the news has traveled to all the villages, and nobody will listen to us anymore. They won't even accept our receipts and promissory notes, my dear friend. They want cash. Do you have it?"

Hasan Aqa said: "We might be able to get some. But don't forget how useful the one decree of Mizanoshshari'eh was. Besides, what else could we have done? Could we have sent him into exile? That would have been worse. He would have gone and provoked the people from outside. Now at least we can keep and eye on him."

Mirza Asadollah said: "You mean he is now sitting quietly by? I am sure that the ruckus with the seminary students is not his last shenanigan. Tomorrow he will probably provoke the old women and the orphans of the city."

Hasan Aqa said: "We have taken care of it. If he plays the same tricks, we will get the same old women and orphans to go to his secret warehouses and we will expose him. After all, you can only avoid violent measures to a degree."

Mirza Asadollah said: "Do you think these threats will make him change his behavior? Overnight he will distribute all he has in his warehouses among the bazaar merchants who are his partners in hoarding."

Hasan Aqa said: "That wouldn't work. Most of the city porters are Followers of Truth. We would be informed immediately."

Mirza Abdozzaki said: "My dear friend, I don't understand at all. What is all this arguing for? If you are talking about the anticipated food supplies for the city, all the warehouses are full right now. In fact, the rumors among the people are unfounded, my dear friend. After all, about the same number of Followers of Truth have taken refuge in the city as the number of government troops who left the city."

Mirza Asadollah said: "Look, Seyyed, you cannot just leave the business of the city food supplies to guesses and estimates."

Hasan Aqa said: "In any case, I must beg of you. I, for one, don't dare talk to Number One of this business anymore. Since the explosion of the cannons, he has gone into forty days of seclusion and won't admit anyone."

Mirza Asadollah said: "This can't be. What can seclusion accomplish? You must send for a few competent coppersmiths to find out where the problem lies. From top to bottom, everybody in the country is afflicted by forty days of seclusion and fortunetelling. Both you and them. You might as well go into seclusion, Seyyed, for providing food supplies for the city. Now, what do you say?"

Hasan Aqa said: "Stop joking around, Mirza, I don't have the patience."

Mirza Asadollah said: "I am not joking, Hasan Aqa. I wanted you to realize that there is no difference between you and them."

Hasan Aqa said: "How could there be no difference? You just can't change your mind once you have said something, can you?"

Mirza Asadollah said: "They checked to see what hour was auspicious, went into seclusion and consulted astrological signs, and so do you. They left the scene and are now waiting for events to turn in their favor by themselves so that they can return. And you sat by and waited for the government troops to leave the city before you took over. And now, still, you are waiting for the envoy of the Sunnis to come and make a deal with you rather than with the government. Nobody seems to want to confront what happens face to face. Even you who make so many claims are opportunists."

Mirza Abdozzaki asked: "Then, my dear friend, what should be done, in your opinion?"

Mirza Asadollah said, frustrated: "Don't keep asking me what is to be done. I don't know. Why don't you go ask the leaders who either run away or go into seclusion as soon as something happens? Every child knows that there is a way to do everything. For instance, this business of the food supplies: Starting tomorrow, get the Followers of Truth to take a census in the city. Make an inventory of all the warehouses. Even put down on paper how many hoarders there are. This is easy enough to do!"

Hasan Aqa said: "Then, will you sign the confiscation papers for the hoarders' property?"

Mirza Asadollah said: "What do you mean? Do you want to force me to issue injunctions?. Then you don't need my injunction anymore. You know how to send the people to the warehouses of the hoarders."

Hasan Aqa said: "I wanted you to understand that governing is not an easy task."

Mirza Asadollah said: "I told you that on the first day. You just felt like taking over the government, and now you are stuck with it. You don't have any plans. This is why I don't see any difference between this government and the one before it. In fact, we are not living a human life. We are living like plants. Just like a tree. When winter comes, the leaves fall off and it waits for spring for the leaves to grow again. Then, it waits for summer to bring fruit. It waits for rain, fertilizer and so forth. Always waiting for changes in nature, external changes. They were like this, and you are the same, not realizing that if you wait for external changes, there might be a flood, or a typhoon or a drought."

Mirza Abdozzaki interrupted Mirza Asadollah:

"My dear friend, here you go again. Don't you think with all the cannons they are casting they are getting prepared?"

Mirza Asadollah said: "Yes, they are, but they are getting prepared to kill, in other words, for death, not for life. These gentlemen were

supposed to provide a better opportunity for the people to live. Now they are stuck; their leader has gone into seclusion. Why? Because they were not expecting such provocations. That means they were not prepared to confront external events. Exactly like a tree. This seclusion business is for those who think external changes are either God's blessing or a celestial calamity. And this is exactly the way things were at the dawn of creation."

Hasan Aqa said: "Mirza, all you know is to sit on the sidelines."

Mirza Asadollah answered: "Is this on the sidelines? I was afraid to issue rulings and make judgments. Now I am forced to make judgments a hundred times a day. And you still want me to issue injunctions for the confiscation of people's property."

Hasan Aqa said: "Then, are you suggesting that the people should die of starvation so that the hoarders can go on with their business?"

Mirza Asadollah said: "If all the people in the city were to die, the hoarders could not sell their food supplies at twice the price. The question is, what should we be doing to ensure that the people will be comfortable and nobody will need to hoard anything. This task requires planning. All those who have stained the government with the blood of the people have had the same problems. One person or incident or another would oppose them or make it unpleasant for them, and then they would be frightened, just like you. Then they wouldn't know what to do. Should we confront the issue like a frightened person? And how? Should we confiscate the property of one person or another? Should we eliminate this or that person and suppress this or that movement without realizing that the roots are still being established? When you eliminate hoarding, a new problem will arise. You have to find out why a person engages in hoarding at all."

Hasan Aqa said: "Tell me, did we have the chance to do all of this?"

Mirza Asadollah answered: "I told you from the very beginning that you were beating your head against a brick wall. I knew that if you were to become a judge you could not pretend to be puritanical anymore. I knew that you would have to close your eyes, give rulings, spill blood, create fear and make people afraid so that you would not be afraid. I was against any sort of government from the very beginning. I said from the very beginning that problems can be resolved only through arbitration; otherwise, nothing can be resolved, even to the day of judgment. That is why the seeds of every government take root during the previous one..."

Mirza Asadollah was continuing the speech when lunch was brought in. It was steamed rice with a few scattered pieces of tough meat and some bread, crushed walnuts and goat cheese. The discussion had to end and Hasan Aqa had to apologize for not having found meat. Mirza Asadollah said that nowadays, one did not have to apologize. Then, they decided to take a census in the city and from the next morning, Mirza

Abdozzaki began with the help of all the scribes at his disposal to take a census and establish rationing in the city. First, they determined the rations of the harem and the Palace, which caused much commotion and clamor, then for the seminary students, then for the Calenders, who had come to some good fortune for a while now and were spending like there was no tomorrow.

On the second day of the census taking, a rumor was spread that the census was only a cover for the Calenders who were secretly getting ready to conscript soldiers. Assuming that caution was the wisest policy, the city people hid their young men and did not report their names for the census. They would swear on the Holy Book that they had either left with the troops or had died. While Mirza Abdozzaki and his colleagues were engaged in the frustrating task of trying to estimate the actual population of the city, in addition to the shortage of meat, a shortage of charcoal, firewood and fodder was created. Right in the middle of the winter cold, with snow piling up behind the house doors, in the season of meat shortages, not only did the shops have no charcoal, firewood or fodder, but the butchers did not dare to open their shops. All the incoming firewood and charcoal would go straight to the Palace kilns. As for the villagers, who had become hesitant in dealing with the Calenders for some time now, they were forced to slaughter their donkeys and horses to make preserved meat which they stored in animal skins, because the people who had difficulty in getting bread and meat for their own consumption could no longer worry about feeding the family's lame donkey. So, many of the stables in homes were emptied. In fact, the storytellers believe that keeping a stable at home went out of fashion from that time and that houses became more spacious.

Dearest reader, events continuously went from bad to worse. Every day, the people had to tighten their belts a notch and they felt more and more despair and frustration. Towards the end of the fifth month of the Calenders' rule, once again, all the people in the city, men and women, poured onto the streets--exactly like ants whose nest has been flooded and who sense danger--frightened and awe-stricken. First one by one and then group by group and neighborhood by neighborhood, they came out of their houses and followed the crowds. Then they wondered what they should do. Since there was not much they could do and the Calenders had not treated them badly, they rushed towards the mulberry gardens around the city which belonged to the religious endowments. With axes and adzes, they chopped down the bare trees, which were buried up to their middles in snow, and carried the pieces to their houses. But worst of all, through the provocation of the government secret agents, who were becoming more active every day, two Calenders were killed in the commotion, because they did not want to accompany the people or lend their adzes to anyone, or because they had insulted someone or had tried

to prevent someone from doing something. As soon as the news reached the Palace and the tekkes, the Calenders, armed and angry, poured into the city and the situation reverted to what it had been before. On one side were the people and on the other, the Calenders, exactly like the government guards, patrolmen and night watchmen, who had been feared and avoided by the people. People no longer dared to leave their homes alone and unarmed, neither the people nor the Calenders. The Calenders who had thus far avoided violent action, changed their ways, first by beating the people who crowded in front of the bakers' shops, and then by pushing and shoving those who were summoned by the court. Eventually it got to the point that one day, without the permission of Mirza Asadollah and his colleagues, they hanged three hoarders on a sunny, cold morning, right in front of their own warehouses.

Dearest reader, as soon as the reports of the hanging of the three bazaar merchants spread throughout the city, the bazaar closed down and it was rumored that none of the merchants would buy Calender-made goods and no money-changer would honor their receipts, promissory notes, and bills of lading. It is true that the next day, the bazaar leaders went to the Palace and pledged to reopen the bazaar, provided the corpses were brought down and buried immediately, which was done. The frozen stiff corpses were taken from the Calenders and brought to the cemetery with chanting, which sounded a hundred times louder with the shouts of the government secret agents. However, it was already too late and the people of the city were now, once and for all, in opposition to the Calenders.

Worst of all, at precisely the moment when the corpses were being escorted to the cemetery with standards, hearses and decorated catafalques, the envoy of the Sunnis arrived at the city gate accompanied by his entourage. No matter how the Calenders tried to gloss things over, they were not successful. The long line of the funeral procession moved very slowly, with shouts of "There is no god but God" and "God is most munificent" rising up to the sky. The cold weather outside the city gate was quite severe and the envoy of the Sunnis came face to face with the mass of people in the funeral procession moving out of the city towards the cemetery.

Although the hanging of the three bazaar merchants was a good warning to other hoarders, and at least three large food supply warehouses were opened to the people, who could finally get their hands on some food and whose fear of famine was reduced, what had been lost could not be regained. The people of the city and the Calenders were now confronting each other, and the secret agents of the government aggravated the situation. It is true that the storytellers did not have the time in the course of these commotions and events even to scratch their heads and were, in fact, unable to find out what was said by the envoy

of the Sunnis to Torab Tarkashduz. Nevertheless, from the conversation between Hasan Aqa and Mirza Asadollah, who had gone to complain the next day, one could guess that the talks between the envoy of the Sunnis and Torab Tarkashduz had not been all that rosy.

Mirza Asadollah's complaint was as follows. The day after the hanging of the hoarders, he went through all sorts of trouble to find Hasan Aqa and took him to some corner of one of the tekkes and said to him right then and there:

"You see, friend, your hands have finally been stained with blood."

Hasan Aqa, angry and upset, said:

"Are you now scolding us too? We gave up on most of our principles not to spill any blood. Do you remember the business of the women, or that of the seminary students, or the exemption of the property of Mizanoshshari'eh? But the shrouds of the two Calenders have not yet dried."

Mirza Asadollah responded: "So this was revenge, right?"

Hasan Aqa said: "Supposing it was. After Number One issued the decree, he fainted."

Mirza Asadollah said: "And the envoy of the Sunnis probably held some smelling salts to his nose."

Hasan Aqa could no longer maintain his composure. He said: "Look, Mirza, when you talk in this tone of voice, what do you expect from the envoy of the Sunnis? Mizanoshshari'eh, Khanlar Khan and all the secret agents of the city are busy provoking the people constantly. And you talk like you do. When it comes to this, to hell with the envoy!"

And so, the storytellers realized that the envoy of the Sunnis had not been of any help. The same day, the rumor spread that His Majesty had made a compromise with the Sunni government and had traded away a part of the country for four hundred long-range cannons. His intention was to set out for the city once the cold weather had ended.

In any case, not only had the envoy left, but when the bazaar reopened, even the money-changers seemed to have melted and disappeared into the ground. Not only did their shops not reopen, but they disappeared altogether. Of course, what was to the Calenders' advantage was that they did not need much money. Except for the early days when they used money to purchase the brass mortars, neither were the Calenders paid wages nor did they need money to buy what they needed from the bazaar. They procured their needs through bartering. However, when the villagers stopped honoring the Calenders' promissory notes and bills of lading for delivering wheat, barley and livestock, hard times began. Now, the money-changers had also disappeared. What was to be done? They waited a few days, then a week, and then a fortnight. The money-changers still did not return. In addition, the warehouses were emptying one by one and something had to be done. Each of the money-changers who was sought out was either

bedridden with pneumonia or on a trip. Finally, on the sixteenth day, the Calenders raided the money-changers' shops and broke into their safes and cash boxes, but found nothing. Then they went to their houses and arrested seventy of them, tied them up, took them to the jailhouse and fined each of them two thousand gold coins. The Calenders were lucky, for the bazaar merchants were not very happy with any of the money-changers anyway, who had all become rich through usury. In fact, they were hated by the bazaar merchants. Although nobody complained in the bazaar and the city was calm for a while, unfortunately, the Calenders had to repair the gates of the jailhouse, that is, the very gates and walls that they had broken down themselves, and to follow step by step the path necessary to govern a city of this kind. In other words, from the next day on, they established tolls at the city gates and controlled the traffic of the people. They began to collect taxes from the taverns and opium dens. They cut the rations of the seminary students and the Palace harem in half, as well as the rations of the leper house and mental asylum. When it came to this, the secret agents of the government began spreading rumors: "People, are you aware that the Calenders intend to let the lepers and crazy people loose in the city in order to save on the food supplies?" The people, who could be provoked by the slightest bit of news, one evening, led by the secret agents, poured out into the streets once again shouting and yelling: What are we supposed to do? Someone shouted: "Let's go set the leper house on fire." The crowd, shouting and yelling, set out towards the leper house. As they were going through the alleys looking for torches, Mirza Asadollah's uncle, the physician, cane in hand, arrived huffing and puffing at the Packsaddlers' Tekke. Since this matter concerned his responsibilities, as soon as he heard the news, he closed his office and left.

Mirza Asadollah and his colleagues were still busy with the shouts and cries of the heirs of the three hoarders who had died on the gallows when his uncle entered the prayer hall.

"You stupid boy! Those hoodlums are about to set the leper house on fire, and you are busying yourself with inheritance disputes. To hell with all inheritance and heirs. You should not have supported these people; but now that you have, they are indebted to you, so get up, let's go do something for these poor people."

Mirza Asadollah hurriedly set out, accompanied by all the Calenders of the Court of Justice. They somehow found a donkey for the uncle and by taking a shortcut through the back alleys, they arrived at the leper house before the city hoodlums. The Calenders had lined up with their rifles loaded, ready to fire, when the crowd of thugs arrived with torches in their hands, screaming and yelling.

As the crowd was advancing, Mirza Asadollah himself gave the order to fire. With this command, five Calenders fired their weapons. A loud

noise was heard and the crowd stopped a hundred paces from them, exactly like a herd which suddenly reaches a cliff. Meanwhile, a group of a hundred Calenders, who had come to the aid of Mirza Asadollah and his group, arrived in a hurry from the various alleys and surrounded the hoodlums. To make a long story short, guns were fired, rocks were thrown, Asadollah's uncle's forehead was cut and his donkey killed, two Calenders and five of the thugs were killed, and fifty of the latter were arrested before the situation was quieted down and the leper house was saved from being torched. Mirza Asadollah had just brought his uncle home and returned exhausted when Hasan Aqa came in.

"How are you, Mirza? I hear you issued the order yourself."

Mirza Asadollah said: "Well, you know, the old man was so weak he couldn't sit up straight on his donkey. And then, they were about to set the leper house on fire. It was a very serious business."

Hasan Aqa said: "Yes, Mirza, it is always like this when one forgets all about the hows and whys."

Then he presented him with a second plaque of appreciation from Torab Tarkashduz and said that the rations for the hospital had been doubled. After he left, not only could Mirza Asadollah not eat dinner, but he remained awake all night thinking. He was deep in thought, until the oil in the lamp burned out, and he dozed off where he was sitting at the *korsi* !

Dearest reader, the inauspicious three days of lunar quadrature lasted for six months. The earth had just begun to breathe again and the ice in the pools to melt when one morning rumors spread throughout the city that the government troops were moving rapidly towards the city. Let's not even get into what was said about His Majesty's wheelings and dealings with the neighboring Sunni government, but the four hundred cannons had increased to four thousand, one province of the country had become half the country, and all the army cannoneers had become Sunnis, who were now coming to avenge the blood of all the Sunnis killed in the course of those years, and they were going to line up the Shi'is in front of cannons and shoot them. As the scent of spring penetrated the most hidden back rooms of the city, the news of the advance of the government troops also spread. Some people had even fabricated a rumor that the Calenders were tired of governing and had sent a pleading letter to His Majesty to return and take charge of the monster he had created. Of course, this last statement was said in jest. However, the first result of the news of the troop movements was that the tattoo shops became as crowded as the bakeries with people who had tattoos of battle-axes on the backs of their hands and were willing to give an arm and a leg to have those tatoos removed. During those days, many people of the city cut or burned the backs of their hands or rubbed on them vinegar extract and acid or a paste of pure arsenic sulfide. In short, they did all they could to remove the tattoos. It got to the point

103

that even men who had pictures of Bizhan and Manizheh tattooed on their chests or backs or battle scenes of Rostam with his double-pointed beard and the head of the White Demon tattooed on their arms, and even old gypsy women who had tattoos of snakes, scorpions, or dragons on their throats, all poured into the tattoo shops to have them removed, having forgotten completely about famine and the shortage of bread. It is true that fresh clover was sprouting in the ruined mulberry gardens around the city and the scent of spring had affected the people and had halted their greed. However, the important thing is that when a human being's mind becomes preoccupied, he no longer worries about his stomach and what is below it. And the people of that city and that age had really become preoccupied, since every one of them was worried about how to prove that he had no relations with or fondness for the Calenders when the government troops arrived and about what he must do to save his little place of business and bread and butter.

Now, as for the other side, when the Calenders heard the news, they rushed to the moats around the city and patched up all the holes. They destroyed all the embankments, except for a couple of those which bridged the southern and eastern city gates. So they prepared the moat to let the spring runoff fill it up by the next morning. When their minds were set at ease in this regard, with shouts and chants, they carried all the cannons they had built outside the city walls. All around the city, behind every trench, they mounted two cannons within the distance of half a field and assigned five cannoneer Calenders to every cannon. They took the horses and mules which pulled the carts and let them graze in the mulberry orchards. They also sent five of their old cannons towards the mountains to the south of the city and blocked the mountain pass which the government troops would have to cross to get to the city.

As for our scribes, they were so busy with their own work that they did not have time to think that the situation might turn around. However, at sunset on the day that the news of the movement of the government troops spread throughout the city, Khanlar Khan, the harem eunuch, sent for Mirza Abdozzaki to come by the harem for a short visit. Previously, as you know, such visits were not unusual. Mirza Abdozzaki, who thought a new problem might have come up in the harem, went there. After the usual greetings, they sat down to talk. Khanlar Khan came straight to the point:

"What will you do if the government troops arrive, Seyyed?"

Mirza Abdozzaki said: "The same thing that all the Followers of Truth will do, my dear friend."

Khanlar Khan said: "If they are all thrown in tubs of boiling water, what then?"

Mirza Abdozzaki said: "My blood is no redder than others, my dear friend."

Khanlar Khan said: "Then you are a real devotee, Seyyed, aren't you? It is not like you, Seyyed."

Mirza Abdozzaki said: "It's not a matter of being a devotee. But every thorn becomes useful some day."

Khanlar Khan said: "Then you really believe? Well, now, you don't have to try to convert me. I just wanted to tell you that His Majesty has put a new harem together for himself."

Mirza Abdozzaki said: "Well, my dear friend, congratulations to you."

Khanlar Khan said: "Why don't you understand, Seyyed? That means that he is no longer interested in this harem."

Mirza Abdozzaki said: "This was clear from the very beginning, my dear friend. Otherwise, he would have taken them along."

Khanlar Khan said: "Look, Seyyed, don't pretend you don't understand. You know that the troops will come and take the city, and as for your Followers of Truth, they are finished. And nobody wants to sacrifice himself for nothing. Now, are you prepared to think and make a deal rationally?"

Mirza Abdozzaki said: "A deal, my dear friend, what deal? I have nothing to exchange for..."

What he was saying remained unsaid. He had just realized what Khanlar Khan wanted. So, he just stared into Khanlar Khan's eyes and remained silent. Khanlar Khan, who found a favorable opportunity, said:

"Look, Seyyed. Before the two of us, many people have fought over a woman. But none has resolved the quarrel with such peace and sincerity. Do you understand what I am trying to say to you? I know that your life is dear to you. But I thought you might be interested in saving the lives of some of the Followers of Truth as well, right? If so, divorce her and leave. I will save the lives of most of you."

Mirza Abdozzaki stared into Khanlar Khan's eyes for a while longer. Then, he was about to say something, but he realized he could not tolerate the situation any longer. He grumbled something under his breath and got up and left without saying goodbye. For a while, he walked in the Palace courtyard. What should he do? What should he not do? He jumped on his mule and set out in the dark of the night towards Mirza Asadollah's house. While he was waiting for the door to open, he tied his donkey to a ring on the door, then slipped inside. Mirza Asadollah was sitting by a brazier when Mirza Abdozzaki entered, confused and bewildered. That winter, the people of the city had put away their *korsis* earlier than usual. However, anyone who could afford it would keep a brazier of hot charcoal in his room at night. Mirza Asadollah sent Zarrintaj Khanom and the children to the other room and said:

"Now what's happened, Seyyed?"

105

Mirza Abdozzaki plopped himself down right where he was by the door and said: "A bad situation, my dear friend, a really bad situation. We've got to think of something. I am going crazy, my dear friend, crazy."

Mirza Asadollah said: "Now, why don't you come sit by the fire? Tell me what has happened."

Mirza Abdozzaki dragged himself over to the brazier, sat across from Mirza Asadollah and explained all he had heard from Khanlar Khan very slowly and briefly. Then he said:

"You see, my dear friend? We are back again to square one. Now he confronts me openly and says what he wants. I spit on this life. I wish that I had had one of those rifles with me, my dear friend, and that I knew how to shoot him in his big belly, the son of a bitch!"

Mirza Asadollah, who was dumbfounded by what he heard, said, after a few minutes of silence:

"So, the troops are coming back! Didn't you ask how...?" He was interrupted when Mirza Abdozzaki yelled:

"Are you out of your mind, my dear friend? If they wanted to make a deal on your wife, would you ask them how?"

Mirza Asadollah said: "Forgive me, Seyyed. I didn't realize what I was saying. It really is a bad situation. How about making a visit to Hasan Aqa? To tell you the truth, this business is much more important than you and me. In this way, this pig is offering a way out to the Followers of Truth. It is not merely with you that he wants to make a deal. Get up, let's see if we can find this leader of the people tonight."

They set out and went to Hasan Aqa. After a couple of hours of searching, they finally found Torab Tarkashduz, who was inspecting the cannoneers around the city. They explained the situation to him, walking along the moat in the dark of the night. When Torab Tarkashduz heard the story, he stopped and said:

"What a bastard. He thinks he is going to win the game that easily?" And, as if talking to himself, he added: "So, finally, this harem has become useful." And he said loudly: "But if they were so sure of their success, they would not try to make such an offer."

Mirza Abdozzaki ventured: "My dear friend, suppose they win. Should we think about the Followers of Truth or not?"

Torab said: "Of course, we should. But why should you have been chosen for the purpose, huh? You must really be fond of your wife, dear Seyyed."

Instead of Mirza Abdozzaki, who was being addressed, Mirza Asadollah said:

"Unless he wanders off into the desert."

At this moment, the four reached one of the trenches outside the city walls. A small fire was burning, which reflected a trembling, long,

huge shadow of a cannon on the city wall. The five cannoneer Calenders arose hurriedly, greeting them with "Allah, Allah," and then dropped their heads. Torab Tarkashduz greeted them, examined the cannon and said:

"For the time being, the destiny of all of us is tied to the mouths of these cannons. If we were the kind of people who would want to make a deal, we would not have cast cannons. For now, go and rest, because in a few days, you will not find the time even to sleep."

On their way back, our scribes and Hasan Aqa were silent for a while. Then Mirza Abdozzaki, as if talking to himself, said:

"No, my dear friend, now it is different." And he was silent again.

Mirza Asadollah asked: "What is different, Seyyed?"

Mirza Abdozzaki answered: "Everything, my dear friend. Darakhshandeh, you, the Followers of Truth, and I. Now I am not the only one facing Khanlar Khan. And Darakhshandeh is almost tying herself in the warps and wefts of the carpets. Yes, my dear friend."

And they were silent again. They arrived home very late. Each stayed awake until dawn, thinking. The next morning Zarrintaj Khanom set out for work as usual. Since their visit to Hasan Aqa's house, she had set up five carpets in Haji Mamreza's house, with the help of Darakhshandeh Khanom. Nowadays, she would only drop by to look over the carpet weavers at Mirza Abdozzaki's house, who now had Darakhshandeh Khanom as their master weaver, and then she would go to Haji Mamreza's house, where she spent the rest of the day. When Zarrintaj Khanom arrived, she called Darakhshandeh Khanom, took her to a quiet corner of the house, and said:

"Sister, the situation seems to be changing for the worse again."

Darakhshandeh Khanom said: "Oh, sister, what business is it of ours? A carpet is always a carpet and will always have a buyer."

Zarrintaj Khanom said: "Well, sister, what if they get our husbands in trouble?"

Darakhshandeh Khanom said: "What trouble? Have they gained even a horse or a mule from all this? What have they gained from all this Calender business? And besides, do you think it would sink into this seyyed's head? I tell him: 'Man, leave this Calender business.' Do you think he listens? Now, what do you think might happen?"

Zarrintaj Khanom said: "Nothing, sister. I am only saying this as a precaution. The government troops might be returning. And when the troops are back, they won't look to see if anyone has taken any horses or mules. After all, sister, both my husband and yours have gone and helped these people. You can't hide that. And you know that they are not thinking about themselves. They say the troops have four hundred cannons; have you heard that?"

107

Darakhshandeh Khanom said: "Oh sister, are you forgetting the Calender-made cannons? But you are right, though. Remember the cannons that exploded?"

Zarrintaj Khanom interrupted her and said: "No, sister, it is not all that bad. But the Calenders have a hundred and twenty cannons altogether. In any case, we have to think about what might happen some day."

Darakhshandeh Khanom thought for a moment and said: "You know, sister, last night my husband came home and told me the story about Khanlar Khan. I suppose your husband also told you. I have thought it all through. Poor man could not sleep all night. We talked about everything. You know, sister, other women have to carry their loads for a whole nine months, but I am my own boss. I hang my load on the carpet loom, and for as long as I want to. Then I can bring it down. It is true that all the carpets in the world are not worth a single strand of Hamideh's hair, but everybody's lot is different. May God bless you and Mirza, who opened my eyes. I told my husband not to worry at all. I wouldn't even spit in the face of that wind bag. But I am prepared to fool him. I will show him what a helpless woman can do."

Zarrintaj Khanom jumped up, kissed Darakhshandeh Khanom's face and said:

"I knew it, sister. Someone who would flit around wouldn't be able to stick to any kind of work. By the way, tell me, did the girl who cut her finger with wool yesterday come to work today?"

Darakhshandeh Khanom said: "No, sister. I am afraid she might have gotten herself in trouble. Would you drop by the physician's house on your way and ask him, if it is not too much trouble, to pay her a visit? I don't know why, but half the carpet weavers have not shown up today."

Zarrintaj Khanom said: "Don't you know? The people are fleeing the city. You really are wrapped up in your work, sister."

Darakhshandeh Khanom said: "So this is really serious, isn't it? Well, while you make your rounds, I will also put on my veil and call on that wind bag."

Here, they ended their conversation and left the house together. Darakhshandeh Khanom set out for the Palace and Zarrintaj Khanom went to the late Haji Mamreza's house. You have no idea how crowded the streets were. People, mostly on foot and some riding, were carrying all their belongings on their backs or in pushcarts, and men, women and children were headed towards the city gates. The upcoming war and the recent famine that had brought the people to their knees had frightened them more than ever. So anyone who could would gather up his belongings, lock up his house leaving it to God, and flee with his wife and children. The Calenders could have asked for nothing better. The smaller the population of the city, the smaller the food supplies

they would need. Besides, the cannons of the government troops would kill fewer people. Furthermore, they would be able to act more freely. So, the announcement was made throughout the city by the town criers that, children being exempt, any two adults must pay only one gold coin as a toll to leave the city. Thus in a couple of days the city was almost deserted, and except for a few of the poor people, the Calenders themselves or the secret agents of the government, nobody remained.

Dearest reader, it was the feast of *Chaharshanbehsuri*, which is celebrated on the eve of the last Wednesday of the year. The sun was still on the horizon and a few people in the city still had time to get the bushes to burn in the celebration when the muffled sound of cannons was heard from south of the city. The people forgot about everything else and climbed up to the highest roofs of the houses they knew of in their neighborhoods. The sun still had not set when dust rose up in the distance on the road, and then twenty or thirty riders appeared. The riders had not yet reached the city gates when suddenly the rumor spread through the city that the cannons in the Calender camp on the mountain pass to the south of the city had been destroyed and that the government troops would arrive that very evening to massacre the populace. So the people were again frightened, and those who had stayed on came out of their houses, wondering what to do. Suddenly, they rushed towards the mosques, which they had not even visited for six months, and instead of celebrating by jumping over bonfires, they placed Korans on their heads and prayed all night. Perhaps for this reason, they did not realize that that very night a group of a hundred Calender horsemen quietly and abruptly ambushed the government troops camping at the foot of the mountain, and set a part of the camp on fire. They took some two hundred fifty horses as booty and returned. The next morning, when the Calenders pranced the captured government horses around the city to show off the brands on their hindquarters to the people, the people's fear subsided somewhat and they went back to their work and businesses.

Of course, there was no sign of the government troops that day. However, close to sunset, once again dust rose up on the road south of town and the advance guards of the troops were seen. At night, when the government troops camped, their campfires could be seen only a parasang away. So the people became frightened again and rushed back to the mosque to plead with God all night. As for the other side, another night attack would have been impossible. But the Calenders had the situation under control. Two hours before sunrise the next day, all the people of the city were awakened by the deafening sound of the Calenders' artillery, and once again the people went on the roofs to see the government troops in deep trouble, trying to retreat. Apparently, the Calenders, in order to fool the troops, had sent their smallest short-range cannons to the mountain pass. The troops thought that all Calender-made cannons were of the same range, and with much daring

they had come and camped within a distance of one or two fields from the city. They did not know that when the Calenders succeeded in taking over the city, they had gained access to a good number of brass mortars and had made their cannons much longer and heavier. The range of these new cannons was easily more than the distance of two fields. So the government troops once again suffered losses and were forced to retreat, leaving five carts of food supplies behind, which the Calenders carried into the city with the help of the people and distributed among the starving people. Again, the fear of the people subsided.

Of course, the Calenders knew that if they were going to face a lengthy siege, they would be defeated in a month. But they were hoping to make a move once every few nights, take something from the troops, and make them retreat more in order to liberate the large farms in the vicinity of the city. Hence, on the third day of the siege, they divided their cannons into two groups. They moved one group before the city gates and the second group to a city square facing the government troops for future attacks. However, the government troops, who had learned their lesson from the first encounter, surrounded the city. Every regiment and battalion had camped in some part of the desert. Now, the distance of none of these groups was less than a parasang from the city. There was no use in engaging in combat, so both sides sat waiting. A week went by and no one noticed that New Year had come and gone. The remaining inhabitants of the city, instead of celebrating the New Year, growing the traditional greenery and engaging in spring cleaning, would gather in the mosques with their Korans, praying.

On the other hand, when the secret agents of the government saw that the troops did not have the courage to attack and that the Calenders would have the upper hand for some time to come, they began making their own preparations, because they all knew that if the siege would last for long and His Majesty would become tired of it, the court astrologer might once again consult the stars and dissuade the troops from taking the city, thus wasting all their own efforts. Or, if the city were taken after some fighting, His Majesty might get angry and issue orders for a massacre, to make towers out of chopped-off heads and run the mills with the blood of the people, without pity for children or adults. So, not one, two or three days, but a whole week they held secret meetings, met with Khanlar Khan and Mizanoshshari'eh in secret, and consulted with them on what they were to do. Finally, guided by Khanlar Khan, they decided to go at night to open the secret water passage in the Palace and flood the gunpowder storage with the water from the moat. The good thing was that it was spring, and, since there was plenty of water, the water guards would be on vacation. As for the Calenders, they had taken their cannons away from the moat, and nobody would find out what was going on. So, one night, a hundred

secret agents set out with picks and shovels and quietly reached the largest city dike, which would open up to the Palace and which had been closed up by the Calenders at the beginning of the siege. Within two hours, they released the water, which quietly ran through the secret water channel of the Palace. They made holes in one or two of the walls and let the water run out. By dawn, the water reached the gunpowder storage. What had occurred became known to everyone when in the morning the women in the harem ran out of their rooms without their veils and footwear, for there was a flood the color of black tar.

The news reached Torab Tarkashduz, who realized all was lost. He immediately issued orders to stop movement to and from the Palace, close the city gates and stop even the flight of messenger pigeons. Then he sent for Khanlar Khan, who was dragged in. Before the Calenders could kill him with kicks and punches, Torab Tarkashduz remembered the night when Mirza Abdozzaki had brought a message from him. So he asked the Calenders to stop and held a private meeting with Khanlar Khan. After an hour, he came out and immediately summoned the Calender leaders for consultation. When about thirty Calender leaders were present, the consultation began. First, they exchanged reports and then Torab Tarkashduz began to talk:

"Tonight the government troops will find out about the flooding of the gunpowder storage, by tomorrow at the latest. Then our hands will be tied and before we are able to get gunpowder, it will be too late. You will remember that the envoy of the Sunnis was not much help either. The government was a better business partner for them. In our case, we had nothing to offer except to prohibit the killing of Sunnis. Khajeh Nuroddin has gone in person and has given them the seven border cities in exchange for four hundred cannons. In other words, he has leased them for six months. If we could put up resistance for this period of time, there would be no problem. We made it through a very severe winter. Alas, none of us thought about protecting the gunpowder storage. In addition, as soon as the weather gets warm, the ants will come out of their nests. With our reputation for confiscating and distributing land, tomorrow each one of the khans and feudal landowners might come to help the government. Given this, the only advantage in our staying is to become a negotiation tool in the old enmities between the khans and highway robbers. But, if we save our lives, we might at least keep the spark of Truth burning. Since we took over, we have only spilled blood thirty times, ten of whom were our own people. It is true that in order to prevent killings, one must at times be willing to kill or be killed, but at present we are not in a situation which would require mass suicide, and our staying on would mean mass suicide. Therefore, we must leave the city."

Mowlana, whom we met earlier, asked: "Where to?"

Seyyed said: "This is the next problem. First we must see if it is in our interest to leave or not. In my opinion it is."

Since everyone agreed, Torab Tarkashduz continued:

"When we were disappointed in the envoy of the Sunnis, we sent Seyyed to the Indian Court, where, as you know, they advocate Universal Peace. Seyyed returned from India last weekend with an invitation. I believe that if we could handle the troubles on the road, it is in our interests to accept this invitation. But how can we take this long road safely? Khanlar Khan has come offering us a deal. He says, if we take the women of the harem with us, not only will they not bother us, but five hundred gold coins will be paid for every woman. And they have the divorce papers ready. As you know, the legal waiting period required to finalize their divorces has ended. Apparently, there are some three hundred odd in number. I think such a harem would at least make a good gift to the Indian Court."

Mowlana interrupted Torab and complained:

"If I am not mistaken, the mission of our uprising is ending in pimping."

Some laughed and some began to think. Torab Tarkashduz smiled and continued:

"Would you like us to wed all of them, Mowlana? In any case, a new harem of horny women from the tropics has been put together for the Court and the old one is now in the way. It is in our interests to select the youngest and prettiest ones to take along, those who can both survive the long trip and also be appetizing gifts for the Indians. I told Khanlar Khan that this deal can be made if he comes along with us as a hostage up to the border. Now, before you state your views, Seyyed will read you the text of the invitation of the Indian Court."

The seyyed read the text of the invitation and after an hour of consultation about which road to take, what to take along, and what guarantees they should secure, they finally decided to start on their way that night. Then they assigned tasks.

A group of Calenders was assigned to occupy the government troops with battle all day, with hit-and-run tactics that would tire them enough that they would sleep soundly that night. At night, they would burn the bonfires beside the cannons brighter than ever and then they would catch up with the others in time. Another group was assigned to pack up all the food and ammunition in saddlebags. One group was assigned to widen the starter holes of the cannons, and one group was assigned to gather up all the horses and mules in the city. When all the tasks had been assigned, they decided to meet three hours after dark by the eastern gate of the city.

Dearest reader, Hasan Aqa was one of those present in the consultation meeting. After the meeting, first he went to the Palace where he found Mirza Abdozzaki and told him the whole story. He told

him to wrap up his business and be ready at the appointed time. Then he asked him to go to Mirza Asadollah and ask him to get ready to leave. So Mirza Abdozzaki rushed to the Packsaddlers' Tekke, where neither the rifle-carrying Calenders could be seen hanging around the halls and the courtyard as usual nor any of Mirza Asadollah's colleagues. Only Mirza Asadollah was sitting behind his desk, alone, copying a book of poetry. Clearly, it was all over. After greetings, Mirza Abdozzaki briefly explained the events as well as the results of the Calenders' discussions. Finally, he said:

"In any case, my dear friend, the Followers of Truth will leave tonight. Starting tomorrow, it will be the same old story again."

Mirza Asadollah said: "You will, no doubt, leave with them?"

Mirza Abdozzaki said: "Of course, my dear friend; I do value my life, you know. These are no longer the times of Leyli and Majnun, for me to sacrifice both my reputation and my life for a woman. And I have talked it all over with Darakhshandeh. Thank God, she doesn't need me. In fact, my dear friend, you should also leave."

Mirza Asadollah asked: "Why? What has happened? This was all a fever which has now subsided."

Mirza Abdozzaki said: "My dear friend, do you think you are dealing with angels? The first person who will be coming after you is the Chief Constable's deputy. My dear friend, have you forgotten when we went to the village what we did to him? You and I have helped these people, my dear friend. That means we are partners in their crimes. Don't you realize that this government is founded on grudges?"

Mirza Asadollah said: "I know, Seyyed. But I have not committed any crime."

Mirza Abdozzaki said: "I don't understand, my dear friend. If the troops come, the first person they will arrest is you. With your past record and present work in the Court of Justice, my dear friend, do you think they will come to give you a crown of glory?"

Mirza Asadollah said: "Well, and then?"

Mirza Abdozzaki said: "Then, nothing, my dear friend. Do you want to sacrifice your life? Do you want to be martyred? This business of martyr worship of yours is now turning to martyrdom exhibitionism, my dear friend."

Mirza Asadollah said: "What can I say to that, Seyyed? But now I know why one accepts martyrdom. Because he has lost the game and is unable to escape. So he stays on to suffer the consequences of his loss. When a person runs away from something or somewhere, it means that he can no longer tolerate that thing or place. And I want to be able to tolerate it. For me, this is only the beginning of the test."

Mirza Abdozzaki said: "You see, you are mimicking a martyr, my dear friend. Wasn't it enough for us to mourn the martyrs so much for so long? We leave the action to others and content ourselves with

113

pretending to be martyrs. My dear friend, this is why we are always lagging behind. Have you forgotten that you used to say that one must have a plan beforehand? Well, my dear friend, this escape is also a plan. It is preparation for later. My dear friend, this is also a kind of resistance."

Mirza Asadollah said: "No, escape is not resistance. It is leaving the battlefield. One who runs away strips himself of honor. Even in a game, you must either win or lose. There is no third alternative. It is not a bazaar transaction, with a middleman in the middle. It is the business of truth and falsehood."

Mirza Abdozzaki said: "My dear friend, you are really talking like a martyr. You even believe it."

Mirza Asadollah said: "Then, did you think we were playing a game? Do you remember how hasty you were and how hesitant I was? And besides, where will you escape to? What color do you think the sky is over India? The sound that you hear in the distance is the sound of empty drums."

Mirza Abdozzaki said: "My dear friend, I said that we will go to prepare ourselves for the next resistance."

Mirza Asadollah said: "No, you are finished. This was an adventure for you, and it is all over now. Mine, however, has just begun. For me, the most effective kind of resistance against oppression is martyrdom, although I am not worthy of it. As long as there is a government of oppression and we are unable to do anything, justice can only be kept alive through the memory of martyrs."

Mirza Abdozzaki said: "You see, my dear friend, you are finally confessing. In the end, so many memories of justice have been buried with the bodies of so many martyrs. How have they helped overturn injustice, my dear friend? And now you want to act like a martyr?"

Mirza Asadollah said: "The fact that you and I moved with hope means that we had those martyrs before our eyes. We wanted to preserve their legacy. Do you know, Seyyed, it is true that martyrdom does not stop injustice against the lives and property of people, but it wipes the domination of injustice from the spirit of the people. The memory of the martyrs governs the people's spirits. And this is the burden of trust. People give up their bodies to the domination of injustice, but not their spirits. This is precisely the legacy of humanity. This is what will reach the next generation aside from the rotten book of history."

Mirza Abdozzaki said: "After all, my dear friend, if the goal were merely to resist injustice, what you say would make sense. But, my dear friend, resistance is not a goal. The elimination of injustice is the goal."

Mirza Asadollah said: "You see that it did not work, despite the fact that we even had cannons."

Mirza Abdozzaki said: "I have a thousand things to do, my dear friend. Will you come or not?"

Mirza Asadollah said: "No. Starting tomorrow, I will go to work at the door of the Grand Mosque."

Mirza Abdozzaki said: "So, my dear friend, you have decided to sacrifice yourself for nothing, right?"

Mirza Asadollah said: "No. I want to reconcile my life."

Mirza Abdozzaki said: "You, my dear friend, will lose your life by staying."

Mirza Asadollah said: "No. I want to test myself one more time. I will stay and give meaning to my life."

Mirza Abdozzaki said: "My dear friend, your children are the meaning of your life."

Mirza Asadollah said: "No. If in compensation for all the blessings that I have wasted, I am able to give something, I will have given meaning to my life. My children are the natural continuation of my life, they are my natural continuation. They are not the human meaning of my life. When a seed falls off the tree, it must grow. But I was not a tree. I did not live the life of a plant. In my stead, anyone else could have been a father, the father of these or any other children. But no one else can and no one has been able to be Mirza Asadollah the scribe, who writes letters at the door of the mosque. I am the only one who has carried this load. I cannot leave it halfway down the road and run away. I must carry it to the end."

Mirza Abdozzaki said: "My dear friend, I have looked up to you all my life. I have envied you all my life. But in this final turn, I cannot follow in your footsteps. You are really being pigheaded, my dear friend."

Mirza Asadollah said: "Instead, you will be free, Seyyed. You will be all by yourself. After all, there is a you and there is an I. And as for your wife, you have nothing to worry about. Only, tell her not to give up carpet weaving. Zarrintaj may also be able to raise the children through her carpet weaving. And make a visit to Mashhadi Ramazan, the grocer, and Hasan the Fiddler. Ask them; they might go with you."

Here, their conversation ended. Mirza Abdozzaki wept all the way home. All that day, while the people in the city were busy quarrelling over bread and food and the tattoos on their hands, the Calenders were secretly packing up, loading up the remaining gunpowder, destroying the cannons, grooming the horses and mules, selecting their best rifles and breaking or burning the rest. When the city went to sleep, they respectfully mounted Khanlar Khan on a horse, and, along with one hundred twenty young women of the harem seated on palanquins, set out for India through the eastern gate of the city. But their bonfires by the cannons burned until midnight.

Next morning, the people of the city, headed by Mizanoshshari'eh and the secret agents, bareheaded and barefooted, with Korans on their heads and bread and salt on trays, came out of the city gates to welcome the government troops. His Majesty, who was still asleep, awoke to the weeping and wailing of the people. Mizanoshshari'eh and seven of the bazaar merchants who were freed that very morning from the jailhouse were given audience. Mizanoshshari'eh offered congratulations and prayers. He expressed his concern for what had befallen Khanlar Khan. His Majesty mounted his horse before breakfast and entered the city with pomp and glory. It is true that all the Calenders had escaped, but lo and behold, so many people were arrested and jailed! Two hundred houses in the city were plundered, mostly the houses of those who had fled before the seige. Seven persons of no particular consequence were sacrificed before His Majesty's steed, purportedly as the leaders of the Calenders, and a thousand more were arrested and put in jail. The next morning, in front of the Palace Gate, seven prisoners were hanged, and seventy others were scalded with burning candle wax or stuffed in cowhides and sewn up or had molten glass poured in their eyes or were dipped in tubs of boiling water. It was also decided that seven hundred people would be sent into exile, and the rest, those who paid tributes, were freed. Those who could not grease someone's palm were left in the corner of the jailhouse.

Dearest reader, among the characters of our story, Mirza Abdozzaki and Hasan Aqa and his brothers left with the Calenders. Mashhadi Ramazan, the grocer, who was fed up with his life and did not want to go with the Calenders, was captured and scalded with burning candle wax the next day. Hoseyn the Fiddler, who had spent his whole life entertaining in feasts and celebrations, stayed behind and was arrested. His remaining hand was split in two lengthwise and he was hanged by the feet. Asadollah's uncle spent all he had in one day; and, with the help of the elders of the city and bribing Mizanoshshari'eh, the Chief Constable, the Civil Magistrate and his deputy, he was able to put Mirza Asadollah's name on the list of those to be exiled. Now, let me tell you about Darakhshandeh Khanom, who not only did not go to Khanlar Khan's harem, she even saved the house of the late Haji Mamreza from being plundered because it was being used for carpet weaving. Gradually, her work became so popular that her handmade carpets were known from St. Petersburg to China. Zarrintaj Khanom and her children moved to the uncle's house. The corpses were still on the gallows, and the corn poppies were just starting to bloom in the alfalfa fields under the mulberry orchards around the city, when early one morning, Asadollah's uncle set out with Hamid carrying Mirza Asadollah's sandals, vest, and staff to the jailhouse, where Mirza put them on and wandered off into the desert.

EPILOGUE

...And now, let us return to the story of our own shepherd, who became a vizier in the manner in which he did and died as he did.

Well, dear reader, as you know, after the death of our shepherd vizier, his sons returned to the city and, lacking any particular skill, they became partners in running a school. But, as the saying goes, "If having a partner were such a good thing, God would have taken one on for Himself." The two brothers did not get along, especially given the fact that running a school was not that profitable in that day and age. One could barely make a living for two families at it. So, one brother sold his share of the business to a stranger and went in search of the friends and acquaintances that he had acquired at court during the time of his father. He spent all the money he had made from the sale of his share of the school on bribing one person or other, and he finally became a Court Scribe. After passing through all sorts of stages and positions, he was, in the end, appointed the Court Poet Laureate. But the other brother, whose skin was much tougher, managed to remain a schoolmaster and eventually bought out the stranger's share and became a well-known teacher in the city. As fate would have it, and as storytellers have reported, our tale was written by that very schoolmaster, who left it as a legacy. But the storytellers have been divided into two groups. One group says that our story was written by Mirza Abdozzaki, who accompanied the Calenders to the Indian Court, where Zoroastrians, Jews, Moslems and Christians dined around the same supper cloth, and at the time when Shi'is and Sunnis were busy killing each other, they spoke of Universal Peace. Another group of storytellers say that this was not the case and that our story was written by Mirza Asadollah after twenty years of Calender life and travels, because at the end of one of the extant manuscripts of the story we read:

"Dear son, if you remember, one day we were talking about inheritance, and I told you certain things that I do not think you understood. In any case, this story is my legacy to you, your inheritance. And you should also know that my father had left me another inheritance, which, alas, I could not leave to you. It would not be of any use to you anyway. Do you remember the torn shepherd's vest, the sandals, and the staff which your mother was always fussing

117

about? Yes, dear son, those were also left to me as my inheritance from my father, and now they have become useful to me."

But to us, who are neither storytellers nor historians, it makes no difference who wrote the story. So, we finish our story to have time to concern ourselves about the "happily ever after."

GLOSSARY OF TERMS

'Abbâsi: a monetary unit named after Safavid Shâh 'Abbâs I (ruled 1587-1629), then equivalent to 4.64 grams in silver or gold. By the end of the 19th century, an *'abbâsi* equalled two hundred *dinârs* or four *shâhis*.

Abjad (letters): a system of calculation in which every letter of the Arabic alphabet is given a numerical value. For more, see G. Weil and G.S. Colin, "Abdjad," *Encyclopaedia of Islam: New Edition* 1 (1960): 97-98.

alef: the first of thirty-two letters in the Persian alphabet, which is based on the Arabic alphabet with the addition of four letters.

'Ali (d. 660): the cousin and son-in-law of the Moslem Prophet Mohammad (c. 570-632) and the fourth caliph of Islam. More importantly for Iranian Shi'i Moslems, 'Ali is the first of twelve *emâms*, including his two sons Hasan and Hosayn and the latter's descendants, who are held to have been the legitimate successors to Mohammad. For more see *emâm* = imam, and H.A.R. Gibb, "'Ali b. Abi Talib," *Encyclopaedia of Islam: New Edition* 1 (1960): 381-386.

"And lo! Those who disbelieve": a Koranic verse, LXVIII: 51.

Anushirvân: Khosrow (Chosroes) I, known as Anushirvan the Just, the famous Sasanian king who ruled from 531-579.

âqâ: An honorific used to address and refer to males, *âqâ* is not, however, used as "Mr." can be in English to refer to oneself. *âqâ* can appear before a surname as in the phrase "âqâ-ye Tehrâni" [Mr. Tehrâni] or after a given name as in "Ahmad âqâ." The second construction is used in addressing servants or working class acquaintances, intimate friends, and relatives. By itself, *âqâ* can mean "Mister" or "Sir" as in "bebakhshid, âqâ" [excuse, me, sir]. In Shi'i Moslem parlance, *âqâ* can respectfully denote a religious leader.

'Ashurâ: the name of the tenth day of Moharram, the first month in the Islamic lunar calendar. On this day in the year 680 Shi'i Emâm Hosayn and his followers were slain in battle with the forces of the Caliph Yazid on the plains of Karbalâ. For more on the day in general, see P. Marçais, "'Ashûrâ," *Encyclopaedia of Islam: New Edition* 1 (1960): 705.

Ashtar Pokhtor: probably a reference to "Eshpokhtor" [inspector], a name given by Iranians to the Russian commander Tesit Sianov at the time

119

of the Russo-Persian wars during the reign of Fath'ali Shâh Qâjâr (ruled 1797-1834).

Azrael: the angel of death and one of four archangels in Islam. When it comes time for a human being to die, a leaf with the person's name on it falls from a tree beneath the throne of Allâh. Azrael (= 'Ezrâ'îl) reads the name and is responsible for separating that person's soul from his/her body after forty days. For more, see A.J. Wensinck, "Izrâ'il," *Encyclopaedia of Islam: New Edition* 4 (1978): 292-293.

Behârol'anvâr: title of the most famous collection of Shi'i traditions (written 1659-1694), published in a 110-volume edition in Tehrân (1956-1972). Its author is the Safavid theologian and scholar Mollâ Mohammad Bâqer Majlesi (1627-1698), the most influential Shi'i author ever.

Biruni, Abu Rayhân (973-c. 1050): a Persian-speaking scientist and scholar who wrote in Arabic and was a prominent figure in the Ghaznavid court, accompanying Sultan Mahmud on expeditions to India. For more, see D.J. Boilot, "al-Bîrûnî," *Encyclopaedia of Islam: New Edition* 1 (1960): 1236-1238.

Bizhan and Manizheh: legendary lovers immortalized in Ferdowsi's *Shâhnâmeh* [Book of Kings]. Their story is presented in Reuben Levy's synoptic prose translation called *The Epic of the Kings* (London: Routledge & Kegan Paul, 1967), pp. 152-172.

Cabbageheads: reference to Shi'i clerics, alluding to the shape of their turbans.

Calender: According to Webster's *Third International Dictionary of the English Language Unabridged*, the word derives from the Persian *qalandar* and denotes "one of a Sufic order of wandering mendicant dervishes." *Qalandar* is the word Al-e Ahmad uses in the novel. For more, see "Introduction," p. xx.

Chahârshanbeh'suri: a traditional Iranian New Year's gathering on the final Tuesday evening before the beginning of spring, at which people jump over small fires while ritually calling for the fire to draw the (yellow) sallowness of the old year from them and to inspire them with (red) life of the new year. For more, see **New Year.**

Divân: the collected, nonepic verse of a traditional poet.

Emâm: see **Imam.**

Ghazal: the most important traditional Persian lyric verse form, consisting of between four and thirteen or so couplets, the first closed and the others open, with an overall rhyme scheme of aa, ba,ca,da, etc. Love is the basic subject of ghazals, and Hâfez (c. 1320-c. 1390) the most famous ghazal poet in history. *Hafez, Dance of Life* (Washington, D.C.: Mage

Publishers 1988) provides a multidimensional introduction to Persian ghazals.

God's Grand Name: Among Allâh's many epithets, one is believed to be *esm-e a'zam* [the grand name], and is a mystery. A person with the knowledge of this name is believed to possess great powers of the unknown.

Hâji: the title given to a Moslem male who has made the *hajj* or holy pilgrimage to Mecca incumbent at least once in a lifetime upon Moslems with the health and means to do so. A woman who makes the *hajj* is called *hâjiyeh*. For more on the hajj, see David E. Long, *The Hajj Today: A Survey of the Contemporary Makkah Pilgrimage* (Albany: SUNY Press, 1979).

Hallâj, Mansur (c. 857-922): the famous Arabic-speaking mystic who was tried, convicted, and beheaded in Baghdâd by the caliphal authorities for blasphemy, for having reportedly said "Anâ'l-haqq" [I am the creative truth, i.e. God]. For more, see L. Massignon and L. Gardet, "al-Hallâdj," *Encyclopaedia of Islam: New Edition* 3 (1971): 99-104.

Haydar and Safdar: titles of the Prophet Mohammad's son-in-law 'Ali. For more, see **'Ali.**

Haydaris and Ne'matis: followers of two Sufi leaders Soltân Mir Haydar Tuni (d. 1426/7) and Shâh Ne'matollâh Vali (d. 1431). The proverbial expression "Haydari-Ne'mati quarrel" can refer to any factional conflict, especially hostility rooted in popular religious fanaticism. For more, see Hossein Mirjafari, "The Haydarî-Ni'matî Conflicts in Iran," translated and adapted by J.R. Perry, *Iranian Studies* 12 (1979): 132-162.

Hosayniyeh: a term used for Shi'i teaching and gathering centers named after the third imam. The most famous was Tehrân's Hosayniyeh-ye Ershâd, where the social reformer 'Ali Shari'ati (1933-1977) lectured from 1967 until his arrest by Pahlavi authorities in 1973.

Imam: The term denotes, first, a person who stands in front of the ranks of praying Moslems and leads community prayer. In Iran, the term *emâm-e jom'eh* [Friday imam] is used for a religious leader in any community who leads the Friday community prayer. In Arabic and among the Sunnis, the term is also used to refer to a man learned in Islamic sciences. For Shi'i Moslems, an imam is a hereditary successor to the Prophet Mohammad as leader of the Moslem community. For Twelver Shi'is, there are twelve imams, all considered divinely guided, infallible and sinless, the last of whom is the called "Imam of the Age." For more, see "Imam of the Age" and W. Madelung, "Imâma," *Encyclopaedia of Islam: New Edition* 3 (1971): 1163-1169.

Imam of the Age: the "Mahdi" or "Hidden Imam," the twelfth Shi'i imam who disappeared in 873 and is expected to remain in occultation until the end of time when he will establish a universal order of justice.

Jafrdân: *jafr* means "hidden knowledge"; while *dân* is a verb stem denoting "knowing." Therefore, the surname or title "Jafrdân" means one who possesses esoteric knowledge.

Kalim Kâshâni (d. 1650): a Persian ghazal poet from Hamadân who lived a long while in Kâshân and was named poet laureate in Mughal India during the reign of Shâh Jahân (1628-1659).

Karbalâ: the Iraqi desert site where Hosayn, the younger son of 'Ali and the third Shi'i imam, was killed along with seventy followers by the forces of the Omayyad Caliph Yazid ibn Mu'âwiyah on 10 Moharram 61 AH (= 680 CE). For more, see **Killing the Imams.**

Kaykhosrow: a legendary Iranian king of the Kayâni dynasty treated in Ferdowsi's *Shâhnâmeh.* The great legendary hero Rostam served Kaykhosrow and other Kayâni monarchs.

Khâjeh Nasiroddin Tusi: see Nasiroddin Tusi.

Khânlar Khân: the name alludes satirically to Parviz Nâtel Khânlari (b. 1913), the Pahlavi-era official, educator, scholar, and literary figure. For more, see "Introduction" above, p. xxi.

Khânom: an honorific for woman denoting "lady," "madam," and the like, it can appear before a surname in contemporary Persian or following a given name.

Killing the imams: a reference to eulogististic accounts of the martyrdoms of the Shi'i imams, especially Hosayn. On dramas about these events, see Peter J. Chelkowski, editor, *Ta'ziyeh: Ritual and Drama in Iran* (New York: New York University and Sorush Presses, 1979).

korsi: a traditional heating apparatus consisting of a stool or low table under which a brazier full of glowing crushed charcoal is placed and over which a quilt is stretched, covering the torsos of persons seated around it, cushions at their backs.

Kuchek Khân, Mirzâ: a landowner and liberal intellectual who organized a 1915 meeting in Tehrân to plan social and political reform. His followers were called "Jangali" [forest men], and they fought the Russians and the British in Gilân. Later, as the leader of a separatist movement in Gilân with Bolshevik ties, Kuchek Khân was defeated by Rezâ Khân in 1921. For more, see Richard W. Cottam "Separatist Movements," *Nationalism in Iran* (Pittsburgh: University of Pittsburgh Press, 1979), pp. 102-106.

Layli and Majnun: legendary Arab lovers. Having lost his heart to Layli, Majnun also loses his mind; his name in Arabic means "crazed." For more on the treatment of the legend in Persian literature, see J.T.P. de

Bruijn, "Madjnûn Laylâ," *Encyclopaedia of Islam: New Edition* 5 (1986): 1103-1105. Nezâmi's famous verse version of the story is available in a condensed prose translation by R. Gelpke with E. Mattin and G. Hill called *The Story of Layla and Majnun* (Oxford: Cassirer, 1966),

Majles al-Bokâ: "Gathering of Tears," a traditional compendium of stories for Shi'i mourning.

man: a variable unit of weight, most commonly equivalent to approximately 3 or 6 kilograms.

Mashhad: The major city in the eastern part of Iran, Mashhad grew as a result of being the burial place of Rezâ, the eighth Shi'i imam, who died there in 818. In fact, the originally Arabic word "Mashhad" means "place where a martyr is buried."

Mashhadi: the title given to a Moslem who has made a pilgrimage to Mashhad to the shrine of the eighth Shi'i imam Rezâ (d. 818) in whose honor a great shrine was built.

Mazdakites: adherents of a religious movement during the later Sasanian Empire (224-640s). It ended with the execution of its leader Mazdak and many of his followers in 524.

Mirzâ: an abbreviated form of *amirzâdeh* [born of a prince] and can denote prince, as in its use in the name Iraj Mirza (1885- 1925), the Qâjâr poet and royal family member. It is also used as an honorific for males and denotes a secretary or scribe, and is used in the novel in this sense.

Mizânoshari'eh: the Congregational prayer leader or imam.

Moharram: the first month of the Islamic lunar calendar year; see **'Ashurâ**.

Mohtasham Kâshâni (d. 1587): a Safavid poet best known for verses commemorating Shi'i imams.

Nasiroddin Tusi, Khâjeh (1201-1274): an astronomer, chronicler, and politician with Shi'i sympathies who served the Mongols. His most famous work is available in English as *The Nasirean Ethics*, translated by G.M. Wickens (London: Allen & Unwin, 1964).

Nasta'liq: a cursive calligraphic style used in Persian writing.

New Year: called "Nowruz" [New Day] in Persian, the most traditional and joyous event in the Iranian solar calendar year. It begins on the vernal equinox, March 21st usually, the very first day of spring. New Year's customs include anticipatory spring house cleaning, the purchase of new clothing, presentation of gifts by older to younger family members and of bonuses and special *aydi* [holiday gratuities] to employees and workers, a

ritual New Year's fish and rice dinner, visits to the homes of friends and relatives, and much more. It is an extremely sociable time that officially begins on the last Tuesday evening before the New Year with a traditional gathering called Chahârshanbeh'suri (for more, see **Chahâr-shanbeh'suri**). The official end to "Nowruz" celebrations comes on the 13th of Farvardin, the first month in the Iranian solar calendar, when everyone leaves home for a picnic or other outing because staying at home is assumed to bring bad luck. The old year's atmosphere thus leaves the home, and fresh new air will be brought back.

Nezâmolmolk (d. 1092): the famous vizier of the Saljuq Sultan Malekshâh and author of a famous treatise on politics available in English as *Book of Government*, translated by Hubert Darke (London: Routledge & Kegan Paul, 1960).

Night of Holy Strangers: the evening of the tenth day of Moharram called "'Ashurâ." For more, see **'Ashurâ**.

Qalandar: see **Calender**.

qanât: a "gently sloping tunnel dug horizontally into an alluvial fan until the water table is pierced. Water filters into the tunnel, runs down its gradual slope, and emerges on the surface as a stream." Paul W. English, *City and Village in Iran* (Madison: University of Wisconsin Press, 1966), p. 30. For a diagram of a typical *qanât*, see ibid., p. 31.

qerân: or *riyâl*, one-tenth of a *tumân*, a basic unit of Iranian currency. In the 19th century, it was a silver coin, equal to one *riyâl* or 100 *dinârs*. Today, it is a term still synonymous with *riyâl*, which is valued officially at $.07 USA (October 1988).

Rostam: the most famous Iranian hero of legend, the leading heroic figure in Ferdowsi's *Shâhnâmeh* [Book of Kings]. Among his many feats was the slaying of the White Demon. Rostam appears in English literature as one of the two protagonists in Matthew Arnold's famous *Sohrab and Rustum* (1853). The handiest English translation of Ferdowsi's *Shâhnâmeh* is Reuben Levy's synoptic *The Epic of Kings* (Chicago: University of Chicago Press, 1967).

Rumi, Jalâloddin (1207-1273): the greatest Sufi poet ever, whose Persian *Masnavi-ye Ma'navi* [Spiritual Couplets] and *Divân* [Collected Lyric Poems] are classics of gnostic verse. For more, see Talat S. Halman, "Jalâl al-Din Rumi," *Persian Literature*, edited by Ehsan Yarshater (Albany: SUNY for Bibliotheca Persica, 1988), pp. 190-213.

Seyyed: The word can mean "sir" or "leader or refer to the Prophet Mohammad, but is generally used as a title to refer to any descendant of the Prophet.

"Shajan, Shajan": a prayer to ward off evil and mishap.

Shâhi: Literally meaning "pertaining to the Shâh," the term denotes an Iranian monetary unit in use during the Qâjâr era (1796-1925). In the early twentieth century it was equivalent to fifty *dinârs*.

Shams-e Tabrizi: "Shams [The Sun] of Tabriz," Rumi's inspirational beloved and guide from 1244 to 1248. For more, see **Rumi,** the full title of whose *Divân* is *Divân-e Shams-e Tabrizi.* A bilingual sampling of those poems appears in *Selected Poems from the Dîvâni Shamsi Tabrîz,* edited and translated by R.A. Nicholson (Cambridge: Cambridge University Press, 1898; reprinted in paperback in 1977).

Shaykh Bahâ'i (1547-1621/2): a scholar-poet with a place of honor at the court of Safavid Shâh 'Abbâs I (ruled 1587-1629). Writing in Persian and Arabic, his best known works are an anthology called *al-Kashkul* [The Beggar's Bowl] and a verse composition in closed couplets called *Nân va Halvâ* [Bread and Halva].

Shoe storage area: the special location for keeping shoes customarily removed upon entering the prayer hall of a mosque.

Shur and Mahur: two classical Iranian musical modes.

Sin: the fifteenth letter in the Persian alphabet.

Siyâq: an outmoded system of accounting used mostly by bazaar merchants, involving abbreviated symbols based on Arabic numerals.

Sohravardi(1153-1191): a famous Sufi and theologian who was accused of heathenism and strangled in jail. His *'Awârif al-Ma'ârif,* available in H. Wilberforce Clarke's *Divan-i-Hafiz,* 2 volumes (Calcutta and London: 1891), is one of the most popular Sufi treatises.

tekke: according to *Webster's Third International Dictionary of the English Language Unabridged,* the term is Turkish and denotes "a dervish monastery." The word "Compound" is used as a synonym.

"There is no god but God": *lâ ilâha illâ Allâh* : Koran, XLVII: 21, the first part of the profession of faith by which one becomes a Moslem and an utterance often recited in moments of distress or sorrow. Called *nafy* [negation], this part of the profession is followed by the *esbât* [affirmation], which goes: *wa muhammadun rasâlu allâh* [and Mohammad is the Allâh's prophet].

"Those who practice injustice...": Koran, XXVI: 227.

Yeh: the thirty-second and last letter of the Persian alphabet.

Zâd al-Ma'âd: a Persian work by Mohammad Bâqer Majlesi, in which he praises Safavid Soltân Hosayn (ruled 1694-1722). Majlesi, who practically

ruled Iran for several years during Soltân Hosayn's reign, held that Shi'is should respect monarchs. For more, see **Behârol'anvâr** and Abdul Hadi Hairi, "Madjlisî, Mullâ M.B.," *Encyclopaedia of Islam: New Edition* 5 (1986): 1086-1088.